Impressionism
A Centenary Exhibition

This exhibition has been made possible
through the assistance of
the National Endowment for the Humanities
and the New York State Council on the Arts

Impressionism

A Centenary Exhibition

Preface by Jean Chatelain, Directeur des Musées de France,
Administrateur de la Réunion des Musées Nationaux, and

Thomas Hoving, Director, The Metropolitan Museum of Art

Foreword by Hélène Adhémar, Conservateur en Chef,
Galeries du Jeu de Paume et de l'Orangerie, and

Anthony M. Clark, Chairman,
Department of European Paintings,
The Metropolitan Museum of Art

Introduction by René Huyghe, Member of the Académie Française

Catalogue by Anne Dayez, Curator,
Galeries du Jeu de Paume et de l'Orangerie, and

Michel Hoog, Curator,
Galeries du Jeu de Paume et de l'Orangerie, and

Charles S. Moffett, Guest Assistant Curator,
Department of European Paintings,
The Metropolitan Museum of Art

The Metropolitan Museum of Art
December 12, 1974 - February 10, 1975

English translation of entries
1-3, 5-7, 9, 12, 16, 18, 20-21, 23-25, 28-29, 32, 34-37, 39-40, 42
by Richard A.H. Oxby

Designed by Bruno Pfäffli
(Atelier Frutiger & Pfäffli), Paris

Photoengraving and type set by
Bussière arts graphiques, Paris

Printed in France by
Imprimerie moderne du Lion, Paris

Library of Congress Cataloging in Publication Data

Dayez, Anne.
Impressionism.

Translation of Centenaire de l'Impressionnisme.
Includes bibliographical references.
1. Impressionism (Art) — Exhibitions.
2. Impressionism (Art) — France.
3. Painting, Modern — 19th century — France. I. Hoog, Michel,
joint author. II. Moffett, Charles S., joint author. III. New York
(City). Metropolitan Museum of Art. IV. Title.

ND547.5.14D3913 759.4 74-11243
ISBN O-87099-097-7

Contents

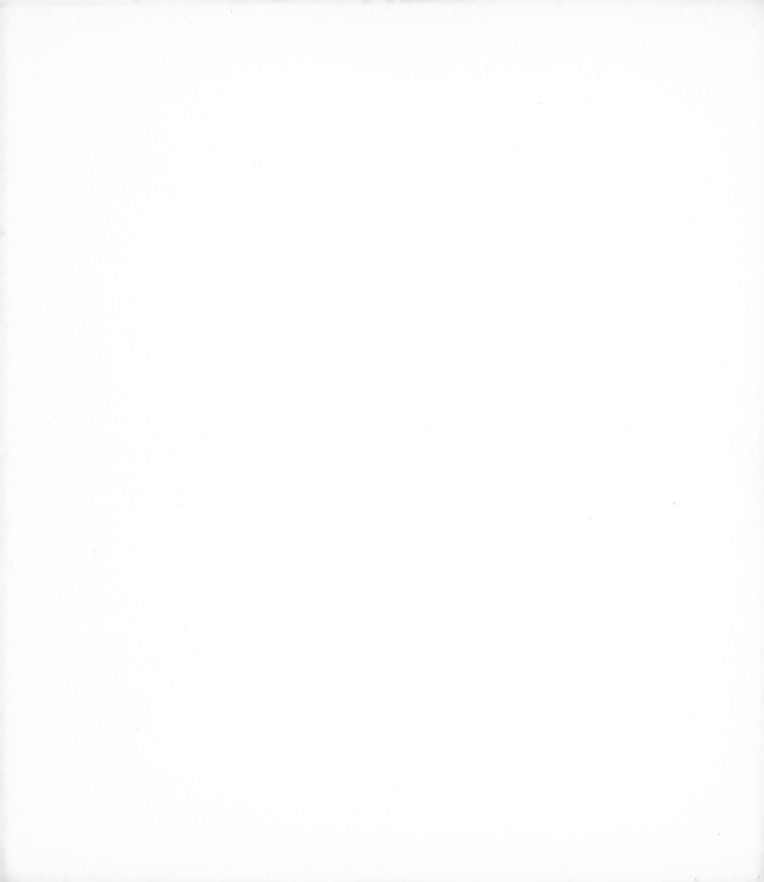

Preface

As soon as the Musées Nationaux de France began to organize this exhibition, it became evident that it would be difficult to carry through such an enterprise satisfactorily without the help of an associate in the United States, where so many masterpieces of the Impressionist school are to be found. The choice of the Metropolitan Museum of Art was the result not only of the size and quality of its collection of Impressionist works but also — and perhaps more importantly — of the close and friendly relations that have long existed between the Metropolitan and the Réunion des Musées Nationaux de France, especially the Louvre.

Accordingly, an agreement was worked out for a joint effort to avoid competition for loans, combine the institutions' powers of persuasion, and possibly facilitate matters of transportation and insurance.

But it should be noted that this exhibition of great Impressionist paintings from European and American public and private collections is only one of the events in what is now a well-established international exchange program. The first fruit of our joint exhibition efforts was *Masterpieces of Tapestry from the 14th to the 16th Century,* seen in 1973 at the Grand Palais in Paris, and this spring at the Metropolitan. *Nineteenth-century Drawings from the Metropolitan Museum of Art,* exhibited at the Louvre from last October to January, was followed by *Italian Renaissance Drawings from the Musée du Louvre,* which opened at the Metropolitan in October. A further exhibition in this extraordinary constellation will be *French Painting from David to Delacroix,* which will also be seen at the Detroit Institute of Art.

However, exhibitions do not represent the only activity in which museums can act together. Indeed, following the enactment of the General Exhibition Agreement with the Musées de France, our institutions decided that, instead of competing for a work of art they both wished to acquire, they would purchase it jointly, splitting the cost and exhibiting it alternately for five-year periods at the Metropolitan and at the Louvre. This unprecedented joint ownership of a work of art by a private American institution and a French state institution has now led to other developments : in June of this year a similar agreement was reached by the two institutions to display a reconstituted masterpiece of Sumerian art, the statue of Ur-Ningursu, which up to now had been in two parts — the head in New York, the body in Paris.

We feel that these first steps in international cooperation open the way to arresting or at least attenuating the competitive struggle that exists between the great museums of the world, a struggle financially burdensome and unacceptable when practiced by institutions that ultimately perform the same cultural task.

In yet another and very promising aspect of our program, we have decided to exchange professional staff : two French curators will soon cross the Atlantic to work for the Metropolitan and two American curators will go to France. We hope thus to create in a few years a network of friendly and personal ties that will assure better than any protocol or legal document the continuing close cooperation between our institutions.

It is sometimes said that the fairest flowers spring from the most difficult soils. Accordingly, we should be thankful for the special difficulties encountered in the course of celebrating the beginnings of Impressionism, for they have allowed us to strengthen the links that unite us in the pursuit of our common objectives : the informed presentation of superlative works of art.

<div align="right">
Jean Chatelain

Thomas Hoving
</div>

Foreword

We wish to pay tribute to the memory of Theodore Rousseau (1912-1973), former Director of the Department of European Paintings and later Vice-Director for Curatorial Affairs of The Metropolitan Museum of Art, who played an important role in the selection of the pictures for this exhibition.

We wish also to thank Charles Durand-Ruel, who, in keeping with a long family tradition, remains a devoted advocate of the Impressionists and has made his archives available to us.

We also thank Professor John Rewald, the well-known authority on Impressionism, whose extraordinary scholarship is the foundation of all research in this field.

The goal of this exhibition is neither to assemble a group of works painted in 1874 nor to mount a retrospective of the Impressionist movement. The collections of the Galerie du Jeu de Paume (Musée du Louvre) and the Metropolitan Museum of Art already offer the finest and most complete survey of Impressionism. Our purpose is instead to bring together the most significant and distinguished Impressionist pictures executed during the difficult early years of the movement, which lasted from approximately 1860 until the appearance of Neo-Impressionism with Seurat in the mid-eighties.

The combined efforts of the Metropolitan and the Louvre have, for the most part, succeeded in their aim. Nevertheless, some important works were not available for the exhibition because of delicate physical condition (some are still on their original canvases and have not been relined), or because of restrictions, often specified by the terms of a gift to a museum, requiring that they never be loaned. Among the pictures unavailable were : Manet's *Olympia* (Jeu de Paume), *Déjeuner sur l'herbe* (Jeu de Paume), *Music in the Tuileries* (National Gallery, London), and *The Bar at the Folies Bergère* (The Courtauld Institute, London); Monet's *Le Déjeuner* (Museum of Frankfurt); and Renoir's *The Luncheon of the Boating Party* (The Phillips Collection, Washington, D.C.) and *Loge* (The Courtauld Institute, London).

We are indeed grateful to the museum directors and curators and the private collectors who have made some of their most important works available for this celebration of the genius of these young painters on the hundredth anniversary of their first exhibition.

1874 was the year in which Impressionism was first presented to a wide audience in the form of a public exhibition of paintings that clearly advocated a new aesthetic. The works had been chosen by the artists themselves (the Société Anonyme des artistes peintres, sculpteurs, graveurs, etc.) and were shown at 35 Boulevard des Capucines in a studio rented from the photographer Nadar. Of course isolated examples of Impressionist painting dating before 1874 could be cited, and the critic Théophile Thoré (William Bürger) (1807-1869) had recognized the beginnings of the new movement well before 1874.

Pontus Grate has shown that Thoré "indicated unequivocally in his *Salon of 1838* that everything exists by virtue of its light source... For Thoré the fascination with painting was light itself." Grate further explained Thoré's interests as "the subjectivity of the visual experience of color and overall harmony." Twenty years later Baudelaire praised Boudin for "everything [in his work that was] rather unsubstantial, rather intangible in form and color, beginning with the waves and clouds, for which he always recorded in the margin the day, the hour, and the wind." Moreover, in the often neglected novel *Manette Salomon* (1866), the Goncourt brothers related how the painter Coriolis brought from the Middle East a conception of a world that was "fine, delicate, misty, ethereal, subtle." At one moment in the novel they depicted Coriolis leafing through albums of Japanese prints in search of "real light," the light of the open air, as well as the beauty of the Parisian woman, the "modern expression." At the end of his life Coriolis painted only pictures of "couleur exaspérée" in the south of France. Coriolis was an Impressionist before the fact; the Goncourts' foresight had indeed predicted the directions in which painting would develop, from Manet and Monet to van Gogh.

Nonetheless, although the visionary Goncourts predicted Impressionism and some of the forms it took, their vison was neither as subtle nor as wide-ranging as the movement that emerged in France after the Franco-Prussian War, after the discovery by Monet and Pissarro of Turner and Whistler. Impressionism cannot be given a capsule definition limited to its preoccupation with modern life, Japanese art, and plein-air painting. Before anything else, its emphasis on *resonant color (vibration colorise)* rendered through adjacent strokes of color interactivating one another is its most important characteristic. The common interest in *resonant color* is the source of real innovation in the work of Monet, Renoir, and their circle, and, in some instances, Manet too.

The unifying principle of the movement was recognized during the Impressionists' own time by the critic Duranty. In 1879 he described

the group as concerned with "a system of color resonance achieved through small, separate spots of unbroken color that interact." In his famous essay, *La Nouvelle Peinture...*, Duranty reiterated his ideas, saying that the basis of Impressionism lay in the principle of division of color : "They are not merely concerned with that fine flexible play of colors which results from the observation of the most delicate value in tones which contrast with or penetrate one another. Their discovery actually consists in having recognized that full light *de-colors* [bleaches] tones, that the sun[light] reflected by objects tends (because of its brightness) to bring them back to that luminous unity which fuses its seven prismatic rays into a single colorless radiance : light" (as quoted in Linda Nochlin, *Impressionism and Post-Impressionism, 1874-1904*, Englewood Cliffs, New Jersey, 1966, p. 4). Edmond de Goncourt asserted a similar belief when, in a moment of annoyance, he wrote that "the Impressionists are only... makers of spots, and, what is more, spots stolen from the Japanese" (Edmond de Goncourt, *Journal,* May 8, 1888).

A similar line of thinking explains Zola, who, even more than his comrades, encountered difficulties in explaining aesthetic phenomena. For example, the hero of his novel *L'Œuvre* makes "a new study of light, which contradicts all the regular habits of the eye." Duranty, perhaps phrasing the problem a little better, spoke of "the crispness of color that astonishes many people" and the "lovely pure tones" (1872).

Naturally, there was a shock element to the exhibition of work by the Société Anonyme... in Nadar's studio in 1874 — the group of pictures with their resonant, vibrant colors came as a surprise to an audience that was used to seeing in a different way. In any case, the public, the artists, and the collectors, despite their inability to understand exactly what had happened, knew that there had been a break with the past and that art had begun to move in new directions.

Hélène Adhémar
Anthony M. Clark

Shifts in Thought During the Impressionist Era :

Painting, Science, Literature, History, and Philosophy

When overwhelmed by a wealth of diverse information, the human intellect requires categories and classifications. It thereby thwarts the risk of being overpowered by infinitudes of fact and boundless information. Groups and units are necessary in order to organize and analyze. Through mathematics, systems were developed to meet these needs; previously, ideas and words were the seeds of a solution.

Art, on the other hand, is innately reluctant to engage in such activity, because its primary value is the sense of individualism that it engenders. It seeks the unique, at odds with a sense of the universal, the One. "Patiently or impatiently, become the most indispensible of Beings," as Gide advised Nathanael in *Nourritures Terrestres*. Every artist aims at this in his work; it is the source of his *raison d'être*. He wants to create. And what can be created that is not new? Aesthetics have developed very slowly toward a realization of this; but acceptance of the idea has come only recently, from the moment that primary importance was first given to individualism, and later increasingly to the undermining, revolutionary, and seminal function of art.

However, simultaneous but contradictory tendencies transpired : collective labeling of schools and styles soon spread wildly, confusing the specific with the general. At the beginning of the nineteenth century the practice gained momentum when, in the attempt to distinguish groups more clearly, Romanticism and Neo-Classicism were seen as opposing schools. Later in the century the first important group easily recognized as a definite school, because it held its own exhibitions and carefully selected its own members, was designated Impressionism. It soon gave birth to "Neo-Impressionism" and opened the door for a proliferation of *-isms* in the twentieth century, about which there has been abundant ridicule : Symbolism, then Nabism, Fauvism, Expressionism, Cubism, Surrealism, etc. All these names have turned contem-

porary art history into a chessboard on which the *-isms* have been positioned and maneuvered like pawns.

What is the truth? Was Impressionism a discipline or a form of expression for exceptional personalities? One could argue the point indefinitely. For Impressionism can be understood in at least two ways : either as a thin thread that ties together a group of individuals normally quite distinct and not likely to be confused with one another, or, on the other hand, as an unquestionably homogeneous group. Not only were the Impressionists supported (often heroically under less than favorable conditions) by a single dealer, Durand-Ruel, whose name deserves a place in history beside the painters', but their individuality was underscored by an unprecedented move when, in 1874, they decided to form the *Société anonyme des artistes peintres, sculpteurs, graveurs, etc.,* probably at the urging of Monet. The group also invited friends, artists whose work was less controversial than theirs, to exhibit with them in order to swell their ranks and to mitigate anticipated adverse public opinion. However, the public and the critics were not conciliated, and they launched a highly critical attack. The next year these painters, labeled Impressionists because of the title of a painting by Monet (see no. 28 in this catalogue), underscored their solidarity by holding an auction of their own work at the Hôtel Drouot. Thereafter the *Société anonyme...,* in assertion of its own existence, put on public exhibitions in 1876, 1877, 1879, 1880, 1881, 1882, and 1886.

Of course the group was only a rallying point; as the years passed some abstained, some retreated and later came back, and new members were occasionally admitted, laying the groundwork for the secession of the Divisionists in the eighties. Nevertheless, the nucleus of the group was stable. Thus, it is plausible to conceive of the group as a generalized entity; in bypassing petty historical details, one can define the motivating forces that they held in common; in transcending the limits of the painting itself, one is able to see a dominant thrust, a drift characteristic of their period as a whole and spanning the various aspects of its art, literature, philosophy, and science. One could not hope for a more expansive point of view in order to define the deepest points of an underlying sense of homogeneity.

Never has this core issue — which dominates but often confounds art history — been more clearly or as simply put : is art essentially *individual* or essentially *collective* in its bearing? Is creativity an exclusive and irreducible manifestation of the human spirit, or is it instead the expression of a period — a convergence of the coordinates of time and space, drafted with care by the cartographers of the mind? Surprisingly,

life is subtler, simpler; and because it proffers the reflection of its pluralistic aspects, why should we want a reflection of our dearth of ideas in but a single aspect?

The work of art — such a wonderful example of individual predication — living within itself and for itself, is like a loose page inserted by the artist into the pages of time, to be removed by the reader at will — oblivious of its context; however, it is simultaneously a deep, spreading root in the soil of an era that it penetrates in order to bring to the surface its most secret essences to transform them into visible blossoms.

What is Impressionism? It is Manet, Degas, Renoir, Pissarro, Monet and Cézanne; it is the convergence of the loose bonds between these individuals, each with his own obsessions but working together in a common venture without the loss of his own particular character; nevertheless, Impressionism was also a collective intellect (although as individuals they only *thought* of one thing at a time, life itself is a culmination — it *is* everything simultaneously). The Impressionists, because of their particular mode of plastic expression, embodied the spirit of the period.

A period is like a wheel with radiating spokes; interrelationships seem less and less likely toward the ends of the spokes where the gaps between are widest. But the spokes directly opposite one another (i.e., those headed 180 degrees away from each other) are mutually exclusive in direction and location — their end points are infinitely extendible in opposite directions in space. However, if we trace them back toward the center of the circle, we find that they are all joined in a common center at the hub of the wheel, the heart of its movement and unity.

Thus — like individuals — literature, art, philosophy, and science seem only to have chance contacts and tenuous links. Superficially, this may often be the case, but in reality they are interrelated in common points of origin and are but differing modes of a center that is recognizable as the spirit or "soul" of a period. The ancient philosophers understood the full meaning of *analogy,* and how analogies could be used to return to otherwise inaccessible fundamental truths. In ways often not immediately apparent, an analogy can express the dynamics of internal structures and their unifying principles even though our attention scans or fixes on external appearances. Where individual words are too divisive (because of their specificity), and where thought refuses to transcend its own boundaries, analogies, in contradistinction, permit insight into deeper interrelationships. The situation is similar to the geology of a landscape whose surface contours preoccupy us and dissipate our perception, hindering realization of what is beneath the surface.

Impressionism and Science

It is often said that Impressionism is a child of a century steeped in science. In discussions of the aftermath of Impressionism, people have even described the Impressionist movement as an attempt to wed art to physics; Impressionism has been understood as seeking in the latest discoveries of Chevreul, Helmholtz, N.O. Rood, and, later, Charles Henry, the secret of perfect vision, based on the prismatic division of light into a quantifiable scale of measurable color through which the painter could, at least in theory, achieve a more accurate simulacrum of visual experience. This is to attribute to Impressionism a program that only really applies to its successors, the Neo-Impressionists — Seurat and his circle — who forced to the extreme a concern with closing the gap between nature and scientific investigation of natural phenomena : optics and research into the perception and correct reproduction of colors, geometry, and methodical proportions in the calculation of shapes.

The Impressionists did not go as far; they proceeded according to instinct and intuition. Nonetheless, they were generally aware of recent discoveries. Allusions to them already had appeared in the pages of Delacroix's *Journal.* Yet artists in the nineteenth century (especially Delacroix) were wary of the new scientific spirit; they reacted against the increasing scientific presence, which they believed threatened what they represented, defended, and held as their *raison d'être.* It was not long before Symbolism, which appeared on the heels of Impressionism itself, countered forcefully and rejected the two key points that science offered to the world : on the one hand, concrete reality, the source of indisputable fact; and on the other hand the logic arrived at through reason, the catalyst of *laws.* Symbolism underscored the preëminence of *ideas;* it abstracted from visible reality the substantive appearance of ideas through imagery. Symbolism boldly took the offensive. Nevertheless, science preserved its dream of providing for all the material and spiritual needs of future society; it already believed itself the source of morality, and even, with Auguste Comte, of religion. Impressionism offered science the opportunity to absorb art, reducing it, in theory, to a problem of optics.

However, there existed a more complex relationship between Impressionism and science : a common intellectual attitude. Impressionism did not evade the bourgeois aesthetics of the nineteenth-century middle class, for whom art was a mirror of reality, the faithful reproduction of nature — i.e., realism. Then why did Impressionism meet

with such frantic hostility? The answer is because it contradicted ideas about reality based on ingrained habits, techniques, and traditions — in short, all the universally accepted ideas about reality held by the middle class in the nineteenth century. Impressionism opposed a realism that was predicated by scientific method and controlled laboratory analysis — a realism that flaunted contradictions between the principles it stood for and the results it espoused. Ironically, if optics proved that a shadow was blue, while common sense said that is was gray, Impressionism stood by science, and the public relied on common sense.

Science and Impressionism, each an entity in itself, could be summarized with the same phrase, the same principle : rational sensualism. Each pursued a common, long-standing adversary : fiction, the "imagination" that Delacroix had crowned as the "Queen of all the faculties."

Romanticism was at variance with the middle class and the scientific intellect. Impressionism contributed further to the first of these antagonisms but it deferred to science and accepted its primacy — a major preoccupation of the late nineteenth century.

The Death of Matter

As the end of the nineteenth century approached, the bell tolled for many traditionally held ideas and concepts. But beneath the surface of victorious science itself and the period it had shaped, an unseen development was gaining a momentum of its own.

Science, too, had been drawn into the endless, alternating rhythm that impels Man forward; inextricably woven into the fabric of history, Man will fight against science in one period but ally himself with it during another. One moment he tries to surround himself with the illusion of eternal stability *(nihil mutat)*, as in the Classical period; at another moment he abandons himself to the current that drowns his cries and nullifies his efforts *(omnia transit)*. When the latter prevails Man no longer tries to camouflage historical forces as inertially guided; on the contrary, he celebrates the tireless dynamism, which creates and destroys in the same motion, giving rise to Romanticism and the Baroque. In Classical architecture and composition, all elements relate to a central axis, a point of motionless balance. In classical pediments, as in the human pyramids characteristic of Raphael's compositions,

everything emphasizes the density of the horizontal base, the source and principal component of its form.

However, in Baroque architecture planes begin to move, advancing and receding; the undulating curves rush forward rhythmically. In works by Rubens and Delacroix, figures cross the picture space as if it were a public thoroughfare. They abandoned the artificial, pretentious, rigid systems previously in control of the subject matter of a work of art; suddenly everything was subordinated to the hurried passage of a few seconds.

Within these alternating cycles, the nineteenth century precipitated the collapse, initiated in the eighteenth century, of the illusively sound structures proposed by seventeenth-century thought and society. Romanticism, feverishly embracing a love for tension and a preoccupation with death (also typical of Gothic art), provided an appropriate metaphor for the collapse of a century of Classicism : the depiction of Arab horsemen. History, the basis of contemporary thinking, struck the final blow in the death of the classical idea, so dear to the age of Louis XIV (1638-1715), of a utopia first achieved by Classical civilization, then temporarily eclipsed by centuries of barbarism, and finally reborn during one's own time. The nineteenth century, however, substituted the idea of the relativity of civilizations, each with with its unique and unrepeatable truths, coming one after another without respite. The idea of relativity, to the further detriment of traditional thinking, produced the concept of intellectual relativism, and endowed each individual with his own truth in his own small world — these truths were to be expressed by artistic creation. It was even accepted that such truths might sometimes be incommunicable, a logical extreme generated by the spiraling one-upsmanship of the twentieth century.

The Impressionists liked to paint the breaking up of ice on rivers and streams. Was the late nineteenth century not a similar such phenomenon : that is, the splitting up and dissolving of the solid mass on which civilization had hoped to establish itself forever, the return to its own destiny as fluid, running water, the regaining of its freedom through dissolution and gradual thaw? In all areas of thought, the late nineteenth century substituted the moving for the fixed — the unstable and indefinable for the immobile and the precise. Within this fabric, the Impressionist thread is quite strong : it is the visual manifestation, the imagery, of a new conception of the world — a world remaking itself in all its aspects.

This new conception appears first in a most immediate and concrete form : differences in the nature of subject matter. Perhaps in the future

we will interpret centuries of history through such changes. No two people ever see things in the same way, nor do they think of them in the same way; the various forms in which painters have unconsciously expressed themselves provide insight into the preoccupations and obsessions of each period. The end of the nineteenth century leaned to attitudes of anti-materialism — a natural reaction to the excessive materialism that science insisted on through its positivist approach and devotion to the concrete, a position reflected in art and literature by Naturalism. The unchallenged domination of such thinking found itself suddenly threatened; Symbolism offered an alternative : abstraction, intellection, ideas. Impressionism too, although it remained faithful to the world of reality, looked skeptically at science and the materialist principles that it engendered; it converted and little by little undermined the thinking about matter that until then had passed as the very essence of reality.

A new understanding of nature resulted : all that connoted the inert and stable was increasingly supplanted by the fluid and impalpable; nature lost its attributes of weight, density, and hardness. Its content, form, and palpability gave over to a phenomenon far beyond the limits of simple mensuration.

The change first appeared in the form of an obsession with water that increasingly impinged upon subject matter drawn from the world of solid forms which had still dominated realist landscapes in the mid-nineteenth century. For example, Rousseau and Courbet were preoccupied by botanical and mineral facts. In their work, rocks, tree trunks, soil, and dense foliage seem to be the sum total of nature. Rousseau's water is never more than the dead surface of a pond, smooth, without movement or ripple, flat and heavy with its own weight. In Courbet's work water has no fluidity; it is either a certain quantity of moisture, or, taking the form of a wave, it appears modeled in clay, frozen in motion like figures from Classical legends suddenly transformed by the gods.

Corot, who painted running, musically flowing water, was followed by Daubigny, who was similarly fascinated by fluid environments. Daubigny painted one river scene after another, with the scattered rows of trees along the river banks mingling in the reflections. Here began the intense interest in water in which were the beginnings of Impressionism.

The Impressionists, except in their early days, abandoned the dry, timeworn earth of the Forest of Fontainebleau with its oaks, sand, and rocks. Impressionism turned to the sea; before Monet, nevertheless,

Boudin, Jongkind, and Cals were painting in Honfleur and Le Havre. They were attracted by the fine gradations and subtle movement of the sea. At the same time they discovered Turner and his pictures of water, steam, and speed. The Impressionists began to gravitate around Argenteuil, with its river (the Seine) and sailboats. Monet, who loved water so much that he had a boat made into a floating studio (as Daubigny had done before him), said one day he would like to be buried in a buoy. Seurat did his military service in the Navy at Brest (Brittany), and Signac had the title "Captain in the Merchant Marine" on his calling cards. Pissarro alone held to the terra firma while the others turned to the rivers and the sea for subject matter.

The day came, however, when the transposition was complete: the Fluid supplanted the Solid. In one of Pissarro's paintings greater emphasis was given to the smoke of a small freighter than to its deck, or to the shore that disappeared in the fog — the fog into which Monet had already begun to sink his attention with ravishing delight. In Monet's pictures of London, is the fog appearing or disappearing? There is no definitive answer. Everything has become mist, that vague link between fluid and solid states. Monet, like Hylas, would die leaning over a pond, fascinated still by the fluid surface in which earth, trees, and sky had lost their separate existences: they had become nothing more than soft reflections, submerged in the water and absorbed by it, made into fluent, undulating, stirring shapes.

Furthermore, the goal of the Impressionists' art — the reality that they held to be the first and only principle of their pictorial activity — was that most impalpable of essences, the resonant light whose function it is to transmit all appearance, everything visible in the world.

Literature and music followed accordingly. Before the Symbolists, no one had ever been as fond of fountains and pools and the rise and fall of delicate jets of water. Mélisande lost her ring in "l'eau si profonde"; "il n'y a plus qu'un grand cercle sur l'eau"; "c'est au bord d'une fontaine aussi qu'il vous a trouvée?" Henri de Régnier's memories emphasized things without shape or weight:

De ce que nous avons senti des roses,
De l'eau, du vent,
De la forêt et de la mer...

Evanescent was the term used then; it was the word of the moment. This new emphasis on fluidity and flux produced a new kind of poetry in which Verlaine emphasized,

...l'impair
Plus vague et plus soluble dans l'air,
Sans rien sur lui qui pèse et qui pose.

Verlaine's poetry took on the character of music. Indeed, Vuillermoz was able to define Debussy with words that seem equally suited to Impressionism : "he [Debussy] renewed the dignity of feelings... he abandoned known quantites with a predictable effect in the sphere of the emotions in order to pursue an onrush of reflections, fluencies, shimmerings, iridescences, glimmerings, ripplings, and shudderings." *Jeux d'eaux*, one might say, but that's one of Ravel's titles, like *Miroirs*. Debussy's titles, too, are evidence of the same fascination : *Jeux de Vagues (Wave Games), Nuages (Clouds), Dialogue du Vent et de la Mer (Dialogue Between the Wind and the Sea), Jardins sous la Pluie (Gardens in the Rain), Reflets dans l'eau (Reflections in the Water), Le jet d'Eau (The Fountain), La Cathédrale Engloutie (The Cathedral under the Sea)*. Titles of works by Florent Schmitt reflect the same interest : *Musique sur l'eau (Water Music), Les Barques (The Boats)*. Debussy was also criticized for having given up *form*, a criticism often leveled at the Impressionist painters.

There were no longer any firm, straight lines. Lines floated and moved. In decorative art, linear stylizations seemed to have been created by undines (legendary female water sprites, who could receive a human soul if they married mortals) who had risen from the watery depth covered in wavy seaweed. Straight lines and direct lighting were forbidden, even in physics, where the study of waves was suddenly the center of attention. Furthermore, the language and imagery of philosophy, especially Bergson's writings, were replete with phrases such as "moving," "vital flow," "outpouring," "flux of the inner life," etc.

Science Denies Itself

The reaction against concrete, "material matter" appeared in science itself. However, any links between science and art were unconsciously forged. The period clearly distinguished between *literary* and *scientific* categories and agents — a distinction without precedent in the history of ideas, resulting in two separate disciplines in the teaching profession, as if culture really were comprised of two separate halves.

However, the inexorable drift that characterizes every period impelled science and art along curiously parallel paths. Increasingly,

science, which until then had willfully remained within the the bounds of the measurable (that is, the practical use of the senses; the logical, rational side of the mind), had to confront the perplexing, baffling realities of life, generally considered to be more appropriate to the suggestive, intuitive devices of *literary* thinking. Science was about to abandon its two main lines of defense : the certitude of being able to break down and systematically organize the nature of *matter*, and the immutability of the legal code of reason.

The universe as conceived and explained by science left no room for mysteries that could not be contained by a physical contour, defined with words, perceived by the five senses, or understood by the human mind. Where science had passed, no window remained open through which the mists of the night might penetrate the clear white light of the laboratory; the way was also blocked to all those blurry monsters of the night that hover with their great wings silently beating the air whenever Man loses solid footing and his mind no longer has a rationale to guide it.

But now science itself drove Man from the tiny island of terra firma on which he had taken refuge; it thrust him into the current that he had tried to ignore. Now science, too, would have to admit that the apparent regularity of nature and reason was perhaps no more than a convenient illusion, with which our thought had nourished a myth of clarity and certitude surrounding us.

In earlier periods physics had been wary of energy and life, often the sources of doubt and disorder; it understood them only as a sort of motor element added to matter. "The world in which we live," as Professor Paul Janet (1859-1947) wrote, "is composed of two quite distinct parts : one is the world of nature, the other that of energy... Matter and energy may assume a large number of different forms, but matter can never transform itself into energy, nor energy into matter." Thus the traditional view of matter escaped intact and unscathed : energy, like a fluid propelled through a pipe, could disturb neither the layout nor the logic of the system.

Such complacency quickly faded away, however; late nineteenth- and early twentieth-century physics was particulary inquisitive, and demonstrated that the solidity of discontinuous entities was only an appearance, an illusion. But this is not the place to trace the history of how scientific thought dispersed, broke up, and scattered the traditional concept of matter. Science literally and figuratively pulverized matter, and previous ideas about matter, into an infinitesimal teeming of atoms (approximately ten million atoms in a square millimeter of

hydrogen), each of which broke down into particles, protons, electrons, etc. Even these last mentioned have been shown to be turbulent forces in perpetual motion, electrical particles propelled at bewildering speeds. Faraday found support for his theories in the idea that an atom is a particle of electrically-charged matter. But the inexorable lucidity of the modern mind pursued the problem to the end : what is, one asks, this "particle of matter"? As early as 1905, Dr. Gustave Le Bon (1841-1931) published a study on *The Evolution of Matter.* He demonstrated the existence of a formidable union between matter and energy; the two concepts that Janet had so carefully kept apart had come together. "Energy and matter," Le Bon declared in contradiction to Dr. Janet, "are *two different forms of the same thing.* Matter represents a relatively stable form of intra-atomic energy. Heat, light, electricity, etc. are unstable forms of the same energy... *Matter can be dematerialized by* simply transforming *the stable, condensed form of energy known as matter* into the unstable forms known as electricity, light, heat, etc."

Since Le Bon the erosion of early ideas about matter has continued. Today, matter as it was originally conceived is no longer anything more than a rough idea provided by one means of perception. The very structure of matter is now thought to be electric. Moreover, the work done by Louis de Broglie on the mechanics of wave motion suggests that "electron material as such may finally be an illusion; the energy that accompanies it seems to have a wave origin, and it is only because this energy is localized into what is generally an extremely small space that the electron has been considered a particle."

Thus the concept of matter returns to that of energy, and fuses with it; matter and rays, which are constantly associated, are finally considered as two aspects of the same reality. Radioactive substances had become a subject of scientific study : after the discovery of Roentgen rays (X rays), there followed that of uranium, which Becquerel recognized in 1896 to be the source of similar spontaneous radioactive emissions; two years later, radium was discovered...

Matter was not only deprived of its traditional stability, but even of its identity and physical continuity : the atom appeared to be an enormous reservoir of potential energy which expends itself; physics has established a scale of evolution through which uranium degenerates to lead through the intermediate stages of radiums A.B.C.D.E.F.G. The old alchemist's dream of permutations has become possible again.

The new concept of matter brings it back, ultimately, into confrontation with its traditional adversary : movement. The issue becomes a question of movement and velocity. Bohr would show that the electron

could only move in fixed orbits, and because each of these orbits corresponded to a certain amount of energy, a sudden change from one to another involved radiation or absorption of energy, depending on the direction of the move. Coming full circle, then, science had arrived at a conclusion unforeseeable only a short time before: "elements ultimately composed of pure velocity, i.e., space and time" (Lecomte du Nouy, *Le Temps et la Vie,* 1936). Matter, and previously held ideas about matter, no longer meant anything.[1]

Surely science must remain faithful to that last proof of stability in the world, logic? No. Modern physics is no longer afraid to declare the irrational, if the irrational is a practical and necessary hypothesis. Its analysis of matter forces it to conceive, ultimately, of what Lecomte de Nouy admirably and boldly defined as "movements of elements that seem to have *no existence apart from their movement."* Consider it: physics verifying properties of elements that do not exist apart from these very same properties! The principle of identity is turned inside out. Now we have to conceive of something that has character and movement, and at the same time accept that it does not exist, that only its movement exists. Lecomte du Nouy eventually spoke dispassionately of "the absurdity... in which present-day science cannot avoid culminating, and which simultaneously ruins our concept of matter and our basis of reason and logic."

Impressionism, Vision of a New Universe

Impressionism? What connection did it have with this new attitude, this development of science? Unconscious of it, but nonetheless sometimes anticipating it, Impressionism was, like science, an integral part of the collective thought of its period. Involuntarily, unconsciously, because of the unswerving historical forces of a period, it proffered a vision of the world that was a sort of tangible manifestation of the abstract scientific vision outlined above.

If science, for its part, reduced matter to billions of atoms that made of the universe an immense magma of infinitesimal swirling particles in which chance and the logic of association created bodies, shapes, and objects like so many fleeting apparitions, then Impressionism too, in its own way, reduced things to their fundamental essence. For

[1] We know that since mass is a function of the velocity of the electron it would become infinite it this velocity attained that of light.

the Impressionist painter there were no more contours, no more shapes, no more distinct objects. There was only a cloud of colored flecks whose interrelationships and arrangement provided an illusion of things. In scientific advances and in Impressionism were the same profound poetry and lyrical vision; Clemenceau sensed this when he wrote about Monet's *Water Lily* paintings, perhaps recalling a conversation that he had once had with the artist, his old friend : "Are we not here quite close to a visual interpretation of the brown movements? Enormous distance separates Science and Art, of course, but at the same time, there is all the unity of cosmic phenomena... The man of Science has shown us the eternal movement of the elements, and has put us in a position to assimilate it, to act on it, to live it in Nature."

This glimmer of light, shed by science on the nature of the universe, falls at the limit, almost beyond the limit, of human intellection; it allows us to imagine a limitless state of motion — an unbelievable swarm of activity — from the infinitely small to the infinitely large, producing on every level an effusion of myriad inexorable forces, held in dynamic equilibrium by movement alone. This world, in which we live and act, but of which we only understand phenomena but not the entire phenomenon — this source of apparent peace and security in which things only stand still in our illusions — imparts the same staggering paradox as a stiff, cold, immobile corpse that we suddenly see decomposing in the midst of a teeming mass of powerful, tireless, frenzied worms.

We walk about a piece of architecture, and lean against it, feeling the fine, hard edge of the stone. We draw from observations about the building notions of equilibrium, balance — and yet, albeit hidden from the eye, it is nothing more than a fantastic cloud of sand grains whirling in perpetual motion.

This dynamic, inconsistent universe, built of forces in motion, has never been better portrayed by the instinct of a contemporary painter than in certain Impressionist pictures, in which there is a swarm of brushstrokes, each charged with an intense, vibrating color; the picture can be seen as an unstable cloud that is the world in which we believe, and which we know to be only a habit of our thought.

Van Gogh, through the intuition afforded by his intermittent madness, and in his need for communion with an Absolute beyond the realm of the five senses and beyond reason, was able to body forth a glimmering, in some of his work, of skies in which the furious, blind, mechanical forces of the stars, locked into their common or opposing orbits, are restrained and unleashed, linked and entwined.

Théodore Rousseau, in the middle of the nineteenth century, had already felt the grip of the world's grandeur; he had felt its inner sap, its turbulent and hidden heat, under the motionless bark and in the deep silence of the forest. But consider van Gogh and Seurat, as well. Seurat is shot through with the cold lyricism of a physicist as he contemplates the limitless complexity of the "points" dotted over his canvas ·like atoms under analysis; in his *Cornfield* he filled the entire canvas with them. And van Gogh, with the pluralistic vision of a mystic, glimpsed the frenzied dance of the worlds and the atoms, intuitively feeling their trajectories and circular motions. In some of his day or night skies he reveals all those "magnificent suns" whose "vastes masses d'or" (vast golden masses) Laforgue knotted and un-knotted. He seems to reflect the theories of the physicist Sir Joseph Larmor (1857-1942), who in 1900, in *Aether and Matter,* described atoms as cores of condensed ether rotating at enormous speeds (ether : a medium postulated in the undulatory theory of light as permeating all space and as transmitting transverse waves). Between physicist, poet, and painter there existed, therefore, an outline for a unanimous point of view of which they were all unaware.

The Immediate Data of Consciousness

However, there was an even closer rapport that bound the thinking of the painter, the scholar, and the philosopher at the end of the nineteenth century. Overtly, they all had abandoned nature and the traditionally held related conceptual paraphernalia; but, privately, they had all abandoned the traditional limits of logic. Science, as we have seen, was progressively forced to separate nature from logic, and had to admit and weigh the irrational. Science ended by establishing a link, at an essential point, with the philosophy of Bergson, scoffed at by "scientific" types since publication. Bergson dared to limit and localize the power of rational intelligence; he believed that the intended purpose of the intellect was to focus on the material and inorganic world, to which it is, by nature, suited. The solid and the discontinuous were his province of study. His work is the mainstay and guide of the study of material reality; any investigation of it is based on his ideas. But "our study is efficacious only if directed at fixed points. It is thus stability that our intellects seek" *(La Pensée et le Mouvant).* Our intellect arbitrarily organizes for us an image of the world in which fixity and regularity dominate, and in which everything transpires as if life, the

"vital current," this unremitting flaw in the fabric of the universe, did not exist. In the real world, it distinguishes shapes and objects, and in thought it distinguishes intellectual objects — ideas and notions. In this way everything can be understood and managed.

But where is the profound, ultimate reality, the essence of life "in its natural, pure state"? To reach it, one must enter into direct contact with it, and leave behind all the pragmatic artifice of the mind. We must rely on the instinctual perceptions that enable us, as living beings, to understand life : by intuition. The essence of our effort must be to rediscover and recognize, behind the synthetic constructions of the intellect, "the primary data of consciousness."

Simultaneously, the novel (i.e., Proust) and painting (i.e., the Impressionists) were making parallel attempts to reject the codification imposed by the intellect on the abstract and indefinable truth of life, and to re-establish a natural dialogue with it.

In the character of Elstir, Proust portrayed a typical Impressionist painter. From the beginning, he described "the efforts he made to rid himself, in the presence of reality, of his notions of intelligence." Elstir's goal has a general significance. Our eye only perceives the "immediate data" conveyed by spots of color; it is the brain, with its memory banks and records of experiences, that immediately informs us that a particular configuration amongst others corresponds to a fruit whose contours a finger can trace and whose mass the hand can feel. Thus, from the beginnings of time, artists have been led to paint more than they saw, and sometimes to distort *what they saw* in order to better render *what they knew.* For example, they outlined shapes with contours — abstract fictions delimiting particular shapes predicated by certain angles of vision; moreover, artists superimposed shadows over local color in order to model the volume. When lighting conditions caused two objects of a similar color to blend, outlines were drawn in to separate them.

But — and here Proust speaks — "surfaces and volumes are in actual fact independent of the names of objects that our memory imposes on them when we recognize them... Elstir forced himself to eliminate what he already knew about something that he had just perceived. His effort often amounted to nullifying the catalogue of observations that we call vision." In so defining an Impressionist, Proust was defining himself,[1]

[1] Rivière seems to have identically characterized Proust : "...he dismisses psychological entities and begins with primary experiences... Nothing preconceived ever enters into what he offers us." Edmond Jaloux, too, makes such an observation : "He has been able to free us from artificial logic, and thrust us back to the truth itself."

as well as the Bergsonian methodology, which demanded renewed inquiry of the truth, free of the preconceptions of the intellect, free from prejudice (in the literal sense) in the interpretation of unqualified sensations as supplied by the five senses or intuition.

The Impressionist painter devised a similar technique, and, in defiance of common sense, painted a tree red even if he "knew" it was brown, or a horse blue even if he "thought" it was gray, provided of course that his eye, with no extraneous tutoring, had recorded such perceptions. Here again we discover that the painter, the writer, and the philosopher had adopted the same attitude.

The New Dimension : Time

The painter, the writer, and the philosopher had introduced a new element : time, or to borrow from the language of Bergson, timelessness (la durée).

Previously, the mind tended to consider things and beings as separate realities that were unaffected by passage through time and differing historical conditions. The concept of the separate identities of things and beings remained intact despite various modifications and changing states of definition and point of view; its basic identity remained unchanged. Similarly, centuries passed before painting discovered real light and its phenomena; first, painters had to abandon the unreal, artificially even light, unrelatable to a time of day or a season, that had been devised to model forms and define shapes since the inception of pictorial art. Inculcated concepts had to be eliminated in order to discover true light and its effects. For example, shadow had always been used to model form, not to suggest an actual kind of light.

Similarly, writers often created characters, sometimes relying on archetypes, who then were maneuvered through different circumstances that the author had imagined. The artificial had absorbed the real; preconceptions dominated perception.

Science reflected a similar tendency by the establishment of fixed and general laws, with the result that identical effects repeated themselves in identical circumstances. The formula and the result remained unchanged as long as the formula went unquestioned. "Science," wrote Bergson, "extracts and withdraws from the material world that which lends itself to repetition and calculation, and which consequently does not share in timelessness (la durée)." Language itself, Bergson also

noted, takes little account of time, and that to explain this phenomenon one tends to use only words culled from the vocabulary used to express ideas about space.

The end of the nineteenth century suddenly discovered timelessness (la durée). It created for it the term "fourth dimension," which soon began to turn up everywhere. Bergson, for example, wrote that art, "in never isolating the present from the past that is inevitably always in tow, seems to endow things with a kind of fourth dimension." Here Bergson is close to Proust, who described the church in Combray as occupying "fourth-dimensional space, the fourth being time." Elsewhere, Proust talks of Swann's past impressions as associated with present impressions, thereby giving them a "foundation, a depth, an extra dimension." Bergson's philosophy, Proust's novels, and Monet's "series" paintings are all obsessed with the idea that neither human existence nor things remain the same or continue intact in their identity : each new second brings change, which transforms their very nature.

Bergson insists on a "cone of memory" in which all experiential facts are stored, and which bears down with its ever accumulating weight on its apex, which is the second present, i.e., each new minute adds to this total an element that modifies it, and prevents it from ever being the same again.

Time. Time and the anxiety that it engenders dominate Proust's entire œuvre. His collected work is even titled *A la recherche du temps perdu* (the search for time that is lost; or, the remembrance of things past), the last volume of which is titled *Le temps retrouvé* (time regained, or time found again). Bergson had coined the expression when he declared the need for caution in "méthodiquement d'aller à la recherche du temps perdu" (methodically going in search of time past). Proust bears witness to this quest : the essential novelty in his psychology resides in this perpetual confrontation of Man in his inner life with Time, with the unexpected resurgence of forgotten memories through the impetus of a renewed experience (the famous "madeleine" in the cup of tea — the uneven cobblestones of the Hotel Guermantes). A primary example of Proust's emphasis on the nature and effects of time is his astonishing analysis of the transformations of love through time.

The final sentence of Proust's last book could also serve as his own epitaph : "If only I were left the time to complete my work, I would not fail to stamp it with the seal of Time itself — Time, the thought of which weighed so heavily on me today; were I left the time I would describe men and, although my description might make them seem like monstrous beings, I would depict them occupying a far grander place

in Time than the rather restricted one allowed them in Space, paradoxically an area indefinitely extended because, like giants straddling centuries, places are in simultaneous touch with the periods through which they have endured, periods distant from one another, separated by endless days — in Time!" Time, Proust's leitmotiv; Time, his final word.

Monet's "series" paintings (haystacks, cathedral façades, and poplars) paralleled Proust's work in many ways. In the façade of the Rouen Cathedral, which seems to have gone through centuries with almost no change, Monet discovered a vital fluency, a fluid presence, changing from second to second. He watched the façade as the hours passed with a rhythm of their own; it was as if he could feel the pulse of the cathedral façade in the midst of timelessness (la durée). Monet executed approximately twenty versions of the Rouen Cathedral façade, as if he were painting the different expressions of one person's face. He infused the façade with the life of the changing light and the passing of the days — the life of time, and its dying. Turning again to a passage by Proust about the church in Combray, we note that he, like Monet, described the church in its successive guises, caused by the changing light and the time of day.

It seems a moot point to remark that since Einstein science has emphasized the relevance of time, before anything else. Time has become the essential, indispensable element, although in recent history it was excluded from scientific inquiry except as an element of aberration.

Although artists tend to think of themselves as isolated within their own province, and, like the Impressionists, limited to the rigorous and impartial analysis of their own sensory perceptions, they express, albeit unconsciously and involuntarily, the innermost essence of their period. Each of their works may have the force of prophecy.

The artist is in fact a medium, an augur : working from intuition, trusting in his own feelings, which he translates directly into imagery that is unalloyed by filtration through fashionable ideas and words, he can, if unaffected, visibly manifest forces gathering deep within the consciousness of a period.

There is a vast human consciousness that extant individuals hardly suspect; they are too deeply involved in their own peregrinations. Like electrons whirling around atoms, they spin in their own orbits isolated from the nucleus; yet because of the common origin of their bonds there is a collective consciousness that spreads through the grid of time. It is only later, with the advantage of distance and hindsight, that one sees the resolution, the form of the collective consciousness. Similarly, a

dispersed crowd wandering aimlessly across a plain may, from a mountain, be seen as a compact entity moving toward its goal. The collective human consciousness is aware of its own misgivings, hesitations, efforts, and presumptions. In any case, every individual, inevitably and without exception, shares in the collective consciousness of his period.

Men — and above them, unseen but predicated by their collective substance, is Man. All are in isolation and they unquestioningly follow one another, each believing that he is on a path that he understands, while Man moves along a profound, collective passage that is beyond our comprehension.

René Huyghe
de l'Académie Française

Catalogue

The catalogue entries have been written by :

Anne Dayez (A.D.)
Curator
Galeries du Jeu de Paume et de l'Orangerie

Michel Hoog (M.H.)
Curator
Galeries du Jeu de Paume et de l'Orangerie

Charles S. Moffett (C.S.M.)
Guest Assistant Curator
Department of European Paintings
The Metropolitan Museum of Art

General Bibliography

The latest edition of J. Rewald's *History of Impressionism*, published in 1973, contains an extensive and up-to-date critical bibliography for the whole Impressionist movement. Here we shall only mention monographs devoted to the artists represented in this exhibition and the catalogues of the Louvre and the Metropolitan Museum that discuss most of the works shown and provide provenance, bibliography, and exhibition history.

M.L. Bataille et G. Wildenstein
Berthe Morisot : Catalogue des Peintures, Pastels et Aquarelles, Paris, 1961.

M. Bérhaut
La Vie et l'Œuvre de Gustave Caillebotte, Paris, 1951. (A Catalogue Raisonné by Bérhaut is currently in preparation.)

A.D. Breeskin
Mary Cassatt a Catalogue Raisonné of the Oils, Pastels, Watercolors, and Drawings, Washington, 1970.

F. Daulte
Frédéric Bazille et son Temps, Geneva, 1952.

F. Daulte
Alfred Sisley, Catalogue Raisonné de l'Œuvre peint, Lausanne, 1959.

F. Daulte
Auguste Renoir, Catalogue Raisonné de l'Œuvre Peint, I, Figures (1860-1890), Lausanne, 1971.

P. Jamot, G. Wildenstein, M.L. Bataille
Manet, 2 vol., Paris, 1932.

P.A. Lemoisne
Degas et son Œuvre, 4 vol., Paris, 1946-1949.

L.R. Pissarro et L. Venturi
Camille Pissarro, son Art, son Œuvre, 2 vol., Paris, 1939.

G. Serret et D. Fabiani
Armand Guillaumin, Catalogue Raisonné de l'Œuvre Peint, Paris, 1971.

A. Tabarant
Manet et ses Œuvres, Paris, 1947.

L. Venturi
Cézanne, son Art, son Œuvre, 2 vol., Paris, 1936 (J. Rewald is preparing a revised, corrected, and enlarged edition of this work).

D. Wildenstein
Claude Monet, Catalogue Raisonné de l'Œuvre Peint (in preparation).

Metropolitan Museum

C. Sterling and M.M. Salinger
French Paintings, a Catalogue of the Collection of the Metropolitan Museum of Art, III, XIX-XX centuries, New York, 1967.

Musée du Louvre

L. Bénédite
Musée National du Luxembourg, catalogue des peintures, sculptures, etc. de l'école contemporaine, Paris, 1899.

G. Brière
Musée National du Louvre, catalogue des peintres exposés dans les galeries, I, école française, Paris, 1924.

G. Bazin, H. Adhémar, M. Sérullaz, M. Beaulieu
Musée National du Louvre, catalogue des peintures, pastels, sculptures impressionnistes, Paris, 1958.

C. Sterling and H. Adhémar
Musée National du Louvre, peintures, école française XIXe siècle, 4 vol., Paris, 1958-1961.

H. Adhémar et A. Dayez
Musée du Louvre, Musée de l'Impressionnisme, Jeu de Paume, Paris, 1973.

Frédéric Bazille

View of the Village

Signed and dated, lower right :
F. Bazille 1868
Oil on canvas
H. 52$\frac{1}{8}$, w. 35$\frac{5}{8}$ in. (132 × 90 cm.)

Musée Fabre, Montpellier
Gift of Madame Gaston
 Bazille, 1898

"The tall fellow Bazille has done something I find quite fine : a young girl in a very light dress in the shadow of a tree beyond which one sees a town. There is a good deal of light, sunlight. He is trying to do what we have so often tried to bring off : to paint a figure in the open air. This time I think he has succeeded." So wrote Berthe Morisot to her sister Edma (see no. 32) on May I, 1869, referring to the picture Frédéric Bazille exhibited at the Salon (see M. Angoulvent, *Berthe Morisot,* Paris, 1933, p. 30-32; and John Rewald, *The History of Impressionism* [fourth edition], New York, 1973, p. 643.)

View of the Village has a more traditional spatial composition than a work like Monet's *Women in the Garden* (see no. 25); nevertheless, it is typical of the experimentation before 1870 by the artists who later banded together for the famous group exhibitions beginning with the one at Nadar's studio in 1874. Bazille had treated a similar subject in 1864, *The Pink Dress* (Musée du Louvre, Galerie du Jeu de Paume, R.F. 2450). *Family Reunion,* 1867 (Musée du Louvre, Galerie du Jeu de Paume, R.F. 2749), shown in the Salon of 1868, but retouched in 1869, again treated the subject of figures in the open air, but on a much larger scale (h. 60$\frac{3}{4}$, w. 91 in. [154.3 × 231 cm.]). The present picture is a portrait of the daughter of a tenant farmer at Méric, the artist's parents' estate near Montpellier. The town on the hill in the background is Castelnau.

In the Cabinet des Dessins of the Musée du Louvre there is a sketchbook (R.F. 5259) of Bazille's containing several charcoal studies (folio 52 verso, 53 verso, 54 verso) for *View of the Village;* one of them is squared for transfer, evidence of how closely Bazille followed traditional practices. F. Daulte (see Selected Biblio-

graphy) notes an etching of *View of the Village*, the only known print by Bazille.

Bazille exhibited once again, in 1870, at the Salon before he died that year at the age of 29 in the Franco-Prussian War. The small quantity of work left by this artist who died before his work reached its maturity places him, however, among the most important artists of his generation — the group Louis Leroy labeled the *Impressionists* in 1874.

A.D.

Provenance

Collection of Gaston Bazille; gift of the artist's mother to the Musée Fabre.

Exhibitions

1869 Paris, Salon, no. 149
1900 Paris, *Exposition Centennale de 1900*, no. 22
1910 Paris, *Salon d'Automne rétrospective Bazille*, no. 14
1927 Montpellier, *Exposition Internationale de Montpellier, rétrospective Bazille*, no. 17
1935 Paris, Association des Etudiants Protestants, *Bazille*, no. 18
1939 Paris, Orangerie des Tuileries; and Berne, Kunsthalle, *Chefs d'Œuvres du Musée de Montpellier*, no. 4
1941 Montpellier, Musée Fabre, *Centenaire de Bazille*, no. 25
1947-1948 Brussels, *De David à Cézanne*, no. 104
1950 Paris, Wildenstein and Company, *Bazille*, no. 41
1959 Montpellier, Musée Fabre, *Bazille*, no. 29
1974 Bordeaux, Galerie des Beaux-Arts, *Naissance de l'Impressionnisme*, no. 86

Selected Bibliography

F. Daulte, *Frédéric Bazille et son temps*, Geneva, 1952, no. 36, p. 180-181, and p. 117, 119-120, 134, 145, 147, with a complete bibliography prior to the date of publication;
K.S. Champa, *Studies in Early Impressionism*, New Haven and London, 1973, p. 88, fig. 125;
J. Rewald, *The History of Impressionism* [fourth edition], New York, 1973, p. 218, 223.

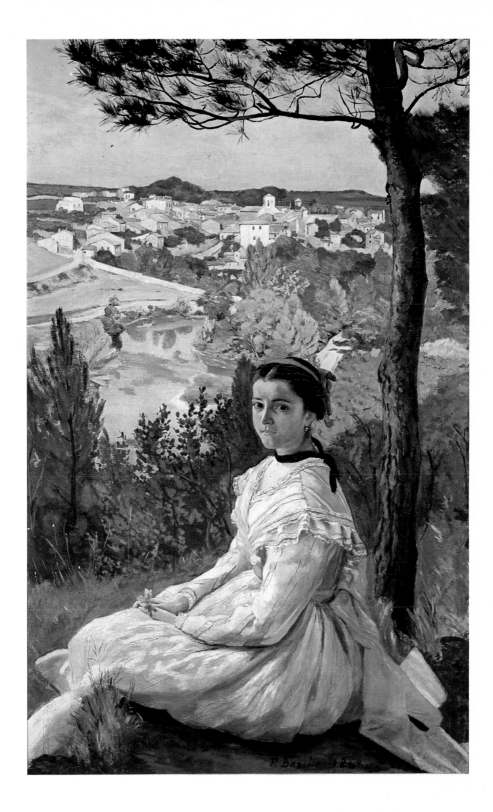

2 Eugène Boudin

The Coast Near Portrieux (Brittany)

Signed, dated, and inscribed,
 lower right :
 E. Boudin Portrieux 74
Oil on canvas
H. 33½, w. 58¼ in. (85 × 148 cm.)

Durand-Ruel Collection, Paris

In 1874 Boudin participated in the first Impressionist exhibition; nevertheless, two works by him had been accepted for the Salon of the same year in violation of the Impressionists' rule not to exhibit there. Boudin exhibited with the Impressionist group only in 1874; in the following years he preferred to submit work for exhibition in the official Salon. Friendship with Monet and ideological sympathies with the fledgling Impressionists no doubt influenced his decision to join the group exhibition in the studio of the photographer Nadar on the Boulevard des Capucines. Boudin had known the young Monet in Le Havre; indeed, in encouraging Monet to paint with him in the open air, he exerted a crucial influence on the development of his young friend. Boudin, although not considered an Impressionist himself, played a formative role perhaps even more important than Jongkind in Monet's early years.

The Coast Near Portrieux reflects a deep sensitivity and the desire to depict an austere landscape without a slick or decorative effect. The rather somber palette is quite different compared to the bright, lively colors of the artist's beach scenes for which he is so deservedly famous.

Boudin had worked in Portrieux in 1873 and returned in 1874. The works he chose to send to the Salon of 1874 and to the first Impressionist exhibition were those painted in Portrieux and along the Breton coast nearby. The picture from the Durand-Ruel collection is exceptionally large compared with most of Boudin's work, indicating that it was probably intended for a Salon — perhaps no. 230 in the Salon of 1874, *Rivage du Portrieux (The Coast of Portrieux)*. This same vague title appears twice in the catalogue of the first Impressionist exhibition where the Durand-Ruel picture may have been shown instead of at the Salon.

A.D.

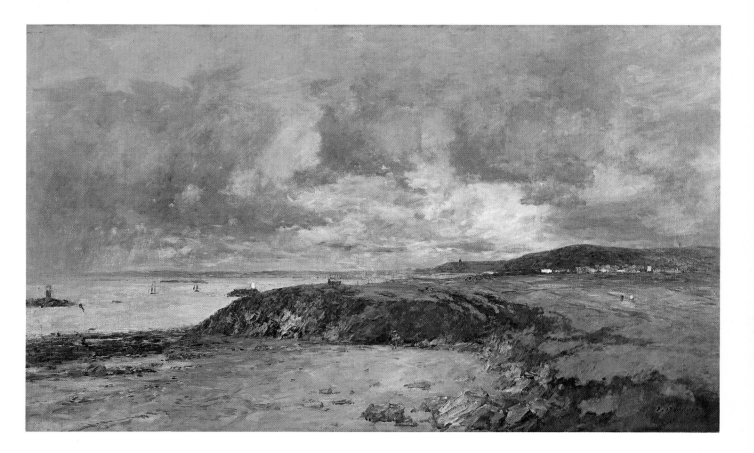

Provenance

The painting appeared in the Durand-Ruel stock books on July 31, 1891, valued at 1000 francs.

Exhibitions

1874 (see entry, final paragraph)
1899 Paris, Ecole des Beaux-Arts, January 9-30, *Exposition des œuvres d'Eugène Boudin,* no. 161, titled *Environs de Portrieux,* 1872, and noted as "belonging to Mr. Durand-Ruel"
1927 Paris, Durand-Ruel Gallery, *Eugène Boudin,* no. 38

Selected Bibliography

R. Schmit, *Eugène Boudin,* Paris, 1973, no. 964.

Gustave Caillebotte

Boulevard Seen from Above

Signed and dated, lower left :
 G. Caillebotte 1880
Oil on canvas
H. 25⅝, w. 21¼ in. (65 × 54 cm.)

Private collection, Paris

Gustave Caillebotte joined the Impressionist group in 1876 and exhibited in every Impressionist exhibition except the first in 1874 and the last in 1886. There are no known works by Caillebotte dating before 1872. However, contact with Degas, Renoir, and Monet may have encouraged him to evolve a highly personal style focusing on "modern" subject matter. The extremely original composition and the ease of execution in *Boulevard Seen from Above* anticipate the pursuits of Vuillard and Bonnard.

In 1882 *Boulevard Seen from Above* was shown in the seventh Impressionist exhibition. Caillebotte played an active part in the planning of the 1882 exhibition and tried to ease the dissension between the different members of the group; it was the last time he participated in an Impressionist exhibition. However, his role in Impressionist affairs was by no means at an end. His death in 1894 brought to the State a bequest of approximately sixty works by Degas, Cézanne, Manet, Monet, Renoir, Pissarro, and Sisley. Among these pictures acquired very early, often to help one or another of his artist friends in their struggle, were masterpieces such as Renoir's *The Swing,* 1876 (Musée du Louvre, Galerie du Jeu de Paume, R.F. 2738), *Dancing at the Moulin de la Galette* (see no. 36), Manet's *The Balcony,* 1868-69 (see no. 21), and Pissarro's *The Red Roofs,* 1877 (Musée du Louvre, Galerie du Jeu de Paume, R.F. 2745).

Incredibly, the bequest met with a stormy greeting from the press at the instigation of academic circles; protracted negotiations were necessary before a gallery exhibiting a selection of the Caillebotte Collection was opened at the Musée du Luxembourg. Thanks to Caillebotte's generosity, several works by each of the Impressionists entered a key public collection during the artists lifetime.

A.D.

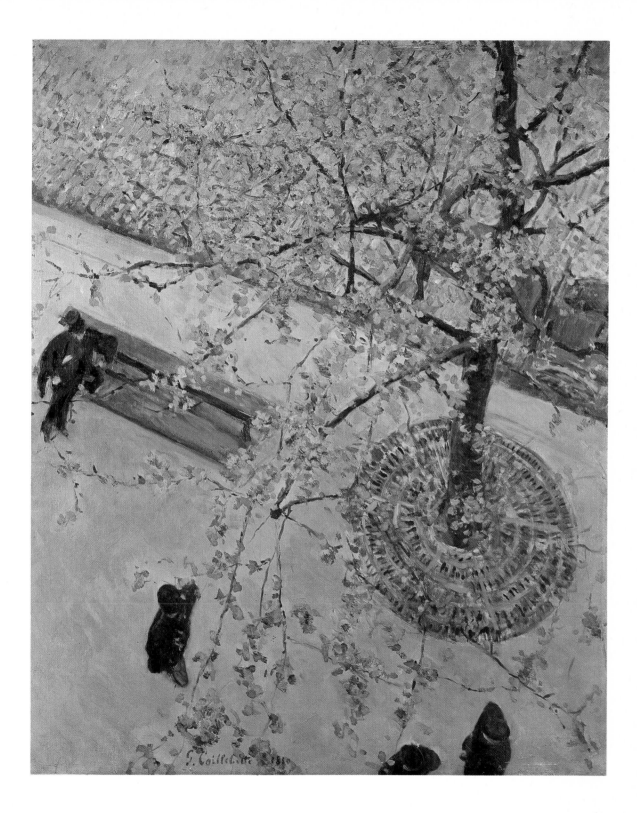

Provenance

The family of the artist.

Exhibitions

1882 Paris, 251 rue Saint-Honoré, *7ᵉ exposition des artistes indépendants,* no. 10
1951 Paris, Galerie des Beaux-Arts, May 25-July 25, *Rétrospective Gustave Caillebotte,* no. 39
1965 Chartres, Musée des Beaux-Arts, June 28-September 5, *Caillebotte et ses amis impressionnistes,* no. 14
1966 London, Wildenstein Gallery, June 15-July 16, *Gustave Caillebotte 1848-1894,* p. 14, 15 (illus.), 25 (no. 26)
1968 New York, Wildenstein and Company, September 18-October 19, *Gustave Caillebotte,* no. 36

Selected Bibliography

M. Bérhaut, *Gustave Caillebotte,* Paris, 1951, no. 107;
M. Bérhaut, *Gustave Caillebotte,* Lausanne, 1968, p. 32;
L. Nochlin, *Realism,* London, 1971, p. 176, fig. 112.

4

Mary Cassatt

A Woman in Black at the Opera

1880
Signed, lower left :
Mary Cassatt
Oil on canvas
H. 32, w. 26 in. (81.2 × 66 cm)

Museum of Fine Arts, Boston
Charles Henry Hayden
Fund, 10.35

Figures in theater audiences appear in the work of Degas, Renoir, and Mary Cassatt, consistent with the Impressionists' interest in the leisure class. In its close-up format and the cropping of the figure, *A Woman in Black at the Opera* reflects particularly the influence of Degas, who had befriended Cassatt and invited her to exhibit with the Impressionist group in 1879.

A Woman in Black at the Opera was painted in the year following open dissension among the Impressionists. In 1879 the word "Impressionist" had been dropped from the title of the exhibition : "It was agreed to speak simply of a 'Group of Independent Artists.' And Armand Silvestre thereupon informed the public : 'You are invited to attend the funeral service, procession, and interment of the impressionists. This painful decision is tendered to you by the *Independents*. Neither false tears nor false rejoicing. Let there be calm. Only a word has died... These artists have decided, after serious conference, that the term which the public adopted to indicate them signified absolutely nothing and have invented another.' But in spite of this change of name, the painters continued to be known as impressionists" (John Rewald, *The History of Impressionism*, New York, 1973, p. 421). The years 1879-1880 were, contrary to Silvestre's remarks, years in which Impressionism broadened its scope, bringing not only Cassatt but also Gauguin into the circle.

Like Degas and Renoir, Cassatt places the part of the painting to which the eye is naturally drawn — the sitter's face — in sharper focus than other parts. Cassatt's Impressionism leans toward optical realism : when one focuses on a face, the surrounding form and space are, in fact, out of focus. This kind of optical truth relates to the concern of Impressionism with an objective statement of color and light, but here there is also a form of reportage, resulting in what might be called documentary Impressionism.

The composition as a whole is typical of a formula developed in the late sixties by Monet (cf. *La Grenouillère*, no. 27, and *Boulevard des Capucines, Paris,* no. 30) : beyond the immediate foreground the artist looks, often from a raised vantage point, into a volume of space that is usually closed at the back. By means of loose brushstrokes the painter emphasized the color-bearing light contained in the enclosed space. In short, like Degas, Cassatt found the artificial light and décor of the opera house an effective vehicle for Impressionist ideas. Also within the Impressionist idiom, Cassatt flattened the picture space and forced the sensation of color and light toward the surface of the painting, by masking the curve of the balcony with the figure of the woman in black, and by permitting the horizontal of the railing to merge with its vertical side in the lower left corner of the picture. Unlike Sisley in *The Bridge at Villeneuve-la-Garenne* (no. 41) Cassatt masked the one element, the balcony, that would provide a clear cue to the space behind. Instead, like Monet and Degas, she chose to emphasize abstract and formal qualities. One has only to compare the dress worn by the woman here to the Worth gown worn by Madame Charpentier in Renoir's portrait (no. 38) to see the differences between a more and a less avant-garde Impressionist style.

It is difficult to know if the subject of the painting has more than superficial significance. The central figure is busily engaged in looking, the gentleman on the other side of the balcony is looking in our direction, and the other people in the painting are, like us, viewers, spectators. Cassatt seems to be making a point about the act of looking and partaking in a visual phenomenon. An analogy between the viewer in the picture and the viewer of the picture is inevitable. As Reff has said of Degas's use of the pictures within his pictures, "...it calls our attention to the artifical aspects of the picture in which it occurs..." (Theodore Reff, "The Pictures within Degas's Pictures," *Metropolitan Museum Journal* 1 [1968], p. 125).

C.S.M.

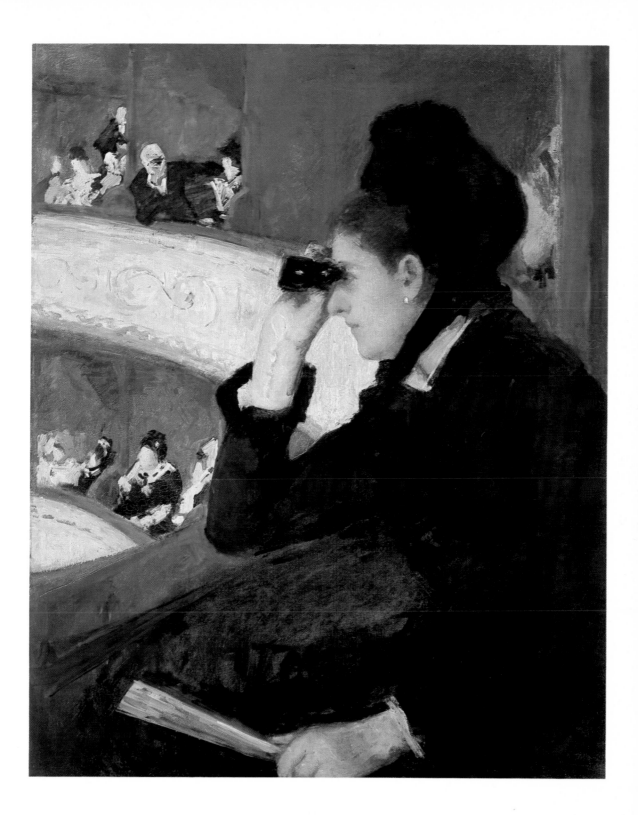

Provenance

J. Gardner Cassatt, brother of the artist (from 1880); Martin and Camentron, Paris (by 1893 ?); Durand-Ruel, Paris and New York; F.W. Bayley, Boston.

Exhibitions

1893 Paris, Durand-Ruel, *Cassatt*, no. 13
1909 Boston, St. Botolph Club, cat. no. 24
1926-1927 Chicago Art Institute, *Cassatt*, no. 1
1928 Pittsburgh, Carnegie Institute, *Cassatt*, no. 2
1933 Chicago, Art Institute of Chicago, *A Century of Progress*, no. 437
1941-1942 Baltimore Museum of Art, *Cassatt*, no. 7
1947 New York, Wildenstein, *Cassatt*, no. 5
1962 Baltimore Museum of Art, *Manet, Degas, Cassatt, Morisot*, no. 101
1970 Washington, D.C., National Gallery of Art, *Mary Cassatt*, no. 18

Selected Bibliography

W.C. Brownell, "The Younger Painters of America," *Scribner's Monthly*, XXII, 1881, no. 3, p. 333 (engraving by A.F.P. Davis, 1880);
F.A. Sweet, *Miss Mary Cassatt, Impressionist from Pensylvania*, Norman (Okla.), 1966, p. 48-49, 137, pl. 11;
American Paintings in the Museum of Fine Arts, Boston, Boston, 1969, I, p. 44, no. 196, II, p. 229, fig. 473;
A.D. Breeskin, *Mary Cassatt, A Catalogue Raisonné...*, Washington, D.C., 1970, p. 55, no. 73 (this painting catalogued and illustrated), p. 250-251, nos. 719-722 (sketches for this painting catalogued and illustrated);
E.J. Bullard, *Mary Cassatt. Oils and Pastels*, New York, 1972, p. 32-33, color pl. 6;
J. Rewald, *The History of Impressionism*, New York, 1973, p. 423, ill. in color p. 425.

5 Paul Cézanne

The Black Clock

About 1870
Oil on canvas
H. 21, w. 30 in. (55 × 75 cm.)

Collection of Stavros S.
 Niarchos

Still-life painting was neglected by most Impressionists, but it occupies an important place in Cézanne's work. The still lifes preceding his Impressionist period are painted in the same heavy impasto, emphasizing contrast, as the other works of the sixties, but differ in their emphatically static character from the movement and activity of his contemporary figure paintings. The composition and handling of the paint indicate Cézanne's awareness of Manet and probably François Bonvin and Antoine Vollon.

The Black Clock has a powerful and precise structure, emphasizing vertical and horizontal lines. As in most of Cézanne's still lifes, the objects are familiar, but their selection is very unusual, if not peculiar. Evidently it is the only example of a clock, albeit one without hands, in the whole of Cézanne's work; the same clock appears, hardly visible, in a sketch for *Alexis Reading to Zola* (private collection, Zurich; see Venturi, no. 118) of 1869-70. It would be difficult to deny the clock a symbolic value, especially as it is associated with another object that is unique in Cézanne's œuvre — a mirror. During the same period he introduced skulls in other compositions (see Venturi, nos. 61 and 68); skulls appear again only in a few works painted just before the artist's death. The repetition, by a man well versed in classical literature, of objects symbolizing the fragility of life and the inevitable passage of time can hardly be fortuitous. It is a kind of modern *vanitas*.

This painting was probably done at Zola's home since the clock and the little vase above it appear in the sketch for *Alexis Reading to Zola* already mentioned; it is usually dated 1869-71 but may be slightly earlier. Cézanne gave *The Black Clock* to Zola, his friend since childhood, whom he saw regularly in Paris between 1868-70. Cézanne always considered it an important work, and, in 1878, though it had little stylistic relation to his work at the time, he chose to represent himself with it in a planned Impressionist exhibition that never took place. M.H.

Provenance

Emile Zola, Médan (in the Emile Zola sale, March 9-13, 1903, no. 114); Auguste Pellerin; Baron Kohner, Budapest; Paul Rosenberg, Paris; G. Wildenstein, New York; Edward G. Robinson, Beverly Hills, California.

Exhibitions

1907 Paris, Salon d'Automne, *Rétrospective d'Œuvres de Paul Cézanne*, no. 8
1932 London, Royal Academy of Arts, *Exhibition of French Art*, no. 441
1933 Chicago, Art Institute of Chicago, *A Century of Progress*, no. 320
1936 Paris, l'Orangerie des Tuileries, *Cézanne*, no. 11

Selected Bibliography

L. Venturi, *Cézanne, son art, son œuvre*, Paris, 1936, no. 69, with a bibliography through the date of publication to which the following should be added :
"La Collection Kohner," *Der Cicerone*, August 1911, p. 588;
J. Meier-Graefe, *Paul Cézanne*, Munich, 1913, p. 74, illus.;
Kunst und Kunstler, January 1914, p. 208, illus.;
K. Pfister, *Cézanne, Gestalt, Werk, Mythos*, Potsdam, 1927, pl. 25;
G. Mack, *Cézanne*, London and New York, 1935, p. 142;
R. Huyghe, *Cézanne*, Paris, 1936, p. 19 (illus., fig. 15), 34;
Amour de l'Art, May 1936, p. 167 (fig. 40);
G. Mack, *La Vie de Paul Cézanne* (English translation by Nancy Bowens), Paris, 1938, p. 128;
J. Rewald, *Cézanne, sa vie, son œuvre, son amitié pour Zola*, Paris, 1939, p. 101 (fig. 20), 170 (illus. opp.);
R. Cogniet, *Cézanne*, Paris, 1939, pl. 14;
E. Faure, *Histoire de l'art*, V, Paris, 1941, p. 204;
E.A. Jewell, *Cézanne*, New York, 1944;
B. Dorival, *Cézanne*, Paris and New York, 1948, pl. 17 and p. 144, with an extensive bibliography;
M. Reynal, *Cézanne*, Geneva, 1954, p. 32-33;
Charles Sterling, *Still Life Painting (from Antiquity to the Present Time)* [revised edition, translated from the French by James Emmons], New York and Paris, 1959, p. 102, pl. 92;
M. Schapiro, *Cézanne* [third edtion], New York, 1965, p. 36, 37 (illus.);
L. Brion-Guerry, *Cézanne et l'expression de l'espace*, Paris, 1966, p. 47 f., fig. 9, opp. p. 48;
J. Rewald, *The History of Impressionism* [fourth edition], New York, 1973, p. 48 (illus.);
M. Schapiro, *Cézanne*, Paris, 1973, pl. 3.

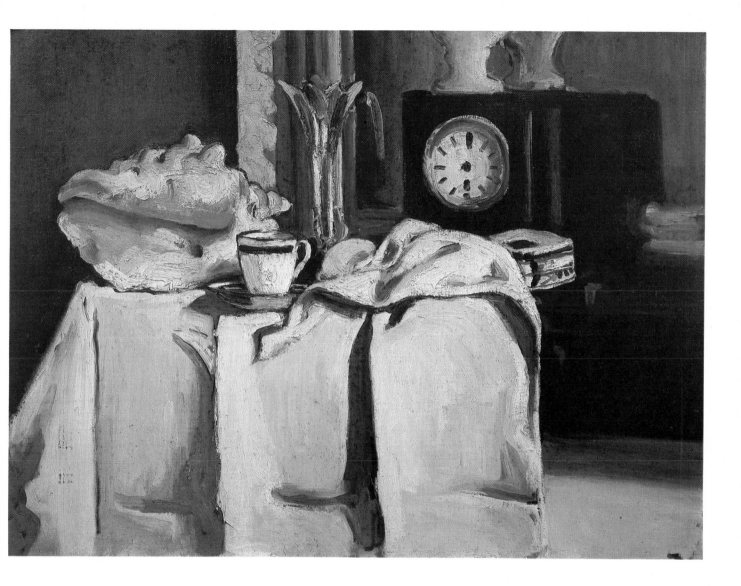

6 Paul Cézanne

The House of the Hanged Man

1873
Signed in red, lower
 left : *P. Cézanne*
Oil on canvas
H. 21½, w. 25 in. (55 × 66 cm.)

Musée du Louvre
 Galerie du Jeu de Paume
 Camondo Bequest, 1908
 R.F. 1970; entered the
 Louvre, 1911

This is one of the few pictures by Cézanne that was exhibited several times with his consent during his life. It has always been considered one of the key works of the artist's brief orthodox Impressionist period.

In the fall of 1872 Cézanne worked with Pissarro in Pontoise and later in the neighboring village of Auvers-sur-Oise. There he met Dr. Gachet, a devotee of avant-garde painting, in whose care van Gogh spent his last months in 1890. Under the influence of his friends, and especially of Pissarro, Cézanne abandoned literary and dramatic subjects, as well as the dark palette and baroque composition characteristic of his early work. The site he chose for *The House of the Hanged Man* shows that he was aware of contemporary works by Monet, Pissarro, and Sisley. His debt to the Impressionists is obvious in the choice of an ordinary village street scene, the emphatically harsh light of the Ile-de-France, the light, silvery colors present even in the shadows, and the broken, scumbled strokes.

However, what was for the others a search for spontaneity became for Cézanne the conscious formation of a disciplined style and the renouncing of his previous manner. The small group of landscapes painted directly from the subject in Auvers mark a clear break, thematically and technically, in Cézanne's career.

Despite characteristics shared with other Impressionists' landscapes, *The House of the Hanged Man* is unique. The composition is boldly organized around a light central focus, from which emanate a number of oblique lines — the edges of walls, roofs, and slopes — that outline a group of carefully articulated triangles. The paint surface is thick, built up in places with a palette knife. Tristan Klingsor noted early the similarity of the coarseness of the paint surface to Chardin's impasto technique (see T. Klingsor, *P. Cézanne*, Paris, 1923, p. 17).

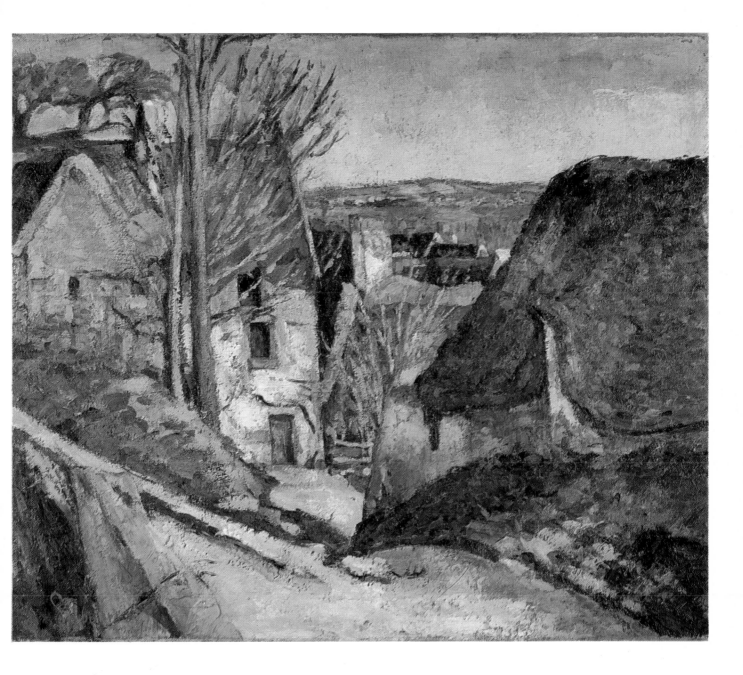

53

The picture is variously dated 1873 or 1874, but it was most probably painted in the spring of 1873 (the vegetation indicates early spring). It is unlikely that a slow worker like Cézanne could have finished a picture begun that spring in time to include it in the catalogue for the first Impressionist exhibition (April 15, 1874). *The House of the Hanged Man* must have been done the previous spring.

This work is distinguished by having belonged to Victor Chocquet, a customs official of ordinary means who formed an outstanding collection of pictures by Delacroix and became one of the first serious collectors of the Impressionists, especially Cézanne and Renoir (see John Rewald, *The History of Impressionism* [fourth edition], New York, 1973, p. 657, for indexed references; P. Cabanne, "Monsieur Chocquet, Don Quichotte de l'Impressionnisme," *Jardin des Arts,* September 1970, p. 45 f.).

M.H.

Provenance

Bought by Count Doria after the first Impressionist exhibition, April 15 - May 15, 1874; exchanged for the picture *Melting Snow,* owned by Victor Chocquet, at Chocquet's request (see Venturi no. 336, the picture in the A. Meyer Collection, New York; see also Roger-Milès, preface to the A. Doria sale catalogue, May 8-9, 1889, p. xii); Veuve Chocquet Sale, Galeries Georges Petit, Paris, July 1-4, 1899, included in lot 106, sold for 6510 francs; bought from Veuve Chocquet sale by Count Isaac de Camondo at the recommendation of Monet (see *Le Siècle,* April 17, 1911); the Camondo Bequest, 1908; entered the Musée du Louvre in 1911; first exhibited in 1914.

Exhibitions

1874 Paris, *Société anonyme des artistes peintres, sculpteurs et graveurs etc. Exposition de 1874* (first Impressionist exhibition), no. 42
1889 Paris, *Exposition Centennale de l'art français,* no. 124
1890 Brussels, *Exposition des XX* (because of an error by L. Venturi, this picture is sometimes wrongly stated to have been in Brussels in 1899, and at the Paris Centennale Exhibition of 1900)
1936 Paris, Orangerie des Tuileries, *Cézanne,* no. 26
1954 Paris, Orangerie des Tuileries, *Hommage à Cézanne,* no. 28.
1974 Paris, Orangerie des Tuileries, *Cézanne dans les Musées Nationaux,* no. 11

Selected Bibliography

L. Venturi, *Paul Cézanne,* Paris, 1936, no. 133, with a bibliography completed by the addition of the following :
Louis Leroy, *Le Charivari,* April 25, 1874;
Marc de Montifaud, *L'Artiste.* May 1874, p. 312;
G. Babin, *l'Illustration,* July 18, 1914;
P. Jamot, *La Peinture au Musée du Louvre, école française, XIXe siècle, 3e partie.* Paris, n.d. [1928], p. 73;
R. Huyghe, *Cézanne,* Paris, 1936, p. 25, fig. 20;
B. Dorival, *Cézanne,* Paris, 1948, plate 32 and p. 147-148;
M. Schapiro, *Cézanne,* New York, 1952, p. 42-43;
H. Adhémar in *Musée du Louvre, catalogue des peintures, pastels, sculptures impressionnistes,* Paris (Musées Nationaux), 1958, p. 20;
L. Brion-Guerry, *Cézanne et l'Expression de l'Espace* (revised edition), Paris, 1966, p. 19;
J. Rewald, "Chocquet and Cézanne," *Gazette des Beaux-Arts,* 1969, p. 66 f.;
J. Rewald, *The History of Impressionism* (fourth edition), New York, 1973, p. 314, 322, illus., 324, 334, 382, 556, 589 [note 51].

7 Paul Cézanne

Still Life with Compotier, Fruit, and Glass

About 1879-1882
Signed, lower left in blue :
 P. Cézanne
Oil on canvas
H. 15, w. 21 in. (40 × 55 cm.)

Private collection, France

"This Cézanne that you ask me for is a pearl of exceptional quality and I have already refused three hundred francs for it; it is one of my most treasured possessions, and, except in absolute necessity, I would give up my last shirt before the picture," wrote Gauguin, who owned *Still Life with Compotier, Fruit, and Glass,* to his friend the artist Schuffenecker in June 1888. In a letter to his wife in June 1885, he wrote : "I'm keeping my two Cézannes; they're rare of their kind, because he finished so little of his work, and one day they'll be worth a great deal" (*Lettres de Gauguin,* edited by M. Malingue, Paris, 1949, p. 75, 132).

This picture is one of the earliest of the so-called constructive period, and also one of the most finished. Cézanne's art had undergone considerable change since *The Black Clock* (no. 5). The objects, especially the fruit, have clean contours and are modeled by color only; the front and top of the chest and the wall behind, instead of meeting at right angles, continue into one another, contrary to the rules of perspective. The compotier is doubly distorted : its bowl is elongated to the left and rises at the back. But the composition is so well organized, cogent, and unified that this break with the rules of traditional perspective is apparent only upon looking closely.

Cézanne's careful and systematic study of the reflections on the bowl and the napkin, and the absence of blacks and browns in the shadows, show what he had learned from Impressionism. He did not break with the movement, he went beyond it. Using the freedom it allowed, he quietly evolved an entire new system of representation that transcended four centuries of Western painting.

Gauguin's enthusiasm for the picture is easily understood. He bought it in about 1884 when he was still somewhat unsure of himself, but in Cézanne's still life he found the successful realiza-

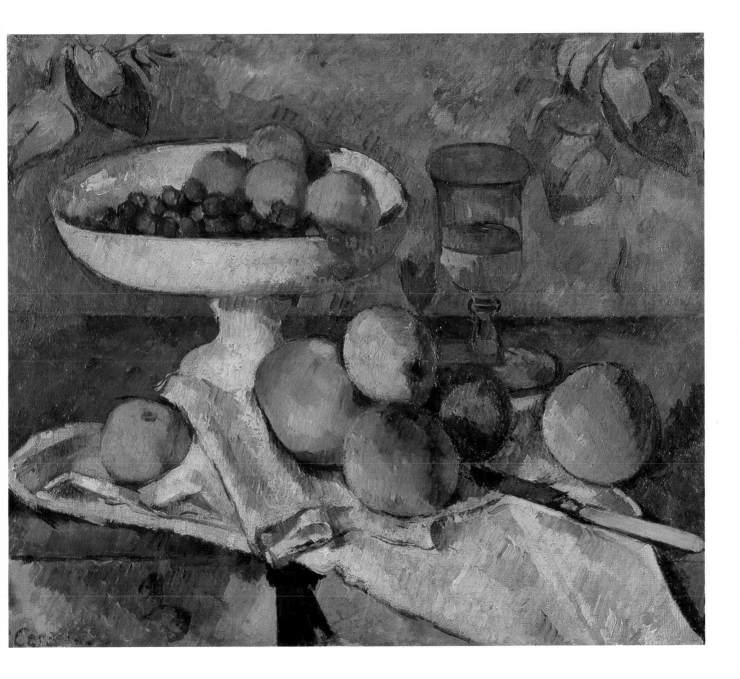

57

tion of ideas beginning to appear in his own work; the Cézanne must surely have been a source of reassurance for Gauguin. It appears in the background of his portrait of Marie Derrien, otherwise known as "Lagadu," 1890; (The Art Institute of Chicago; see G. Wildenstein, *Gauguin*, Paris, 1964, no. 387).

One can also understand Maurice Denis's choice of this still life for his *Homage to Cézanne* (Musée National d'Art Moderne, Paris). Instead of placing a bust of the artist in the center of the composition, as Fantin-Latour did in his *Homage to Delacroix* (Musée du Louvre, Galerie du Jeu de Paume), Denis placed the Cézanne on an easel surrounded by Odilon Redon, Vuillard, the collector and critic André Mellerio, Ambroise Vollard, Sérusier, Ranson, Roussel, Bonnard, himself, and Madame Denis. Denis made a lithographed copy of *Still Life with Compotier, Fruit, and Glass* as well.

M.H.

Provenance

Before 1888, bought by Gauguin from Cézanne; probably in the Ambroise Vollard Collection, since Maurice Denis painted his *Homage to Cézanne* in Vollard's house; Dr. Georges Viau, Paris (in the Viau sale, Paris, March 4, 1907, no. 13, sold for 19,000 francs); Prince de Wagram, Paris; Marczell van Nemès, Budapest (in the van Nemès sale, Paris, June 18, 1913, no. 85); Josse Hessel, Paris; Auguste Pellerin, Paris.

Exhibitions

1900 Paris, *Centennale de l'Art Français*, no. 86
1903 Vienna, *Secession*, no. 13
1911 Budapest, Munich, Dusseldorf, *Exhibition of the Marczell van Nemès Collection*
1933 Paris, *Gazette des Beaux-Arts. Gauguin et ses Amis*
1936 Paris, Orangerie des Tuileries, *Cézanne*, no. 39
1954 Paris, Orangerie des Tuileries, *Homage to Cézanne*, no. 4
1970 Paris, Orangerie des Tuileries, *Maurice Denis*, no. E'

Selected Bibliography

L. Venturi, *Cézanne, sa vie, son œuvre*, Paris, 1936, no. 341, with a bibliography through the date of publication to which the following should be added :
R. Huyghe, "Cézanne et son œuvre," *Amour de l'Art*, May 1936, p. 173, fig. 9;
E. Faure, *Cézanne*, Paris, 1936, fig. 24;
F. Novotny, *Cézanne*, Vienna, 1937, fig. 25;
B. Dorival, *Cézanne*, Paris, 1948, p. 154, pl. 64;
M. Malingue (ed.), *Lettres de Gauguin à sa femme et à ses amis* (second, enlarged edition), Paris, 1949, p. 75, 132;
A. Humbert, *Les nabis et leur époque*, Genève, 1954, p. 33;
J. Rewald, *Le Post-Impressionnisme*. Paris, 1961, p. 183;
K. Badt, *The Art of Cézanne*, Berkeley and Los Angeles, 1965, p. 160;
Meyer Schapiro, *Cézanne* [third edition], New York, 1965, p. 54-55, illus.;
M. Roskill, *Van Gogh, Gauguin, and the Impressionist Circle*, London, 1969, p. 41-46;
M.G. de la Coste-Messelière, "Un jeune prince amateur d'impressionnistes et chauffeur," *L'Œil*, November 1969, no. 179;
Meyer Schapiro, *Cézanne*, 1973, pl. 12;
J. Rewald, *The History of Impressionism* [fourth edition], New York, 1973, p. 474 (illus.).

8

Paul Cézanne

The Bay of Marseilles Seen from l'Estaque

About 1884-1886
Oil on canvas
H. 28¾, w. 39½ in.
 (73 × 100.4 cm.)

The H.O. Havemeyer Collection
Bequest of Mrs. H.O.
 Havemeyer 1929
The Metropolitan Museum
 of Art 29.100.67

Cézanne painted numerous variants of this subject, beginning in the summer of 1876. At that time he wrote to Camille Pissarro : "I must tell you that your letter surprised me at Estaque on the sea shore... I have started two little motifs with a view of the sea; they are for Monsieur Chocquet who spoke to me about them. — It is like a playing card — red roofs near the blue sea... The sun is so terrific here that it seems to me as if the objects were silhouetted not only in black and white, but in blue, red, brown, and violet. I may be mistaken, but this seems to me to be the opposite of modeling..." (quoted in Linda Nochlin, *Impressionism and Post-Impressionism 1874-1904, Sources and Documents,* Englewood Cliffs, 1966, p. 87).

Cézanne's allusion to the design of a playing card and the visual effect characterized as "the absence of modeling" signal an interest in flatness and shallow picture space. As in Monet's *Terrace at Sainte-Adresse* (no. 26) and *Boulevard des Capucines, Paris* (no. 30), in *The Bay of Marseilles Seen from l'Estaque* Cézanne looks down into and across the scene, permitting a high horizon and a tilting of the ground plane toward the surface of the painting, thereby compressing the picture space : "...he represents objects in space so as to reduce the pull of perspective to the horizon; the distant world is brought closer to the eye, but the things nearest to us in the landscape are rendered with few details — there is little difference between the texture of near and far objects, as if all were beheld from the same distance... Cézanne's vision is of a world more stable and object filled and more accessible to prolonged meditation than the Impressionist one; but the stability of the whole is the resultant of opposed stable and unstable elements, including the arbitrary tiltings of vertical objects which involve us more deeply in his striving for equilibrium" (Meyer Schapiro, *Cézanne,* New York, 1965, p. 19).

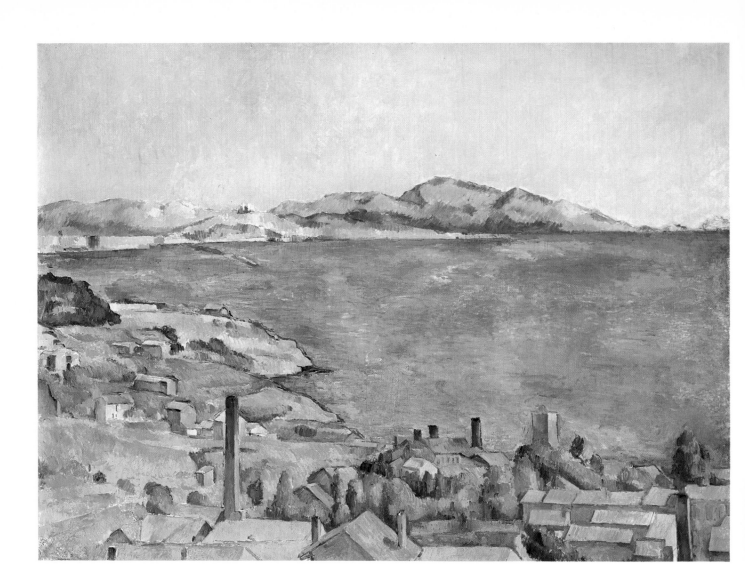

As in the Metropolitan Museum's *Madame Cézanne in the Conservatory*, about 1891, there is a dominant compositional substructure common to much of Cézanne's work and defined by Schapiro as "parallel lines, connectives, contacts, and breaks which help us to unite in a common pattern elements that represent things lying on the different planes in depth" (Schapiro, p. 10). The internal structure that Schapiro describes is the result of the joining of aesthetic decisions with the artist's vision of the natural world. Its purpose, however, is related to the complex problem of *réalisation* discussed by Badt : "For what Cézanne aimed to do was to state a truth about that world which lies always around man, and not just about his own subjective feelings or experiences. Let me stress once more that this did not mean that he had to add to his conception as a whole by painting in details as true to nature as possible or reproducing objects exactly as they strike the eye of the ordinary person looking at them in the everyday world. 'Realization' did not depend on precise reproduction of things but on bringing out their significance. This Cézanne could do only if he made the objects which he was depicting stand out from the outlines which indicated their mere presence and develop into manifestations of functional existence within the picture which he had previously established as a whole" (Kurt Badt, *The Art of Cézanne*, Berkeley and Los Angeles, 1965, p. 214).

In *The Bay of Marseilles Seen from l'Estaque* nothing has been left to chance. Cézanne has moved beyond the Impressionist record and/or examination of the visible world into the less lyrical realm of order and structure. He blurs the distinctions between the visible, given world and a cogent, meaningful response to it. Little, if anything, in the Metropolitan's view of the Bay of Marseilles relates on a one-to-one basis with reality : "Photographs of the sites he painted show how firmly he was attached to his subject; whatever liberties he took with details, the broad aspect of any of his landscapes is clearly an image of the place he painted and preserves its indefinable spirit. But the visible world is not simply represented on Cézanne's canvas. It is recreated through strokes of color among which are many that we cannot identify with an object and yet are necessary for the harmony of the whole... the self is always present, poised between sensing and knowing, or between its perceptions and a practical ordering activity, mastering its inner world by mastering something beyond itself" (Schapiro, p. 10).

Pictures like the Metropolitan's *Madame Cézanne in the Conservatory* and *The Bay of Marseilles Seen from l'Estaque* reach beyond Impressionism, but they are impossible without it. From the early sixties Impressionism, or at least what would become Impressionism, posed aesthetic questions about the processes of art. It was probably inevitable that at least one Impressionist artist discovered and pursued ideas of greater complexity than the formal problems related to color-charged atmosphere. In the mid-eighties when the Metropolitan's view from l'Estaque was painted, Cézanne had greatly reduced his palette and had already begun to concentrate on the pictorial ideas of aesthetic order that provided the transition to Cubism.

C.S.M.

Exhibitions

1930 New York, Metropolitan Museum, *The H.O. Havemeyer Collection*, no. 5
1936 Paris, Orangerie des Tuileries, *Cézanne*, no. 43
1952 Chicago, Art Institute of Chicago, and New York, Metropolitan Museum, *Cézanne*, no. 49

Selected Bibliography

L. Venturi, *Cézanne*, Paris, 1936, I, p. 16, 53-54, 157, no. 429, II, pl. 122, no. 429;
L. Brion-Guerry, *Cézanne et l'expression de l'espace*, Paris, 1966, p. 112-117, 120, 121, 130, 145, 216, pl. 24;
C. Sterling and M.M. Salinger, *French Paintings, a Catalogue of the Collection of the Metropolitan Museum of Art*, New York, 1967, III, p. 105-106, ill.

The Bellelli Family

1858-1860
Oil on canvas
H. 78¾, w. 98 in.
 (200 × 250 cm.)

Musée du Louvre
 Galerie du Jeu de Paume
 R.F. 2210;
 acquired in 1918

When this picture entered the collection of the Musée du Luxembourg, Paris, in 1918, it was unknown to students of Degas and carried only the title *Portrait of a Family (Portrait de Famille)*. An article by L. Gonse and research by P. Jamot and M. Guérin (see Selected Bibliography) yielded a date, 1858-1860, and a title, *The Bellelli Family (La Famille Bellelli)*.

The woman standing at the left is Laura Bellelli (née de Gas), sister of the artist's father. With Baroness Bellelli are her daughters, Giovanna on the left and Giulia on the right. Seated and looking toward his family is Baron Gennaro Bellelli, a follower of Cavour. Bellelli had been exiled from Naples and was living in Florence when this family portrait was painted; he was appointed a senator in the new kingdom of Italy in 1861.

The red-chalk drawing shown hanging on the rear wall has been compared with a sketch on canvas (see Selected Bibliography, Lemoisne II, no. 33), and an etching (Delteil 22) identified as either a portrait of Auguste de Gas, the artist's father and Baroness Belle-lli's brother (see M. Guerin, "Remarques sur les Portraits de Famille peints par Degas," *Gazette des Beaux-Arts* 17 [1928], p. 378-379; T. Reff, "The Pictures within Degas's Pictures," *Metropolitan Museum Journal 1* [1968], p. 129-131), or of René Hilaire Degas, father of the baroness and grand-father of the painter, who died in Naples on August 31, 1858 (see J. Adhémar and F. Cachin, *Edgar Degas, gravures et monotypes,* Paris, 1972, p. xxxix). The latter possibility would explain why Baroness Bellelli is dressed in mourning, a fact sometimes attributed to the loss of her son (see M. Guérin, *Degas* [exhibition catalogue], Paris [Galeries Georges Petit], 1924, addenda p. 24). Admittedly, the chalk study is possibly a drawing for the etching mentioned earlier, but they face the same direction, whereas an etching usually reverses a drawn composition. An impression of the print in the Bibliothèque Jacques Doucet, Paris, bears the inscription *Naples 1857,* but this etching was apparently

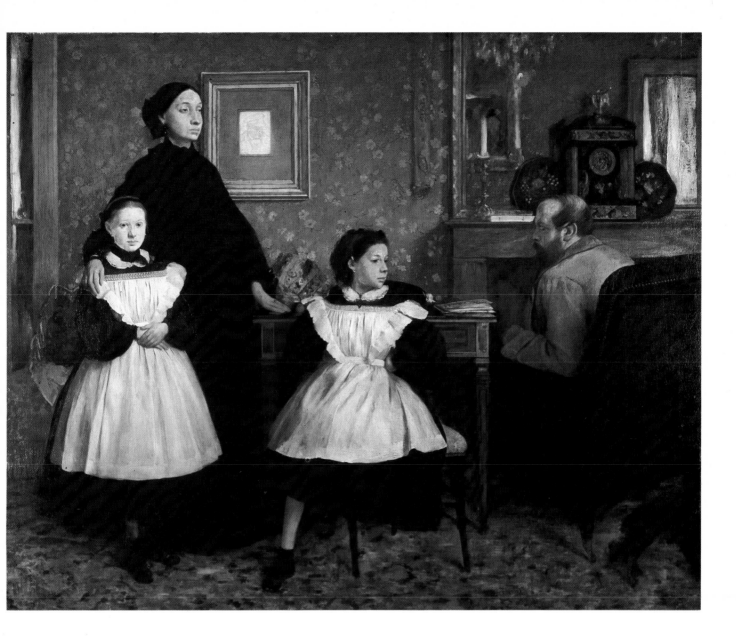

done in Paris (see J. Adhémar and F. Cachin, *Edgar Degas, gravures et monotypes).*

The ongoing publication of Degas's notebooks and correspondence (see Selected Bibliography) has gradually revealed the development of *The Bellelli Family,* Degas's first masterpiece. The young painter arrived at the Bellelli house in Florence in August 1858, after a trip around Italy; he stayed there until the following spring and returned to Paris in April 1859, having made a series of studies and drawings and perhaps having begun the picture itself. On November 27, 1858, he wrote to his friend the painter Gustave Moreau : "I am busy on a portrait of my aunt and my two cousins, I will show it to you when you get back. I'm doing it as if I were doing a picture. I've got to do it well because I want to leave it as a memento. I have an extravagant need to cover canvas; I bring everything I have to the picture. I've had to stop the studies I was doing at the museum, and I no longer budge from the house... My two young cousins look good enough to eat. The older one is really a lovely little thing, the younger one has the devil in her as well as the kindness of an angel. I'm doing them with their black dresses and little white pinafores which suit them delightfully. I have ideas for the picture's background running through my head. I would like a certain natural gracefulness with a nobleness of feeling that I don't know how to describe" (from a letter inscribed *Florence NOV, 1858,* in the Musée Gustave Moreau, Paris, published in Theodore Reff, "More Unpublished Letters of Degas," *Art Bulletin* LI, no. 3 [September 1969], p. 282-283).

In the Drawings Department of the Louvre there is a study for Baron Bellelli (R.F. 15484) inscribed *Florence 1860;* the same poor-quality paper used for this quick sketch of the baron is used for a study of Giulia Bellelli (Musée du Louvre, R.F. 16580). The inescapable conclusion — unless the 1860 inscription was mistakenly added at a later date — is that Degas was still working on the portrait of the Bellellis during another visit to Florence. The letter to Moreau is, however, not entirely clear; it is therefore impossible to know if the picture was completed in Florence or only started there and later continued in Paris. Possibly the painting, based on studies done in Florence, was painted entirely in Paris and completed in 1860 only after another trip to Florence. The latter possibility is strengthened by the existence in Paris of a studio where Degas could have worked comfortably on a picture of such size.

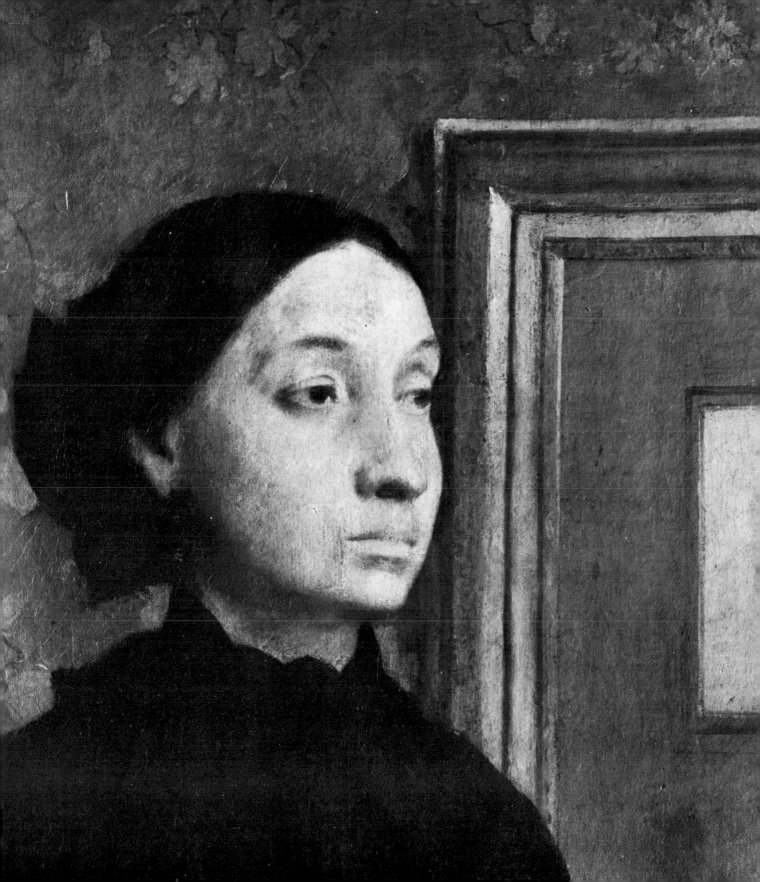

In 1858 Degas was twenty-five; he had rejected the rigidity of the Ecole des Beaux-Arts, where he studied briefly in 1855, and was trying to train himself by studying and copying the old masters. Students of Degas often allude to copies of old master paintings done by Degas during approximately the same period that he worked on the Bellelli portrait. The list includes works by Holbein, Pontormo, Bronzino, and van Dyck, as well as two painters whose careers were ending just as Degas's was beginning, Ingres and Delacroix, with emphasis on the former. Drawings by Ingres, for example *La Famille Forestier* (1806), come to mind in this context.

However, specific comparisons show the extent of Degas's assimilation and transformation of influences. The many drawn and painted studies for *The Bellelli Family* — those known to us are listed in the Appendix — reveal Degas's interest in precisely detailed faces, not surprising given his interest in portraiture. He was, nevertheless, even more interested in the overall composition and the positioning of the figures in familiar, everyday interiors given character by a few personal possessions. This technique is consistent with the aims of the Naturalist movement, but such simplicity did not exclude compositional subtleties, for example the opening of the space into the room behind at the left and the glistening reflections in the mirror over the mantelpiece. Further-more, the sober costumes provided an opportunity for a virtuoso exercise in black and white played against the color in the embroi-dery on the table and the carpet.

Beyond its originality of composition and realist character, unqualified stylistic freedom separates this portrait from contem-porary examples. Its simplified effects and varied treatment of different elements, such as the hardly more than sketched-in dog at the right, attest to Degas's freedom from academic rules.

Degas's interest in the Bellelli family as portrait subjects continued in 1862-1864 when he painted the two daughters by themselves (Los Angeles County Museum of Art; see Lemoisne, no. 126).

A.D.

Appendix

Several preparatory works for *The Bellelli Family* have survived and are cited here according to their "L" numbers (P.A. Lemoisne, *Degas et son œuvre* I and II [catalogue raisonné], Paris, 1946).

Sketches on canvas : 1) *Giovanna Bellelli* (L. 10, Musée du Louvre, Galerie du Jeu de Paume, R.F. 3662, with an inscription on the back in Degas's writing indicating that it was done as early as 1856 in Naples); 2) *Giulia Bellelli* (L. 19, formerly in the collection of Madame J. Doucet, Neuilly-sur-Seine); 3) *Giovanna and Giulia Bellelli* (L. 65, with Seligmann and Co., 1955, and probably a study for a composition that Degas abandoned); 4) *Baroness Bellelli and Her Two Daughters* (L. 66, Paris formerly Durand-Ruel Collection); 5) *Study for a Hand* (L. 66, J. Fèvre Sale, Paris, 1934, no. 115); 6) *Study of Hands* (L. 181, Musée du Louvre, Galerie du Jeu de Paume, R.F. 2226, possibly a later return to the subject); 7) *Study for Baron Bellelli* (not in Lemoisne's catalogue raisonné and now apparently lost; exhibited in 1924 at the Galeries Georges Petit, Paris, no. 9, described in the catalogue but not reproduced.)

The Bellelli Family (L. 64, The Ordrupgaard Museum near Copenhagen, Hansen Collection; possibly a final composition study in pastel of a replica that Degas kept for himself); *Study for Giulia Bellelli* (L. 69, The Dumbarton Oaks Collection, Washington, D.C.).

Thirteen drawings and studies in the Cabinet des Dessins of the Musée du Louvre (see *Degas - Œuvres au Musée du Louvre*, Orangerie des Tuileries, Paris, 1969, nos. 58-71; possibly no. 68, *Study of a Chair*, ought to be eliminated because it bears little relation to the painting. Furthermore, R.F. 15483 and R.F. 29882, as well as a sketch in the Jeu de Paume, L. 10, probably belong to a group antedating 1858.)

The Degas sketchbooks in the Bibliothèque Nationale, Paris, include an important group of studies for *The Bellelli Family,* especially Sketchbooks 18 and 19 (see studies by Boggs and Reff cited in the Selected Bibliography).

Finally, there are studies for Giovanna Bellelli (L. 68, Lerolle Collection, Paris), Giulia Bellelli (J. Fèvre Sale, Paris, June 12, 1934, reproduced, Pl. v), and Baron Bellelli (see R. Raimondi, Pls. 12, 20). Several drawings in the collection of Marcel Guérin also pertain (see P.A. Lemoisne, "A propos de Degas de la collection de M. Marcel Guérin," *L'Amour de l'Art* [1931], p. 285, fig. 41).

Two drawings have been related to *The Bellelli Family* that may have no connection with it : 1) no. 14 in the René de Gas sale, Paris, November 10, 1927 (reproduced); and no. 1965-266 in the Fogg Art Museum, Meta and Paul J. Sachs Collection.

Provenance

Baron and Baroness Bellelli, Florence and Naples, about 1860; Signora Roberto Maiuri (née Giulia Bellelli), Naples, about 1900; estate of Edgar Degas (first Degas sale, Paris, Hôtel Drouot, May 6-8, 1918, no. 4, but purchased a few days before the sale by the French National Museums — René Degas accepted 300,000 francs for it, 50,000 of which were given by Count and Countess de Fels [see L. Gonse, "Etat Civil du Portrait de Famille d'Edgar Degas," *Revue de l'Art Ancien et Moderne* XXXIX (1921), p. 300-302]).

Exhibitions

(Note : *The Bellelli Family* should not be identified with either of the two *Family Portraits* by Degas in the 1867 Salon, nos. 444 and 445)
1918 Paris, Salon
1924 Paris, Galeries Georges Petit, April 12 - May 2, *Degas,* no. 13
1931 Paris, Orangerie des Tuileries, *Degas,* no. 17
1969 Paris, Orangerie des Tuileries, *Degas,* no. 7.

Selected Bibliography

P.A. Lemoisne, *Degas et son œuvre* I and II, Paris, 1946, no. 79, with a complete bibliography to which the following should be added :
P. Jamot, "The Acquisitions of the Louvre during the War, IV," *Burlington Magazine* del XXXVII, 212 (November 1920), p. 219-220;
P. A. Lemoisne, "Les Carnets de Degas au Cabinet des Estampes," *Gazette des Beaux-Arts* (1921), p. 223-224;
L. Gonse, "Etat civil du Portrait de Famille d'Edgar Degas," *Revue de l'Art Ancien et Moderne,* XXXIX (1921), p. 300-302;
F. Fosca, *Degas,* Paris, 1921, p. 20;
J. Meier-Graefe, *Degas,* 1924, p. 15;
P.A. Lemoisne, "le Portrait de Degas par lui-mème," *Beaux-Arts,* December 1, 1927, p. 313;
P. Jamot, "Acquisitions récentes du Louvre," *L'Art Vivant,* March 1, 1928, p. 176;
P. Jamot, *La Peinture au Louvre, école française, XIXᵉ siècle* III, Paris, n.d. [1928], p. 52;
J.S. Boggs, "Edgar Degas and the Bellellis," *Art Bulletin* XXXVII, no. 2 (June 1955), p. 127-136;
P. Cabanne, *Edgar Degas,* Paris, 1957, p. 103-104;
J.S. Boggs, "Degas Notebooks at the Bibliothèque Nationale II, Group B (1858-1861)," *Burlington Magazine* C, no. 663 (June 1958), p. 199-209;
H. Adhémar in *Musée du Louvre catalogue des peintures, pastels, sculptures impressionnistes,* Paris (Musées Nationaux) 1958 p. 31, no. 59;
G. Bazin, *Trésors de l'Impressionnisme au Louvre,* Paris, 1958, p. 89;
J.S. Boggs, *Portraits by Degas,* Berkeley and Los Angeles, 1962, p. 11-17, 58, and notes 51-90, p. 88-90;
H. Keller, *Edgar Degas, Die Familie Bellelli,* Stuttgart, 1962;
J.S. Boggs, "Edgar Degas and Naples," *Burlington Magazine* CV, no. 723 (June 1963), p. 273-276;
T. Reff, "The Chronology of Degas's Notebooks," *Burlington Magazine* CVII, no. 753 (December 1965), p. 612-613;
T. Reff, "Degas's Tableau de Genre," *Art Bulletin* LIV, no. 3 (September 1972), p. 324-326;
John Rewald, *The History of Impressionism* (fourth edition), New York, 1973, p. 56-57.

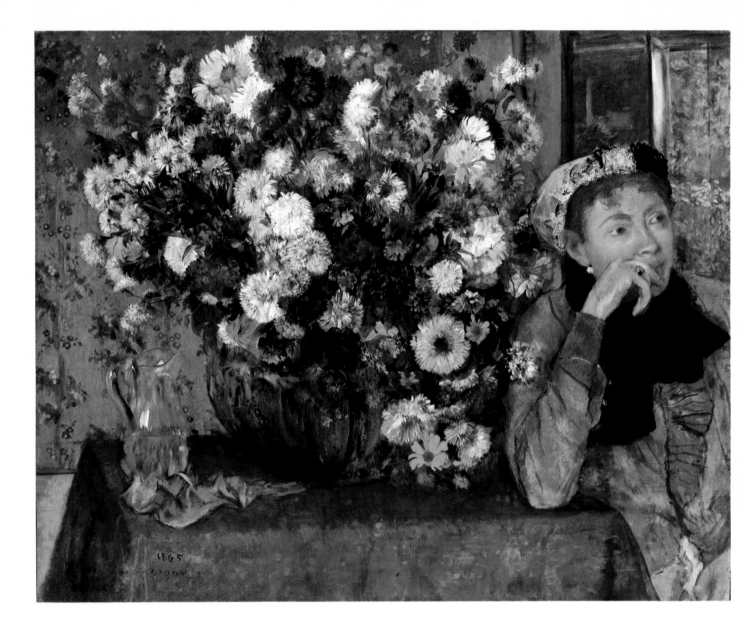

A Woman with Chrysanthemums

Probably 1865
Signed and dated, twice :
 lower left : *Degas / 18[5]8,*
 and *1865 / Degas*
Oil on canvas
H. 29, w. 36½ in.
 (73.7 × 92.7 cm.)

The H.O. Havemeyer Collection
Bequest of Mrs. H.O.
 Havemeyer, 1929
The Metropolitan Museum
 of Art 29.100.128

The sitter has never been satisfactorily identified (cf. Charles Sterling and Margaretta Salinger, *French Paintings, A Catalogue of the Collection of the Metropolitan Museum of Art,* Volume III, [New York], 1967, p. 57-60). Our ignorance of her name is indeed unfortunate, because in a notebook of 1869 Degas refers to position as the telling characteristic of a specific individual in a portrait : "Make portraits of people in familiar and typical positions, above all give their faces the same choice of expression one gives their bodies. Thus if laughter is typical of a person, make him laugh — there are, naturally, feelings that one cannot render..." (quoted in Linda Nochlin, *Impressionism and Post-Impressionism 1874-1904, Sources and Documents,* Englewood Cliffs, 1966, p. 62). Until more is known about the identity of the sitter, any precise significance in the flowers and the abstracted gaze will remain something of a mystery.

As Mongan and Sachs point out in their discussion of the drawing for the woman, "...[*A Woman with Chrysanthemums*] has gained fame as the first of those, common in Degas's later work, in which the figure is not on central axis" (see Agnes Mongan and Paul J. Sachs, *Drawings in the Fogg Museum of Art,* Cambridge, 1940, p. 358-359). The unorthodox composition and the extremely personal interpretation of the sitter testify to the special character of portraiture in Degas's work : "There is no record that he ever accepted a commission for a portrait and little evidence that he sold many portraits" (see Jean Sutherland Boggs, *Portraits by Degas,* Berkeley and Los Angeles, 1962, p. 1). Portraiture, for Degas, had moved well beyond the bounds of an accurate visual record meant for sale; a portrait had to function as a metaphor as well as a likeness.

In 1876 Edmond Duranty, the critic, author, and friend of Degas, made the following observations in a famous essay, *La*

Nouvelle Peinture : A propos du groupe d'artistes qui expose dans les Galeries Durand-Ruel; his remarks endorse in particular the kind of modernism that was reflected in Degas's work, especially the portraits : "...what we need is the particular note of the modern individual, in his clothing, in the midst of his social habits, at home or in the street..."; "...by a gesture, a whole series of feelings"; and, "The idea, the first idea, was to take away the partition separating the studio from everyday life... It was necessary to make the painter leave his sky-lighted cell, his cloister where he was in contact with the sky alone" (as quoted in Nochlin, p. 5). Equally important are Duranty's remarks about asymmetrical compositions and the abrupt cropping of the subject : "If one now considers the person, whether in a room or in the street, he is not always to be found situated on a straight line at an equal distance from two parallel objects; he is more confined on the one side than on the other by space. In short, he is never in the center of the canvas, in the center of the setting. He is not always seen as a whole : sometimes he appears cut off at mid-leg, half-length or longitudinally. At other times, the eye takes him in from close-up, at full height, and throws all the rest of a crowd in the street or groups gathered in a public place back into the small scale of the distance" (as quoted in Nochlin, p. 6).

Although Duranty's remarks in *La Nouvelle Peinture...* were directed at most of the Impressionist circle, Degas seems foremost in his thinking, a likelihood reinforced by his acquaintance with the painter, the sympathies of each with certain kinds of subject matter, and the naturalist-realist penchant of both. Degas, as noted in the entry for his portrait of Tissot (no. 11), thought of himself as a realist although he participated in seven of the eight Impressionist exhibitions between 1874 and 1886. In 1879 it was Degas who urged that the word "Impressionist" be dropped from the announcements of the fourth Impressionist exhibition; although Degas at one point proposed calling it an exhibition of realists, impressionists, and independents, the final solution was "Group of Independent Artists" (see John Rewald, *The History of Impressionism,* New York, 1973, p. 421).

The advanced compositional technique of *A Woman with Chrysanthemums* is not matched by Degas's handling of paint; as Reff indicates," ...[it] is painted in a conventional oil technique — a very sober technique of uniformly thin, flat strokes whose surface displays that smoothness which Degas so much admired

in the work of Ingres and other masters. It was only in the third decade of his career, between 1875 and 1885, that the iconographic and stylistic innovations he had achieved in works like [this] were accompanied by equally radical innovations in material and method" (see Theodore Reff, "The Technical Aspects of Degas's Art", *Metropolitan Museum Journal* 4 [1971], p. 142).

The pair of signatures and dates in the lower left corner remains a problem. Although the date with the blurred signature to the farther left is interpretable as either 1858 or 1868, the other signature and date are given added weight by the drawing in the Fogg Museum that is signed and dated, *Degas / 1865.*

However, evidence gathered by X-ray and by examination of the paint surface in raking light suggests that Degas painted *A Woman with Chrysanthemums* during two separate periods of activity, possibly in 1858 and 1865. It appears that originally it was a flower painting, similar in many ways to a watercolor of 1849 by Delacroix in the Jeu de Paume (illustrated in Maurice Sérullaz, *Delacroix,* New York, [1973 ?], p. 141), and that only later was the woman added. X-rays and pentimenti reveal several flowers painted over in the areas of the elbow, the table top, and the bodice. Furthermore, indications are that the front and right edges of the table have been changed to accommodate the figure. Although a more definitive interpretation will require further technical analysis, a second possibility is that the figure once held flowers in her left hand; however, such a hypothesis is less likely to account for the shifted table edges, the present incorrect perspective of the right side of the table, the absence of adequate volume on the right side of the vase, and a form, visible in the X-ray, where the right edge of the table would be if it were correctly aligned with the other side.

The possibility that the portrait was added to an already finished flower painting is given added support by the existence of the drawing for the figure in the Fogg Museum. Although not as complete as the woman in the painting, the drawing shows an identical expression and posture, further indicating that she was probably conceived as a separate entity and later grafted onto a previously finished, signed, and dated flower painting.

<div align="right">C.S.M.</div>

Provenance

Théo van Gogh, for Goupil & Cie, Paris, succeeded by Boussod-Valadon (bought for 4000 francs from the artist in 1887; until 1889); Mme Boivin, Paris (from 1889); Durand-Ruel, Paris (until 1921); Mrs. H.O. Havemeyer, New York (1921-1929).

Exhibitions

1930 New York, Metropolitan Museum, *The H.O. Havemeyer Collection*, no. 45
1936 Philadelphia, Pennsylvania Museum of Art, *Degas*, no. 8
1937 Paris, Orangerie des Tuileries, *Degas*, no. 6.
1947 Cleveland Museum of Art, *Works by Edgar Degas*, no. 8

Selected Bibliography

P.A. Lemoisne, Degas, *Paris*, 1946, I, p. 55-56, 239, note 117, ill. opp. p. 56, II, p. 62-63, no. 125, ill. (calls the sitter Mme. Hertel); H. Bussiner, "Organic Integration in Cézanne's Painting," *College Art Journal*, XV, Summer 1956, p. 310-311, fig. 7, 8; J. Rosenberg, *Great Draughtsmen from Pisanello to Picasso*, Cambridge (Mass.), 1959, p. 109, fig. 202 (the drawing said to be of Mme Hertel); C. Sterling and M.M. Salinger, *French Paintings, a Catalogue of the Collection of the Metropolitan Museum of Art*, New York, 1967, III, p. 57-60, ill.; A. Scharf, *Art and Photography*, Baltimore, 1969, p. 144, 146, fig. 126; T. Reff, *From Realism to Symbolism, Whistler and his World*, exhibition catalogue, Wildenstein, New York, and Philadelphia Museum of Art, 1971, p. 28; J. Rewald, "Theo van Gogh, Goupil, and the Impressionists," *Gazette des Beaux-Arts*, LXXXI, Jan. 1973, p. 8, 11, fig. 5.

Edgar Degas

Jacques Joseph (James) Tissot

About 1866-1868
Stamped, lower right : *Degas*
Oil on canvas
H. 59⅝, w. 44 in.
 (151.4 × 112.1 cm.)

The Metropolitan Museum
 of Art, Purchase,
 Rogers Fund, 1939
 39.161

Degas's friend the painter J.J. (James) Tissot is best known as a painter of well-dressed women depicted in lavish Victorian interiors or in other fashionable circumstances. Tissot, having allied himself with the Commune, had to flee from Paris to London in 1871. In 1874 Degas wrote to him in London and asked him to participate in the first Impressionist exhibition. Tissot declined.

The similarities between Degas's portrait of Tissot and Manet's *Portrait of Emile Zola* (Musée du Louvre, R.F. 2205 ; no. 20) make a comparison of the two inevitable : "...we find two men dressed with a certain dandified dignity, sitting in rooms which reflect the influence of Japanese art, against walls which are broken by a cubic arrangement of pictures and a canvas or screen" (Jean Sutherland Boggs, *Portraits by Degas,* Berkeley and Los Angeles, 1962, p. 32). Boggs then provides an interpretation of the expressive nature of the portrait of Tissot : "Tissot himself, except for the easel at the right, provides the variation from the general order, and as a result it is he, twisted in his chair, leaning forward a little, looking at us directly as Zola does not, who dominates the painting. The room, even the Cranach head which Degas amusingly brings into relationship with Tissot's own, is subordinated to him; it tells us something about him at first glance, but it is only the body and the head which tell us more. For Degas, portraiture was a concentration upon the individual and expressive character of the human body through which the lassitude, even the slight anxiety of the human body may be revealed" (Boggs, p. 32). Theodore Reff, on the other hand, provides a somewhat different understanding of the picture : "All but one of the six pictures in the background are intercepted by other elements, three of them by the frame. As a result they seem more animated than Tissot himself, particularly since he assumes an attitude of passivity, a kind of elegant nonchalance" (Theodore Reff, "The

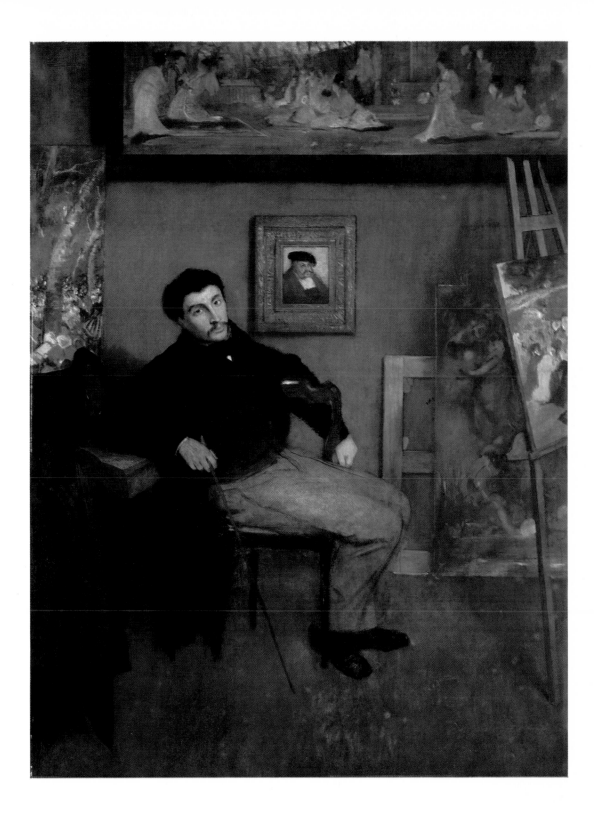

Pictures within Degas's Pictures," *Metropolitan Museum Journal* 1 [1968], p. 135).

Degas has painted his dapper friend with a pointer in his right hand. Probably Tissot has just finished making, or is about to make, a point about one of the paintings in the room. The distinctness with which he holds the stick is unmistakable and underscores a desire that Degas recorded in a notebook of 1869 : "Make portraits of people in familiar and typical positions, above all give their faces the same choice of expression one gives their bodies" (quoted in Linda Nochlin, *Impressionism and Post-Impressionism 1874-1904, Sources and Documents,* Englewood Cliffs, 1966, p. 62).

Only one of the pictures in the background can be identified (see Reff, p. 135-136), a copy of a portrait of Frederick the Wise produced by the workshop of Lucas Cranach. Reff persuasively argues that the remaining visible works are improvisations by Degas of works by Yeishi, Tissot, an unidentifiable Impressionist, and a sixteenth- or seventeenth-century Venetian painter. Reff sees the portrait of Tissot as a synopsis of Degas's aesthetic interests and those of "other advanced painters." Furthermore, he explains why Tissot, with a pointer in his hand, is "neither actively at work in his own studio nor clearly a visitor to another artist's" : "In effect, Degas asserts his belief in the relevance for modern art of several distinctly opposed tendencies : the artificiality of Japanese prints and the realism of European paintings, the immediacy of contemporary genre scenes and the formality of older portraits and narratives, the sober linear style of the Renaissance, and the dramatic colorful style of the Baroque. And in doing so, he expresses in art-historical terms the ideal of sophistication and self-awareness expressed in personal terms in his image of the artist as a dandy" (Reff, p. 140).

Finally, in 1874 when Degas asked Tissot to participate in the first Impressionist exhibition, he invited him as a fellow realist for a "*salon* of realists," an indication that the Impressionist exhibitions, from the beginning, encompassed the work of an avant-garde of great latitude : "The realist movement no longer needs to fight with the others; it already *is,* it *exists,* it must show itself as *something distinct,* there must be a *salon* of *realists*" (quoted in Nochlin, p. 66).

C.S.M.

Provenance

Estate of Degas (first sale, Paris, Galerie Georges Petit, May 6-8, 1918, no. 37, as *Portrait d'homme dans un atelier de peintre)*; Joseph Hessel, Paris, from 1918 after 1921; Adolph Lewisohn, New York (1922-1939; cat. 1928, p. 98-99, ill.); Jacques Seligmann, New York, 1939.

Exhibitions

1879 Paris, 28, avenue de l'Opéra, *La Qua-trième exposition de peinture,* no. 69 (Portrait d'un peintre dans son atelier; owned by M.H.M.L., possibly this picture)
1931 Cambridge (Mass.), Fogg Art Museum, Harvard University, *Degas,* no. 3
1934 New York, Marie Harriman Gallery, *Degas,* no. 5
1937 New York, Durand-Ruel, *Masterpieces by Degas,* no. 2
1960 New York, Wildenstein, *Degas,* no. 14
1968 Providence, Rhode Island School of Design, and Toronto, Art Gallery of Ontario, *James Jacques Joseph Tissot*

Selected Bibliography

P.A. Lemoisne, *Degas,* Paris, 1946, I, p. 56, 240, note 117, II, p. 90-91, no. 175, ill.;
B. Berenson, *Piero della Francesca, or The Ineloquent in Art,* New York, 1954, p. 36;
J. Rosenberg, *Great Draughtsmen from Pisanello to Picasso,* Cambridge (Mass.), 1959, p. 109, fig. 203a (drawing of Tissot);
C. Sterling and M.M. Salinger, *French Paintings, a Catalogue of the Collection of the Metropolitan Museum of Art,* New York, 1967, III, p. 62-64, ill.;
T. Reff, "The Pictures within Degas's Pictures," *Metropolitan Museum Journal* 1, 1968, p. 125, 127, 131, 133, 134 (ill.), 135-140, 150, 164-166;
H. Zerner, *James Jacques Joseph Tissot,* exhibition catalogue, Museum of Art, Rhode Island School of Design, Providence, and Art Gallery of Ontario, Toronto, 1968, in introduction, ill.;
T. Reff, *From Realism to Symbolism, Whistler and his World,* exhibition catalogue, Wildenstein, New York, and Philadelphia Museum of Art, 1971, p. 28;
J. Rewald, *The History of Impressionism,* New York, 1973, p. 207, ill. p. 176.

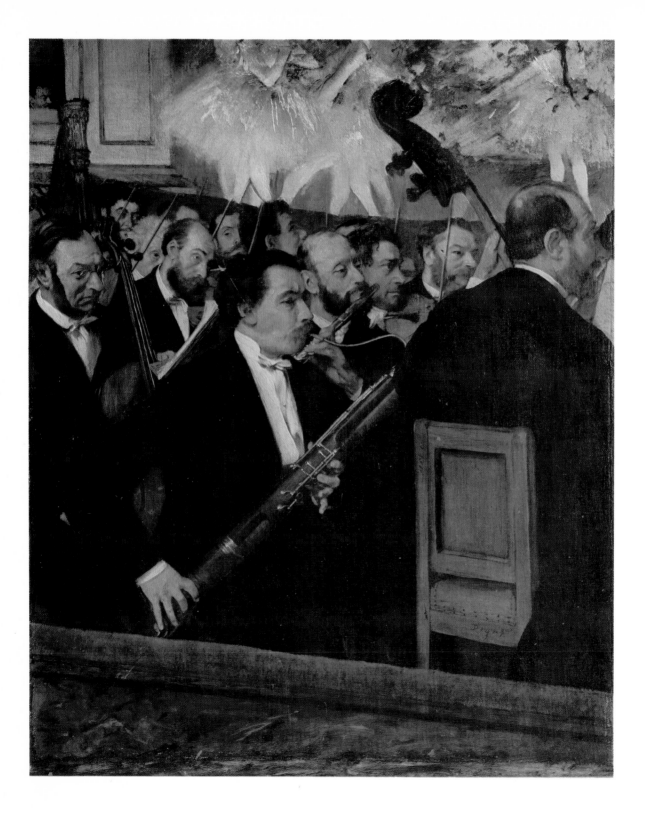

12 Edgar Degas

The Orchestra of the Paris Opera

1868-1869
Signed, lower right, on
 the chair : *Degas*
Oil on canvas
H. 22, w. 18 in. (56 × 46 cm.)

Musée du Louvre
 Galerie du Jeu de Paume
R.F. 2417; acquired in 1924

The motivating idea for this unorthodox composition may have been a portrait of Désiré Dihau, the bassoonist in the orchestra of the Paris Opera. Indeed, he is shown in mid-performance and is the most prominent figure in the picture. The painter, a devotee of music and an opera enthusiast, might often have seen his friend this way. He has imaginatively surrounded the bassoonist with other musicians of the opera orchestra, as well as a number of Degas's own friends who were connoisseurs of music. The following are identifiable from left to right : the composer Emmanuel Chabrier in the left background next to the stage; the cellist Pillet in the left foreground; an unidentifiable, partially obscured figure (the guitarist Pagans?) before whom sits the white-haired dance master of the Opera, Gard; before Gard, Piot-Normand, an artist friend of Degas's; behind Dihau's head and slightly to the left, Souquet; in profile and directly behind the bassoonist's head, Pillot, a medical student, looking toward the stage; in the immediate foreground, Dihau, to whose immediate left is the flutist Altès, who was later conductor of the Opera orchestra; beside Altès, the two first violins, Lancien and Goût; and, finally, at the extreme right, the double-bass player, Gouffé, seen from behind.

This work was most probably painted in 1868. It is Degas's first to show a ballet scene, although the first picture dominated by a ballet subject was not to come for several years (see *The Dancing Class,* no. 15). (The painting exhibited by Degas in the Salon of 1868, *Mademoiselle Fiocre in the Ballet "La Source"* [Brooklyn Museum, New York] belongs in the category of history painting despite its title.)

An entry by Degas from a sketchbook, regrettably undated, in the Bibliothèque Nationale, Paris, notes an interest in the orchestra as a possible subject : "series on instruments and players

— their shapes; twisting of the hands, arms, and neck of the violinist; for example, puffing out and hollowing of the cheeks of bassoonists, oboists, etc." (quoted in Linda Nochlin, *Impressionism and Post-Impressionism 1874-1904 : Sources and Documents,* Englewood Cliffs, New Jersey, 1966, p. 63). The theme of musicians and the stage (for example, *Musicians in the Orchestra,* Städelsches Kunstitut, Frankfurt) or the audience and the stage (the two versions of *The Ballet of "Robert le Diable,"* 1872, in the Metropolitan Museum of Art and the Victoria and Albert Museum, London) was treated several times by Degas. Daumier, whom Degas admired, may have influenced the younger artist in his painting *The Melodrama,* 1856-58 (Neue Staatsgalerie, Munich), and a lithograph, *The Orchestra,* 1852 (see J. Adhémar, *H. Daumier,* Paris, 1954, p. 122, pl. 103), the latter quite close to Degas's interpretation here. However, there is another possible source for the picture, Adolf Menzel's *At the Gymnasium,* 1856 (Nationalgalerie der Staatlichen Museen, Berlin); the German painter had worked in Paris on several occasions and may have been known to Degas.

There are striking differences in spirit and treatment between the very finished portrait-like rendering of the musicians and the sketchily realized dancers, who appear as little more than luminous flutterings. Furthermore, evidence of reworking and altering (beneath the scroll of the double bass and in the area of the stage) suggests that the dancers may have been an afterthought (see P. Jamot, *La Peinture au Musée du Louvre, école française, XIX^e siècle, 3^e partie,* Paris, n.d. [1928], p. 56). Jamot, in fact, relates these dancers stylistically to those in *At the Ballet* (Städelsches Kunstinstitut, Frankfurt), which he dated 1872. A more likely explanation, even if there were revisions, is that the dancers wore part of the original composition, but Degas changed the position of the double-bass player and emphasized the instrument's scroll to establish a connection between these two planes of the picture space.

A sketch in the California Palace of the Legion of Honor, San Francisco (oil on canvas, h. 19½, w. 23½ [50 × 61 cm.]), centers around a portrait of Dihau and the double bassist; the rest of the orchestra and the stage are barely suggested. The positions of the two musicians are markedly different from their places in the finished work, possibly further evidence to explain the changes already noted.

The public immediately labeled *The Orchestra of the Paris*

Opera a work of the avant-garde because of its thoroughly modern subject and its unusual composition. The juxtaposition of the stage and the orchestra pit with the effulgent silhouettes of headless dancers, integrated with the spatial construction only by the extravagant shapes of the double bass, defies the rules of traditional perspective. Degas's inventive genius, his visual acuity in the service of portraiture, and his interest in unusual lighting effects are characteristically in evidence here.

Degas also painted separate portraits of two musicians in the picture : the cellist, Pillet (Musée du Louvre, Galerie du Jeu de Paume), and the flutist, J.H. Altès (The Metropolitan Museum of Art, New York).

A.D.

Provenance

Painted about 1868 for Désiré Dihau (1833-1909), bequeathed to Dihau's sister, Marie; sold under the terms of a life interest, by Marie Dihau (1843-1935) to the Musées Nationaux of France, 1924; to the Louvre in June 1935.

Exhibitions

1870-1871 Lille; loaned by Désiré Dihau to a dealer during the Franco-Prussian War
1871 Paris, Durand-Ruel Gallery, Rue Lafitte (see a letter from Degas to the painter Tissot inscribed "Paris, September 30, 1871" in the Bibliothèque Nationale, Paris; see also M. Guérin, ed., and M. Kay, trans., *Degas Letters*, Oxford, 1947, p. 11-12, letter 1)
1924 Paris, Galeries Georges Petit, April 12-May 2, 1924, *Degas*, no. 30
1931 Paris, Orangerie des Tuileries, *Degas Portraitiste, Sculpteur*, no. 44
1936 Philadelphia, The Philadelphia Museum of Art, *Degas*, no. 12
1937 Paris, Orangerie des Tuileries, *Degas* no. 9
1969 Paris, Orangerie des Tuileries, June 27 - September 15, *Degas*, no. 16

Selected Bibliography

P.A. Lemoisne, *Degas et son œuvre II*, Paris, 1946, no. 186, with a bibliography complete through the date of publication;
M. Guérin, *Le Figaro*, May 21, 1935;
P. Cabanne, *Edgar Degas*, Paris, 1957, p. 109, no. 38;
H. Adhémar in *Musée du Louvre, catalogue des peintures, pastels, sculptures impressionnistes*, Paris, 1958, no. 68;
G. Bazin, *Trésors de l'Impressionnisme au Louvre*, Paris, 1958, p. 113;
J.S. Boggs, *Portraits by Degas*, Berkeley and Los Angeles, 1962, p. 28-30, and p. 92, notes 40-43;
John Rewald, *The History of Impressionism* [fourth edition], New York, 1973, p. 274.

13 Edgar Degas

Carriage at the Races

About 1871-1872
Signed, lower left : *Degas*
Oil on canvas
H. 13¾, w. 21⅜ in. (35 × 54.3 cm.)

Museum of Fine Arts, Boston
Arthur Gordon Tompkins
 Residuary Fund, 1926

Degas's portrait of the family of his friend Paul Valpinçon was first exhibited in 1872 by the Durand-Ruel Gallery in London in the Fifth Exhibition of the Society of French Artists. The importance of the picture to Degas is reflected in a letter he wrote to Tissot (see Degas, *Jacques Joseph Tissot,* no. 11) asking about its reception in London (see Ronald Pickvance, "Degas's Dancers : 1872-6," *Burlington Magazine* CV/723 [June, 1963], p. 256-257) and in Degas's decision to include it in the first Impressionist exhibition in 1874.

In *Carriage at the Races* Degas adopted some compositional techniques from Japanese prints, notably from the landscapes of Hokusai and Hiroshige (see Ernest Scheyer, "Far Eastern Art and French Impressionism," *The Art Quarterly* VI [1943], p. 131). The nearly flat horizon line, and the simplifications of trees, houses, and figures typify the economy of means that Degas and his contemporaries were learning from Japanese art. This reductional aspect of *Carriage at the Races* is commented on by Daniel Catton Rich : "More important today is the controlled artistry with which the whole picture is planned and painted. 'The most beautiful things in art come from renunciation,' the painter was fond of saying, and he has here severely limited his colors to a few finely attuned and greyed hues" (Daniel Catton Rich, *Degas*, New York, 1951, p. 52).

Besides the influence of the Japanese print, the abrupt cropping of the composition on three sides anticipates the passage from Duranty's essay *La Nouvelle Peinture...* quoted in connection with Degas's *A Woman With Chrysanthemums* (no. 10).

The minimal modeling of forms, both in the landscape and the sky, has the effect of flattening the composition by presenting what are essentially two simple rectangles against which we see

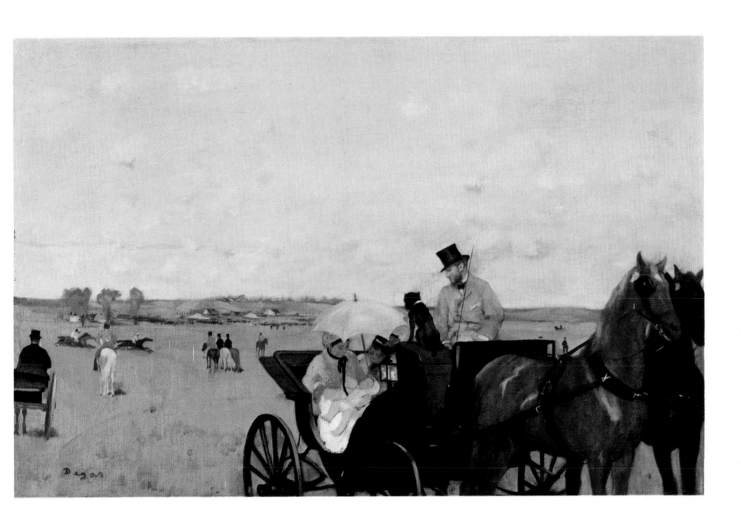

the carriage with the Valpinçon family. Similarly reduced or "flattened" compositions can be found in works by Courbet (e.g. *The Sea*, 1865-1866, The Metropolitan Museum of Art, 22.27.1; and *The Calm Sea*, 1869, The Metropolitan Museum of Art, 29.100.566) and Whistler (*Courbet at Trouville*, 1865, Isabella Stewart Gardner Museum, Boston). Within the exhibition a similar phenomenon is observable in Monet's *Terrace at Sainte-Adresse* (no. 26) and Cézanne's *Bay of Marseilles Seen from l'Estaque* (no. 8).

There is more than passing significance in Boggs's comparison of *Carriage at the Races* to a later Degas, *Place de la Concorde (Vicomte Lepic and his Daughters)* of ca. 1876, now destroyed (cf. Jean Sutherland Boggs, *Portraits by Degas*, Berkeley and Los Angeles, 1962, p. 46-47). Although they both fall into the category that Degas called "portraits of people in familiar and typical positions" (a phrase from a Degas notebook of 1869, cf. Linda Nochlin, *Impressionism and Post-Impressionism, 1874-1904, Sources and Documents*, Englewood Cliffs, 1966, p. 62), the latter picture is an amplification of the ideas presented in *Carriage at the Races*. The flattening of the picture space, the greater emphasis on the picture plane, the more sharply rising background, and the greater simplification in the background elements are attributes that were incipient in the earlier work. The following passage from Duranty's *La Nouvelle Peinture...* makes clear that the two paintings are differently developed aspects of the same interest, what George Heard Hamilton calls, in speaking of Manet, "...the problem... of discovering subjects in modern life, and a treatment appropriate to them" (George Heard Hamilton, *Manet and his Critics*, New York, 1969, p. 115): "Views of people and things have a thousand ways of being unexpected in reality. Our point of view is not always in the center of a room with two lateral walls receding toward that of the rear; it does not always gather together the lines and angles of cornices with a mathematical regularity and symmetry. Nor is it always free to suppress the great swellings of the ground and of the floor in the foreground; it [one's viewpoint] is sometimes very high, sometimes very low, missing the ceiling, getting at objects from their undersides, unexpectedly cutting off the furniture..." (quoted in Nochlin, p. 6). What is left unsaid is that in 1871-1872 Degas was content to exaggerate and simplify what he had before him, what he could see. He later exploited the pictorial possibilities suggested by certain subjects; like Monet he seems to have begun to choose subjects for purposes of pictorial interests. In other

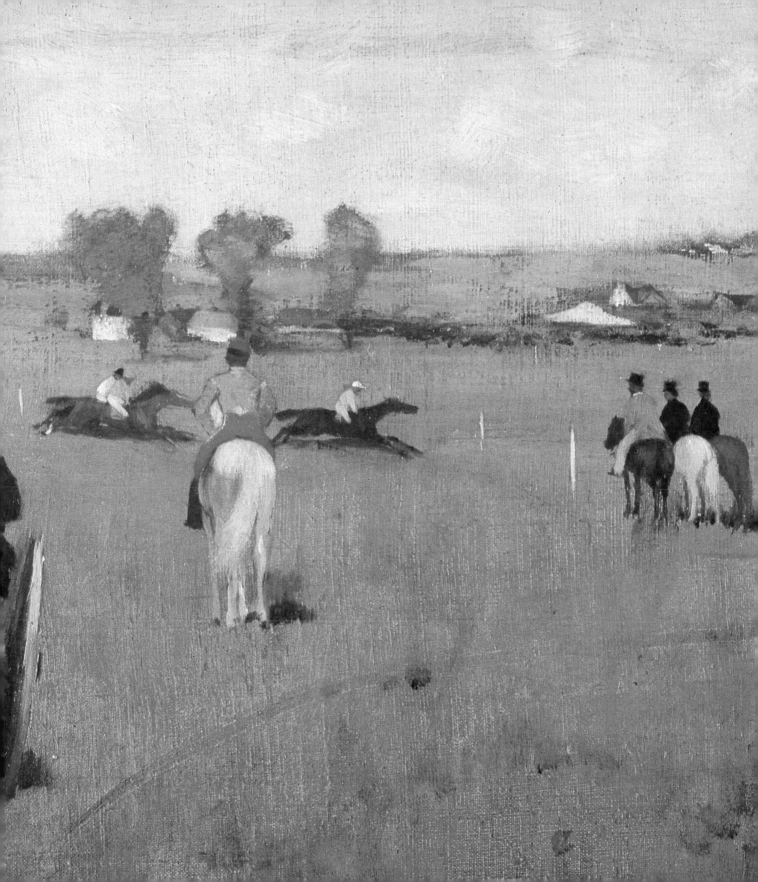

words, the emphasis shifts from the *what* to the *how* of the painting, although he manages, especially in the portraits, to keep the two rather closely balanced.

C.S.M.

Provenance

Jean-Baptiste Faure, Paris (1873-1883); Durand-Ruel, Paris (1893-1926); Etienne Bignou, Paris (in 1926?).

Exhibitions

1872 London, *Fifth Exhibition of the Society of French Artists*, no. 113.
1874 Paris, 35, Boulevard des Capucines, *Société anonyme des artistes, peintres, sculpteurs, graveurs...*, no. 63
1907 London, Grafton Galleries, *A Selection from Pictures by Boudin, Cézanne...*, no. 57, ill.
1917 Zurich, *Französische Kunst*, no. 88, ill.
1922 Paris, Musée des Arts Décoratifs, *Le Décor de la vie sous le second empire*, no. 57
1924 Paris, Galerie Georges Petit, *Degas*, no. 40
1933 Chicago, Art Institute of Chicago, *A Century of Progress*, no. 282
1936 Philadelphia, Philadelphia Museum of Art, *Degas*, no. 21
1937 Paris, Orangerie des Tuileries *Degas*, no. 14
1937 Paris, Palais des Beaux Arts, *Chefs-d'œuvre de l'art français*, no. 301
1958 Los Angeles County Museum, *Edgar Hilaire Germain Degas*, no. 17

Selected Bibliography

P.A. Lemoisne, *Degas*, Paris, 1946, I, p. 85, 102, ill. opp. p. 70 (detail), II, p. 138-139, no. 281, ill.;
S. Barazetti, "Degas et ses amis Valpinçon," *Gazette des Beaux-Arts*, Aug. 21. 1936;
D.C. Rich, *Degas*, New York, 1951, p. 52-53, ill. in color;
P. Cabanne, *Edgar Degas*, Paris, 1957, p. 110, no. 43, pl. 43;
J.S. Boggs, *Portraits by Degas*, Berkeley and Los Angeles, 1962, p. 37, 46;
A. Scharf, "Painting, Photography and the Image of Movement," *Burlington Magazine*, CIV, May 1962, p. 191, ill. p. 188, fig. 7;
A. Scharf, *Art and Photography*, Baltimore, 1969, p. 154-155, fig. 143;
J. Rewald, *The History of Impressionism*, New York, 1973, ill. p. 311.

14 Edgar Degas

Hortense Valpinçon as a Child

About 1871-1872
Oil on canvas
H. 29⅞, w. 43⅝ in.
 (76.04 × 110.81 cm.)

Lent by the
 Minneapolis Institute of Arts
 John R. Van Derlip Fund,
 1948

Degas probably painted this portrait of the daughter of his friend Paul Valpinçon (see Degas *Carriage at the Races,* no. 13) in late 1871 while visiting the family at their country home in Ménil-Hubert, Normandy, during the time that Paris was being ravaged by the destructive turmoil of the Commune : "His friendship for the Valpinçons seems to have been comfortingly separate from his life in Paris... To Henri Lerolle, a good friend, Degas wrote during a visit in 1884 : 'I must tell you that I too am near Vimoutiers, at the home of a childhood friend.' In all likelihood this friendship was just that, a habit from childhood, without any intellectual stimulus but with certain and constant affection from all members of Paul Valpinçon's family" (Jean Sutherland Boggs, *Portraits by Degas,* Berkeley and Los Angeles, 1962, p. 37).

This work reflects an awareness of the compositional techniques of Japanese prints, a characteristic also noted in *Carriage at the Races.* Here, however, the influence is apparent in the numerous patterned surfaces that appear to belong in a single visual plane, thereby flattening the picture space.

While increasing abstraction and flatness are characteristic of Impressionist developments of the early seventies, the avant-garde formal interests of the painting of Hortense Valpinçon have been subordinated to the purpose of portraiture. Hortense is placed in the midst of randomly collected patterns in a shallow space. Degas seems to have intended an allusion to the unformed, piecemeal experiences of childhood, as reflected in the various patterns that are everywhere incomplete or vague.

The section of apple that Hortense holds in her right hand is thought to have been a bribe for the sitter : "We know through a recollection of Madame Jacques Fourchy, Hortense, née Valpinçon, that Degas had given her four quarters of an apple to serve as a reward for good behaviour during the sitting" (*The Bulletin of the*

Minneapolis Institute of Arts XXXVII/10 [March 6, 1948], p. 46-47). However, the purpose of the apple probably extends beyond the need to have Hortense stand quietly; it poses a subtle iconographic possibility that cannot be ignored. Degas, well aware of traditional symbolism, may have intended the apple to suggest that his young girl is not far from the knowledge that will separate her from the random, innocent experiences of childhood.

The off-center composition and the abrupt cropping recall *A Woman with Chrysanthemums* (no. 10) and the passage from Duranty's *La Nouvelle Peinture...* cited in the entry for that picture. Furthermore, the interest in two-dimensional patterns and the shallow space anticipate similar compositional interests in the "intimiste" portraits by Vuillard of twenty years later.

The curious broken black line running down Hortense's back apparently indicates a contemplated change by Degas. Again, a recollection by Madame Fourchy provides a probable explanation : "It is possible that Degas was not satisfied with the limitation of contour and planned to change it. He frequently did this, for he was that uneasiest of all men, a perfectionist. According to Madame Fourchy [née Hortense Valpinçon], he insisted that he had not finished the portrait but Paul Valpinçon knowing his habit of reworking pictures, declared that it was perfect as it was and took it from him" (*The Bulletin of the Minneapolis Institute of Arts,* p. 47). The story indicates Paul Valpinçon to have been as astute a collector as his father, Edouard, who is remembered as a collector of works by Ingres, notably the work that bears his name, *The Bather of Valpinçon* (Musée du Louvre).

C.S.M.

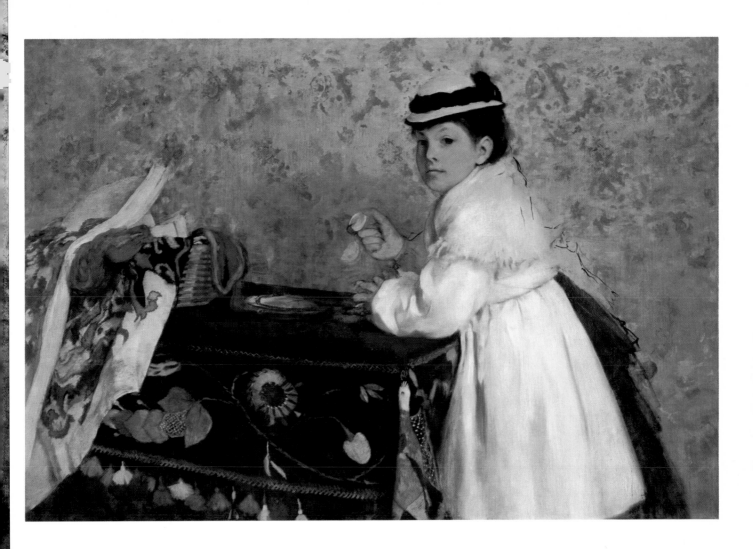

15 Edgar Degas

The Dancing Class

1871
Signed, lower right : *Degas*
Oil on wood
H. 7¾, w. 10⅝ in. (19.7 × 27 cm)

The H.O. Havemeyer Collection
Bequest of Mrs. H.O.
 Havemeyer 1929
The Metropolitan Museum
 of Art 29.100.184

This small picture was probably painted in late 1871; in January 1872 it was entered as *Foyer de la Danse* in Durand-Ruel's stock book in London. The following month it was sold to a Monsieur Brandon (probably the painter Jacques-Emile-Edouard Brandon, who was a friend of Degas's, or possibly to Brandon's son) and subsequently lent by Brandon to the first Impressionist Exhibition in 1874 (see Ronald Pickvance, "Degas's Dancers : 1872-6," *Burlington Magazine* CV/723 [June, 1963], p. 257). Pickvance has also established that *The Dancing Class* is the first of Degas's treatments of the rehearsal room. Although there is evidence that Degas made some changes in this picture while he was working on it (for example, the positions, especially the head of the central figure and her reflection in the mirror, were changed), no preparatory drawings or studies have survived, another indication that *The Dancing Class* is the full record of Degas's initial thoughts about a subject that was to occupy him for years thereafter.

The Dancing Class remains generally within the bounds of an overall middle tone, accented occasionally by a full white (the sheet of paper in the hat; the light coming through the door at the rear) or a full black (the violinist's hat and suit; the violin case). Color in the sense of hue and intensity is subordinated to color in the sense of values (the tonal range from light to dark). This mode relates to the interests of Impressionism in the early seventies, as well as to directions pursued by Whistler since the early sixties.

The painting also bears importance as Degas's first essay in the orchestration of figure groups in an interior : "...stylistically, the most striking feature about these two paintings [the other is *Le Foyer de la Danse à l'Opéra de la rue le Peletier*, 1872, Musée du Louvre, R.F. 1977] is that, for the first time, Degas has concerned himself with the problem of the orchestration of figure-groups in

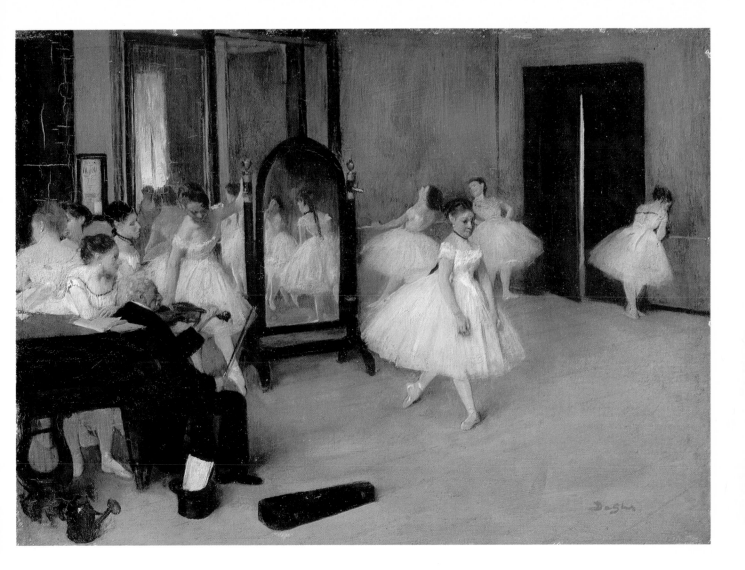

an interior... Degas has clearly stated his interior by using two walls of the room, which create a wedge-like space. A direct source of light has been avoided : an evenly diffused light fills both rooms..." (Pickvance, p. 258). However, it is worth noting that by means of the mirrors and doorways at the left, Degas complicated the spatial illusion and upset what Pickvance calls a "clearly stated... interior." Theodore Reff has discussed Degas's use of mirrors and doorways to create pictures within pictures in order to" ...call attention to the artificial aspects of the picture in which it occurs, reminding us... of the artist's mind and hand..." (see Theodore Reff, "The Pictures within Degas's Pictures," *Metropolitan Museum Journal* 1 [1968], p. 125). Degas's fascination with the unnatural, artificial poses of the dancers is consonant with his interest in the artifice of the picture itself. As if to underscore these concerns Degas provides a visual analogy between the watering can and the shape formed by the violin and the musician's left arm. In later works the watering can is sometimes used as an analogue to the position of the dancer, e.g. *Dancers Practicing at the Bar* (Metropolitan Museum of Art, 29.100.34) and *La Classe de Danse* (Musée du Louvre, R.F. 1976).

In 1874 Edmond de Goncourt noted that Degas's interest in dancers was an extension of a more generalized interest in what Reff defines as "expert, specialized" worlds : "When he painted laundresses in their shops or dancers in their practice rooms, he observed their characteristic gestures and habits of speech, and later surprised Edmond de Goncourt, himself a connoisseur of the precise word, by showing him pictures of these women while "parlant leur langue, nous expliquant techniquement le coup de fer *appuyé,* le coup de fer *circulaire,* etc. Et c'est vraiment très amusant de le voir, sur le haut de ses pointes, les bras arrondis, mêler à l'esthetique du maître de danse l'esthetique du peintre [...while speaking to us with their language and explaining technically the stroke of the iron for pressing and the circular stroke, etc. And it's really very humorous to see him, up on his toes and with his arms curved, blending the aesthetics of the dance master with the aesthetics of the painter]" (Theodore Reff, "The Technical Aspects of Degas's Art," *Metropolitan Museum Journal 4* [1971], p. 143; also cf. John Rewald, "The Realism of Degas," *Magazine of Art* XXXIX/1 [January, 1946], p. 16).

C.S.M.

Provenance

Durand-Ruel, Paris, Jan.-Feb. 1872; Brandon, Paris (from Feb. 1872 until after April 1874); Durand-Ruel, Paris, and 168 New Bond Street, London (until May 1875), and/or Charles W. Deschamps, 168 New Bond Street, London, (until April-June, 1876); Henry Hill, Brighton (1875 or 1876-1889; sale, London, Christie's, May 25, 1889, no. 26, mistitled *A Pas de Deux*, $7\frac{1}{2} \times 10$ in., to Wallis for 41 guineas); Wallis, French Gallery, London (in 1889); Manzi, Paris (until 1916/17); Mrs. H.O. Havemeyer, New York (from 1916/17; cat., 1931, p. 117, ill.).

Exhibitions

1874 Paris, 35, boulevard des Capucines, *Société anonyme des artistes peintres, sculpteurs, graveurs...*, no. 55 (*Classe de danse*, lent by M. Brandon, probably this picture)
1876 London, Deschamps Gallery, 168 New Bond Street, *Twelfth Exhibition of Pictures by Modern French Artists*, no. 2 (as *The Practising Room*)
1928 New York, Durand-Ruel, *French Masterpieces of the XIX Century*, no. 6 (*La Leçon de foyer*, lent anonymously, probably this picture)
1930 New York, Metropolitan Museum, *The H.O. Havemeyer Collection*, no. 48

Selected Bibliography

P.A. Lemoisne, *Degas*, Paris, I, p. 69, II, p. 148-149, no. 297, ill.;
P. Burty, *La République française*, April 25, 1874, reprinted in L. Venturi, *Les Archives de l'impressionnisme*, Paris and New York, 1939, II, p. 289 (refers to a very small [tout petit] picture called *Classe de Danse* in the first Impressionist exhibition, 1874);
M. de Montifaud, *L'Artiste*, sér. 9, XIX, 1874, p. 309 (describes this picture);
Art Journal, XXXVIII, 1876, p. 211;
L. Browse, *Degas Dancers*, New York, n.d. [1949], p. 53-54, 60, 341, no. 17, pl. 17, color pl. II;
P.A. Wick, "Degas' Violinist," *Bulletin, Museum of Fine Arts, Boston*, LVII, 1959, p. 90, 91, 93;
R. Pickvance, "Degas's Dancers," *Burlington Magazine*, CV, 1963, p. 256-259, 265-266;
C. Sterling and M.M. Salinger, *French Paintings, a Catalogue of the Collection of the Metropolitan Museum of Art*, New York, 1967, III, p. 69-71, ill.;
T. Reff, "The Pictures within Degas's Pictures," *Metropolitan Museum Journal* 1, 1968, p. 126;
J. Rewald, *The History of Impressionism*, New York, 1973, ill. in color p. 279.

Portraits in an Office — The Cotton Exchange, New Orleans

Signed and dated,
 lower right : *Degas
 Nlle Orléans - 1873*
Oil on canvas
H. 29⅛, w. 36⅛ in. (73 × 92 cm.)

Musée des Beaux-Arts
 Pau, France
Inventory no. 215 ;
 acquired in 1878

On February 18, 1873, Degas, who was visiting relatives in New Orleans, wrote to his friend the painter J.J. (James) Tissot (see no. 11) :

"After having lost time trying to do portraits of members of the family under the worst lighting conditions that I have ever found or imagined, I have settled down with a strong composition which I'm saving for Agnew [a dealer in London] who ought to be able to sell it to a Manchester collector : because if a textile manufacturer of cotton ever wished to find his painter I would make quite an impression. *Interior of the cotton buyers' office in New Orleans.*

"In the office there are about fifteen people whose attention is directed toward a table covered with the costly fabric; one man is bent over the table and another is sort of seated on it — the buyer and the broker are discussing a sample. A painting of a vernacular subject, if there is such a thing, and I think by a better hand than most others (a size 40 canvas, I think). I'm planning another less complicated and more surprising yet, better art, in which everyone is in summer dress, the walls white, and a sea of cotton on the tables. If Agnew wants both, so much the better.

"However, I don't want to drop my plans for Paris (it's my life style for the time being) with the nearly fifteen days that I think I'll spend here I'm going to put the finishing touches to *The Cotton Buyers' Office.* But I won't be able to take it with me. Boxed up for a long time, and away from air and light, a painting hardly dry will turn to chrome yellow number 3, as you know. I will not be able, therefore, to take it to London or to have it sent there until around April. Until then keep me in the good graces of these gentlemen. There is in Manchester a wealthy textile manufacturer, de Cottrell, who has quite a collection. A good fellow like that would suit me and would suit Agnew even better. But

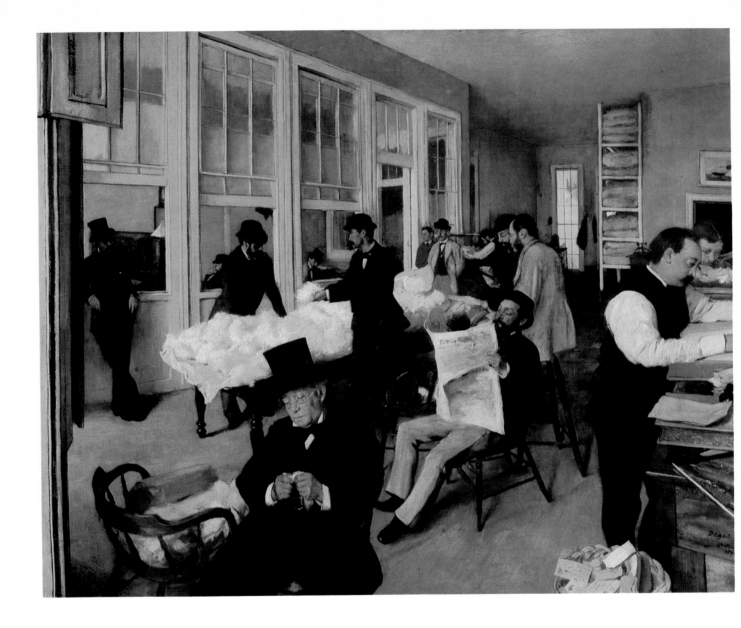

let's cross that bridge when we come to it and not speak indiscreetly" (translation based on M. Kay's in M. Guérin [ed.] and M. Kay [trans.], *Degas Letters,* Oxford, 1947, p. 29-30, no. 2).

The "size 40" canvas Degas mentioned must surely refer to the painting in the Musée des Beaux-Arts, Pau. The whereabouts of the second picture described is not known; Degas may never have painted it. However, the sketch belonging to The Fogg Art Museum, Cambridge (P.A. Lemoisne, II, no. 321), is possibly a study for the projected second composition.

Neither Agnew nor the Manchester collector bought *Portraits in an Office — The Cotton Exchange, New Orleans;* in 1876 it appeared in the second Impressionist exhibition with the title *Portraits dans un bureau (Nouvelle-Orléans)* [*Portraits in an Office (New Orleans)*]. According to John Rewald (see Selected Bibliography) the models for the six men pictured were : in the foreground, Degas's maternal uncle, Michel Musson, who wears a top hat and is seated examining a sample; at the extreme right, John E. Livaudais, the accountant and one of Musson's partners; in profile on a high stool in the right middle ground, James S. Prestridge, Musson's other partner; seated before Prestridge and reading a newspaper, René Degas, the artist's brother and Musson's son-in-law; leaning on the window sill at the extreme left, Achille Degas, the artist's other brother; and finally, seated on the edge of the table in conversation with a customer, William Bell, another of Musson's sons-in-law. Rewald notes that Degas's brothers are not taking part in the activity and concludes that the scene is the offices of Michel Musson's firm, where the Degas brothers would have been visitors.

There are no known preparatory drawings or oil sketches for this work, contrary to the usual case with Degas — *The Bellelli Family* (no. 9), for example. In some ways *Portraits in an Office — The Cotton Exchange, New Orleans* can be interpreted as a modern version of the seventeenth-century Dutch group portraits of corporation officers — for example, Rembrandt's *The Sampling Officials of the Draper's Guild,* 1662 (The Rijksmuseum, Amsterdam), which happens to depict a similar subject. Although the present picture is properly within a long tradition of group portraiture, the Impressionists were ridiculed for painting vernacular subjects. The critics were, of course, outraged when this canvas, equally daring in subject and composition, was shown in 1876. Even Zola, an admirer of the Impressionists, disparaged it : "The best thing he does are his

sketches. As soon as he begins to polish a picture, his drawing grows weak and pitiable; the drawing in pictures like his *Portraits in an Office (New Orleans)* results in something between a marine painting and an engraving for an illustrated newspaper."

A.D.

Provenance

Painted in New Orleans during Degas's stay there, November 1872 — February 1873; purchased by the City of Pau for its museum, March 1878, with funds from the Noulibos Foundation, after the exhibition of the Société des Amis des Arts de Pau. (Note : this was the first time that a French museum bought a work by Degas; it was only after the famous Caillebotte Bequest in 1894 that other works by Degas entered the Musée du Luxembourg. The keeper of the Pau Museum in 1878 was Charles Le Cœur. Probably the purchase was encouraged by one of Degas's friends, Alphonse Cherfils, a resident of Pau.)

Exhibitions

1876 Paris, *Société anonyme des artistes, peintres, sculpteurs, graveurs, etc. Exposition de 1876* [second Impressionist exhibition], 11 rue le Peletier, no. 36, with the title *Portraits in an Office (New Orleans)*; (see A. Wolff's review cited in John Rewald, *The History of Impressionism* [fourth edition], New York, 1973, p. 368-370)

1878 Pau, *Société béarnaise des Amis des Arts, Salon de Peinture de Pau,* no. 87 (see Hairvey, *Mémorial des Pyrénées,* Saturday, February 16, 1878 : "DEGAS [Edgar] no. 87. *Interior of a Cotton Office at New Orleans (United States).* The most expensive but certainly not the most beautiful picture in the exhibition. A little more drawing, a little more color, and another subject, and one would have been able to make something of this canvas")

1900 Paris, *Centennale de l'Art Français,* no. 209

1924 Paris, Galeries Georges Petit, April 12-May 2, *Degas,* no. 43

1936 Philadelphia, The Philadelphia Museum of Art, *Degas,* no. 20

1937 Paris, Orangerie des Tuileries, *Degas,* no. 18

1937 Paris, *Chefs d'Œuvres de l'Art Français,* no. 302

1951-1952 Berne, Berner Kunstmuseum, *Degas,* November 25-January 13, 1952, no. 20

Selected Bibliography

P.A. Lemoisne, *Degas et son œuvre,* II, Paris, 1946, p. 164, no. 320, with a complete bibliography to which the following should be added :

L.E. Duranty, *La Nouvelle Peinture* (edited by M. Guerin), Paris, 1876 (1946), p. 45 (cited by T. Reff, "Degas and the Literature of his Time, I," *Burlington Magazine* CXII, no. 810 [September 1970], p. 584);

A. Pothey, "Expositions," *La Presse,* March 31, 1876 (cited by L. Venturi, *Archives de l'Impressionnisme,* II, Paris and New York, 1939, p. 302);

E. Zola, "Deux expositions d'art en mai," *Messager de l'Europe* (June 1876), as reprinted in *E. Zola Salons,* edited by F.W. Hemmings and R.J. Niess, Paris and Geneva, 1959, p. 195;

L. Bénédite, *Histoire des Beaux-Arts 1800-1900,* Paris, n.d., p. 276-277;

A. Alexandre, "Essai sur Monsieur Degas," *Les Arts,* 1918, no. 166, p. 20;

A. Alexandre, "Degas, nouveaux aperçus," *L'Art et les Artistes* XXIX (February 1935), p. 157;

J. Rewald, "Degas, his family and his friends in New Orleans," *Gazette des Beaux-Arts,* 1946, no. 2, p. 116-118;

A. Krebs, "Degas à la Nouvelle-Orléans," *Rapports France — Etats-Unis,* no. 64 (July 1952), p. 63-72;

P. Cabanne, *E. Degas,* Paris, 1957, p. 33, 110;

R. Raimondi, *Degas e la sua famiglia a Napoli 1793-1917,* Naples, 1958, p. 262, 265;

J.S. Boggs, *Portraits by Degas,* Berkeley and Los Angeles, 1962, p. 38-40, and p. 93 (notes 76-93);

John Rewald, *The History of Impressionism* [fourth edition], New York, 1973, p. 372, 396 (note 40).

Edgar Degas

The Dance Class

1875-1876
Signed, lower left : *Degas*
Oil on canvas
H. 33, w. 31¾ in.
 (83.8 × 79.4 cm.)

Lent anonymously

The Dance Class was executed during 1875 or 1876 and was included in the second Impressionist exhibition in 1876. Similar to *La Classe de Danse* of 1874 (Musée du Louvre, R.F. 1976), this picture is one of a number of compositions by Degas that exist in a related, though always significantly different version (cf. John Rewald, "The Realism of Degas," *The Magazine of Art* XXXIX/1 [January, 1946], p. 13-18).

In discussing *The Dance Class* and its counterpart in the Louvre, Rewald notes, "There are many minor differences between the setting of the two versions : in the Louvre example, floorboards are diagonal, there is a richly architectural doorway, ceiling mouldings, marble pilasters. In the other picture, floorboards are horizontal, the walls and mouldings are simple, a mirror takes the place of the doorway. The dancers themselves are disposed somewhat differently, the dancing master moved to the side" (Rewald, p. 13).

The rapid funneling into space caused by the rushing orthogonals in the earlier version is replaced in the later version by the slower, more deliberate progression into space of the horizontal floorboards. In the later version the triangular disposition of the figures, topped by the figure standing on a platform at the back of the room, is tempered by the pair of figures seated immediately below the uppermost dancer; it is as if Degas were masking a structure that he felt to be too obvious. A similar sense of finesse probably motivated his alleged desire to paint out the watering can in the Metropolitan Museum's *Dancers Practicing at the Bar* (see Charles Sterling and Margaretta Salinger, *French Paintings, A Catalogue of the Collection of the Metropolitan Museum of Art,* New York, 1967, p. 80). Although the watering can appears in other paintings, it is nowhere as blatantly related to the figures as in the *Dancers Practicing at the Bar.*

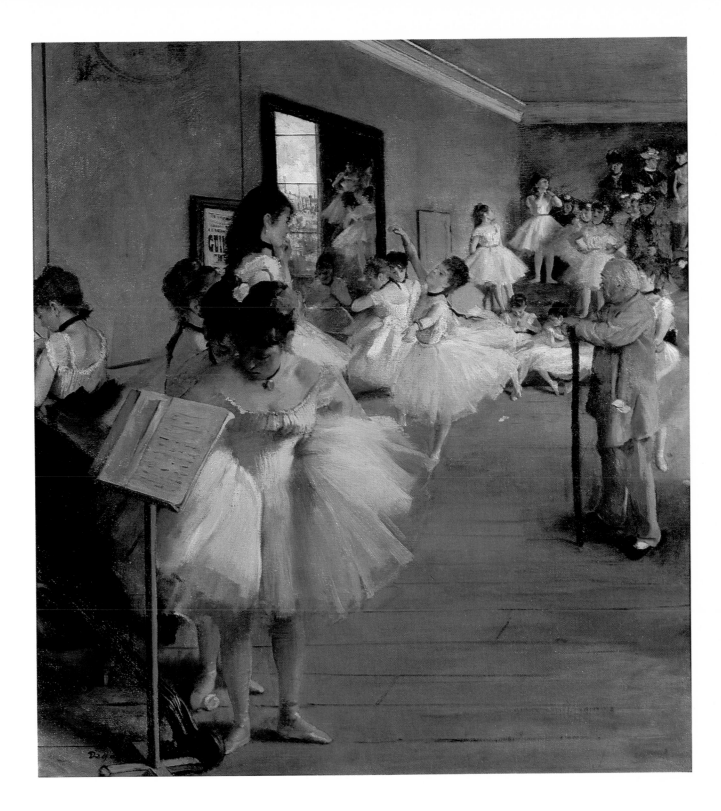

Other changes of similar importance include the music stand and the double bass in the later version replacing the watering can in the Louvre example. The base of the music stand is a far subtler comment on the artificiality of the dancers' postures than the watering can. The mirror in *The Dance Class,* replacing the doorway in the earlier picture, is a device whose purpose is explained by Theodore Reff: "...it [a picture within a picture] also calls attention to the artificial aspects of the picture in which it occurs, reminding us [of]... the artist's mind and hand... In the visual arts it is similar to two other motives that Degas frequently employed... the mirror... and the window or doorway whose frame intercepts in a fixed and equally pictorial manner a sector of the larger field behind it" (see Theodore Reff, "The Pictures within Degas's Pictures," *Metropolitan Museum Journal* 1 [1968], p. 125).

The figure of the dancing master, Jules Perrot, himself once a dancer (see Jean Sutherland Boggs, *Portraits by Degas,* Berkeley and Los Angeles, 1962, p. 56), adds yet another dimension to the painting. He and his unwieldy walking stick provide a counterpoint to the grace of the dancers and the rigidity of the music stand in the foreground. In this painting he has been shifted from the more central and isolated position he occupied in the Louvre version to a position farther to the right. Aligned with a clear orthogonal progression at the right, he fits more comfortably into the composition. His form was, perhaps, too strong a contrast in the earlier work. Moreover, the gesture that Perrot makes in the Louvre's version (as well as in the study in the Henry P. McIlhenny collection, Philadelphia, and the *Ballet Rehearsal,* 1875, in the Nelson Gallery — Atkins Museum, Kansas City) is eliminated in the later work, further integrating him into the more contemplative mood of the picture.

The Dance Class, like Degas's *Carriage at the Races* (no. 13) and Sisley's *The Bridge at Villeneuve-la-Garenne* (no. 41), was once in the collection of Jean-Baptiste Faure, a baritone in the Paris Opera who assembled one of the earliest important collections of Impressionist paintings, including a large number of works by Manet.

C.S.M.

Provenance

Jean-Baptiste Faure, Paris (bought for 500 francs from the artist); Durand-Ruel, Paris, 1898; Durand-Ruel, New York, 1898; Colonel Oliver H. Payne, New York, 1898-1917; Harry Payne Bingham, New York (1917-1955); Mrs. Harry Payne Bingham, New York (from 1955).

Exhibitions

1876 Paris, 11, rue Le Peletier, *2ᵉ exposition des impressionnistes* (lent by M. Faure)
1921 New York, Metropolitan Museum, *Loan Exhibition of Impressionist and Post-Impressionist Paintings*, no. 27

Selected Bibliography

P.A. Lemoisne, *Degas*, Paris, 1946, I, p. 92, 99, 102, II, p. 214-215, no. 397, ill.;
J.B. Manson, *The Life and Work of Edgar Degas*, London, 1927, p. 21;
M. Guérin, (ed.), *Lettres de Degas*, Paris, 1931, p. 16;
J. Rewald, "The Realism of Degas," *Magazine of Art*, XXXIX, Jan. 1946, p. 13, ill.;
L. Browse, *Degas Dancers*, New York, n.d. [1949], p. 343, no. 23, pl. 23;
P. Cabanne, *Edgar Degas*, Paris, 1957, p. 35, 98, 109;
J. Rosenberg, *Great Draughtsmen from Pisanello to Picasso*, Cambridge (Mass.), 1959, p. 113, fig. 214 (drawing for the figure of Perrot);
L.W. Havemeyer, *Sixteen to Sixty, Memoirs of a Collector*, New York, 1961, p. 263-264;
L. Browse, "Degas's Grand Passion," *Apollo*, LXXXV, February 1967, p. 107-109, fig. 5.

18 Armand Guillaumin

The Outskirts of Paris

About 1874
Signed, lower right :
A. Guillaumin
Oil on canvas
H. 23⅝, w. 31⅞ in (60 × 81 cm.)

City Museums and Art Gallery
Birmingham, England
P. 19-58

In 1863 Guillaumin exhibited, along with Manet, Pissarro, Cézanne, Jongkind, and others in the notorious Salon des Refusés. In 1874 at the invitation of Pissarro three landscapes by Guillaumin were included in the first Impressionist exhibition, held in the studio of the photographer Nadar. He participated again in the Impressionist exhibitions of 1877, 1880, 1881, 1882, and 1886. He often worked side by side with his friends Pissarro and Cézanne near Paris in Pontoise and Auvers-sur-Oise. Dr. Gachet, who lived in Auvers and was one of the first collectors of Impressionist paintings, acquired works by Guillaumin even before the first Impressionist exhibition. In fact, Guillaumin's *Sunset Over Ivry* (Musée du Louvre, Galerie du Jeu de Paume, R.F. 1951-34) is listed in the 1874 exhibition as belonging to Dr. Gachet.

Guillaumin was principally a landscape painter. Under the sound tutelage of Pissarro he was able to evolve a very personal style. His bright palette and his interest in textural effects later fascinated Gauguin and van Gogh. Indeed, before he became a painter, Gauguin bought works by Guillaumin; van Gogh, while living in Auvers and in the care of Dr. Gachet before his death in 1890, admired pictures by Guillaumin he saw in the doctor's collection.

The Birmingham Museum's landscape is particularly interesting : its suprising composition, its simplified but sophisticated design solution, the range of color in the shadows, and its bold execution endow it with a unique charm.

The site depicted remains unidentified; consequently it is not known if *The Outskirts of Paris* was in one of the Impressionist exhibitions. A.D.

Provenance

London, Arthur Tooth Gallery; bought by the Friends of the (Birmingham) Museum with funds from the gift of Miss A.G. Cole.

Exhibition

1957 London, Arthur Tooth Gallery, *Recent Acquisitions* XII, no. 4

Selected Bibliography

G. Serret and D. Fabiani, *Armand Guillaumin, 1841-1927, catalogue raisonné de l'œuvre peint*, Paris, 1971, no. 32;
Birmingham City Museums and Art Gallery, catalogue of paintings, London and Birmingham, 1960, p. 65-66.

19

Edouard Manet

Woman with a Parrot

1866
Signed, lower left : *Manet*
Oil on canvas
H. 72$\frac{7}{8}$, w. 50$\frac{5}{8}$ in.
 (185.1 × 128.6 cm.)

Gift of Erwin Davis, 1889
The Metropolitan Museum
 of Art 89.21.3

Here Manet uses the same model, Victorine Meurent, as in *Olympia* (Musée du Louvre, R.F. 644), *Déjeuner sur l'Herbe* (Musée du Louvre, R.F. 1668), *Mademoiselle Victorine in the Costume of an Espada* (Metropolitan Museum of Art, 29.100.53), and other works of the sixties and seventies. Manet never stereotyped her but always adapted Victorine's appearance for the purposes of a particular painting. Victorine also posed for Alfred Stevens, and Jean Sutherland Boggs speculates that Degas used her for his *Young Girl in a Red Peignoir* in the Chester Dale Collection, New York (see Jean Sutherland Boggs, *Portraits by Degas,* Berkeley and Los Angeles, 1962, p. 33). She became a painter herself and exhibited a self-portrait in the Salon of 1876. The sad end of her life purportedly inspired the character La Glue in "The End of Marie Pellegrin" in George Moore's *Memoir's of My Dead Life.*

Woman with a Parrot was painted in Manet's studio on the Rue Guyot and completed in the year following the appearance of *Olympia* in the Salon of 1865. According to Tabarant, it was first exhibited privately in the painter's studio (see A. Tabarant, *Manet et ses œuvres,* Paris, 1947, p. 124). In the spring of 1867 when Manet was not invited to participate in the international exposition on the Champ de Mars, he followed Courbet's solution to a similar situation in 1855; Manet decided to erect a viewing space for fifty of his own works (including *Woman with a Parrot)* on the Place de l'Alma, nearby the official exhibition. He probably would not have ventured so bold a step had he not been encouraged by a series of articles by Zola in *l'Evénement,* one of which was devoted solely to Manet.

Within the history of Impressionism and the rise of modernism, *Woman with a Parrot* has double importance. First, the painting is significant in its reduction of pictorial elements; the picture consists mainly of two broad areas, the light area of Vic-

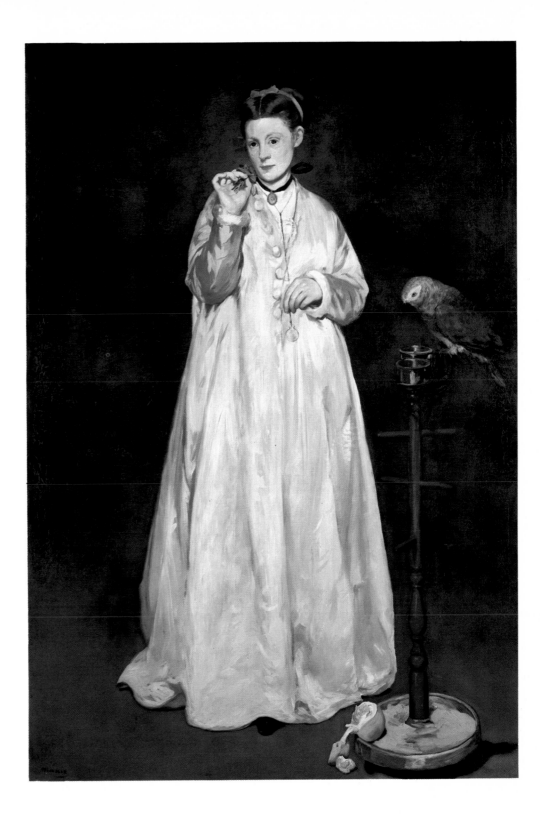

torine and the dark area of the rest. Second, the horizontal of the floor plane merges imperceptibly with the vertical of the background. The result is to flatten the picture space, bringing Victorine and the parrot closer to the picture plane. Manet's primary concerns are as much with the pictorial elements per se as with the subject. In a review of the Salon of 1868 Théophile Thoré succinctly analyzed Manet's interests: "Manet sees color and light, after which he no longer worries about the rest. When he has made the 'spot of color' on his canvas that a person or an object makes on the surrounding environment, he feels that this is sufficient. Don't ask anything else of him — for the moment. He will doubtless work things out for himself later, when he thinks of giving the essential parts of beings their relative values. His present vice is a sort of pantheism in which a head is esteemed no more than a slipper; in which sometimes more importance is given to a bouquet of flowers than to the physiognomy of a woman..." (Théophile Thoré [Burger], as quoted in Linda Nochlin, *Realism and Tradition,* Englewood Cliffs, 1966, p. 69). Toward the end of the same article Thoré's criticism is more direct: "...the portrait of a young woman in a pink dress, standing next to a beautiful grey parrot, roosting on its perch. The soft pink dress harmonizes delightfully with a delicate pearl-colored background. Pink and grey and a little touch of lemon at the base of the perch: that is all. One scarcely pays attention to the head, although it is full face and in the same light as the pink material. It is lost in the modulation of the coloring." Zola, too, had taken a formalist approach in the articles in *l'Evénement* and *La Revue du XIXe siècle,* but his tone was purely laudatory and expressed none of Thoré's reservations.

In an article recently published in the *Metropolitan Museum Journal* (Volume 7 [1973], p. 115-122) Mona Hadler places *Woman with a Parrot* in a long art historical and iconographic tradition: "...one can speculate that Victorine's monocle is actually a man's monocle. Accordingly the flowers would also be a gift from a man as they were in the Olympia... we are provided with the ambience and the clues to the romantic nature of the shared secrets behind the knowing stare of Victorine and her gray confidant. In accordance with the traditional iconography Victorine's parrot is her intimate companion, sees her in the process of dressing, and appears to share the secrets of her personal life" (Hadler, p. 122). Furthermore, Hadler notes that a seventeenth-century Dutch painting by Frans van Mieris, treating the same subject, was" ...illus-

trated in Charles Blanc's *Histoire des Peintres* — a book consulted frequently by Manet in the 1860" (Hadler, p. 118).

Charles Sterling and Margaretta Salinger indicate that "the violent attacks that this attractive and inoffensive painting provoked seemed to have resulted from the presence of the parrot, which recalled to the indignant public Courbet's *Woman with a Parrot* [Metropolitan Museum of Art, 29.100.57], a picture that had caused a scandal at the Salon two years before" (Charles Sterling and Margaretta Salinger, *French Paintings, A Catalogue of the Collection of the Metropolitan Museum of Art*, Volume III, [New York], 1967, p. 40; for the Courbet, see Volume II, p. 124). George Heard Hamilton provides further insight into the possible relationship between the Courbet and the Manet : "In 1866 Courbet had shown at the Salon a large canvas of a reclining nude woman holding a parrot in one hand (New York, Metropolitan Museum). The elaborate pose and artificial gesture were Courbet's answer to the criticism directed against himself, and in a roundabout way, a reply to Manet's challenge in *Olympia*. Courbet's complicated design, sober color scheme, and dense modeling were the antitheses of Manet's clear scale of values and flat pattern. To the public of 1868 it appeared that Manet was offering another rebuttal to Courbet; Courbet's lady had donned her wrapper! That the problem was rather one of discovering subjects in modern life, and a treatment appropriate to them, went unobserved" (George Heard Hamilton, *Manet and his Critics*, New York, 1969, p. 115).

C.S.M.

Provenance

Durand-Ruel, Paris (bought for 1500 francs in 1871-72); Ernest Hoschedé, Paris (bought from Durand-Ruel for 2500 francs; sale, Paris, Hôtel Drouot, June 6, 1878, no. 44, 700 francs to Hecht); Albert Hecht, Paris (from 1878); Durand-Ruel, Paris (1881); Erwin Davis, New York (1881-1889); sale, New York, Ortgies, March 19-20, 1889, no. 99, as Feeding the Parrot, bought in for $1350). Gift of Erwin Davis, 1889.

Exhibitions

1867 Paris, Avenue de l'Alma, *Exposition particulière de Manet*, no. 15
1868 Paris, *Salon*, no. 1659
1872 London, Durand-Ruel, *Fifth Exhibition of the Society of French Artists*, no. 49
1883 New York, National Academy of Design, *Pedestal Fund Art Loan Exhibition*, no. 182
1937 Paris, Palais National des Arts, *Chefs-d'œuvre de l'art français*, no. 356
1955 Paris, Orangerie des Tuileries, *De David à Toulouse-Lautrec*, no. 38
1965 Munich, Haus der Kunst, *Französische Malerei des 19. Jahrhunderts von David bis Cézanne*, no. 161
1971 New York, Wildenstein, and Philadelphia Museum of Art, *From Realism to Symbolism, Whistler and His World*, no. 96

Selected Bibliography

P. Jamot, G. Wildenstein, M.L. Bataille, *Manet* [catalogue raisonné of the paintings and pastels], Paris, 1932, I, p. 37-38, 42-43, 83, 133, no. 132, II, pl. 15, fig. 38;
C. Sterling and M.M. Salinger, *French Paintings, a Catalogue of the Collection of the Metropolitan Museum of Art*, New York, 1967, III, p. 40-43, ill.;
M. Fried, "Manet's Sources," *Artforum*, March 1969, p. 57;
T. Reff, *From Realism to Symbolism, Whistler and His World*, exhibition catalogue, Wildenstein, New York, and Philadelphia Museum of Art, 1971, p. 98, no. 96, pl. 16;
A.C. Hanson, "Popular Imagery and the Work of Edouard Manet," *French 19th Century Painting and Literature* (U. Finke, ed.), Manchester, 1972, p. 158;
M. Hadler, "Manet's Woman with a Parrot of 1866," *Metropolitan Museum Journal*, 1973, p. 115-122.

Edouard Manet

Portrait of Emile Zola

1868
Signed on the blue
 pamphlet to the right of
 the quill pen : *Manet*
Oil on canvas
H. $57\frac{1}{2}$, w. $44\frac{7}{8}$ in.
 (146 × 114 cm.)

Musée du Louvre
 Galerie du Jeu de Paume
Bequest of Madame
 Emile Zola, 1918
R.F. 2205 (accessioned 1925)

Emile Zola, a childhood friend of Cézanne, was introduced to the informal meetings of painters and writers at the Café Guerbois by Guillemet; in his articles Zola championed Manet and the painters of the so-called Café Guerbois Group. In order to thank him Manet offered to paint his portrait.

The critic and novelist is shown in the study of his apartment on the rue de Moncey at the corner of the rue de Clichy (see Selected Bibliography, J. Adhémar, 1960), only a few steps from the Café Guerbois. Zola is seated in front of a table of books and pamphlets, prominent among which is an essay by Zola on the subject of Manet (a reprint, published in Paris by E. Dentu, 1867, of the article by Zola first published in *Revue du XIXe siècle*, no. 1, January 1867). On the wall there is a print, or possibly a photograph, of Manet's *Olympia* (Musée du Louvre, Galerie du Jeu de Paume, R.F. 644), a print by Goya after Velázquez's *The Drinkers (The Triumph of Bacchus*, about 1628, The Prado, Madrid), and a print by an unknown Japanese ukiyo-e artist; to the left there is one panel of a Japanese screen cut off by the edge of the picture. Although a portrait of Zola, the picture is an illustration of Manet's aesthetic orientation as well. Japanese prints had just come into fashion among the artists; indeed, the Exposition Universelle of 1867 (during or just after which the *Portrait of Zola* was probably painted) had been the occasion of an enormous dissemination of Japanese prints.

In updating the traditional portrait of a man of letters, Manet's *Zola* caused an uproar at the Salon of 1868; a significant reverberation is found in the account of a young painter, Odilon Redon, at that time trying his hand as an art critic : "This picture draws the eye, the viewer looks at it in spite of himself; compared to those surrounding it, one finds it extraordinary : it is unique, it arouses interest through its harmoniousness, its freshness, its

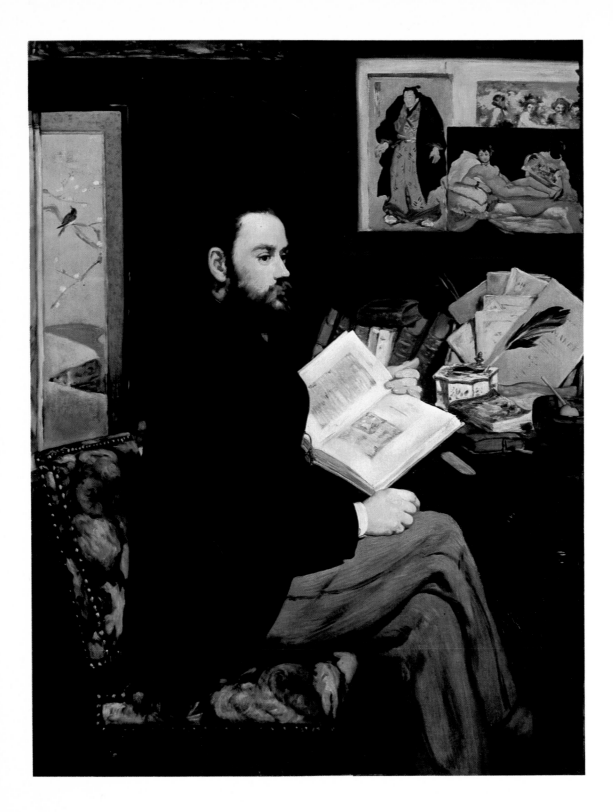

exquisite orchestration of color. The failing of Monsieur Manet and all those who, like him, wish to content themselves with a verbatim transcription of reality, is that they sacrifice Man and his intellect to clever execution, to the accomplished rendering of an object" (Odilon Redon, *La Gironde,* 1868, quoted by R. Bacou, *Odilon Redon,* I, Geneva, 1956, p. 45).

Although Zola's face is somewhat inexpressive, because he stares blankly into space and has let his glasses fall to his lap, rarely has Manet's execution been as subtle or as accomplished. He has skillfully rendered differences in texture : the upholstery of the chair, the grain of the screen, and the printed image of *The Drinkers* versus the paper of the border. In contrast to the gray pants and the black jacket, Manet has handled the still life with fresh, clear colors; particularly notable is the harmony of the cool yellow and pale blue that reappears in the Turkish slipper in *Olympia.* The carefully orchestrated execution is also evident in the basic compositional arrangement : pentimenti testify to an important change in the position of Zola's right leg, which was originally much higher.

Relations between Zola and Manet were never very cordial. The commitment of Manet and the nascent Impressionists to subjects from modern life paralleled Zola's own interests; support for the Impressionists was at least an opportunity to justify his own work as a novelist. However, it is questionable whether he understood the Impressionists or if he was really interested in the painting of his time. For example, he failed to understand Cézanne, a friend since childhood, and considered him a failure. Among statements about Manet attributed to Zola, the little-known account by the Symbolist poet Adolphe Retté is noteworthy : "I told Zola how much I liked the portrait of him by Manet, which was hanging in the room with the billiard table; he replied, 'Yes, that portrait isn't bad; but Manet was not a very great painter; his talent never fully developed.'

"His opinion, expressed in this way, came to me as something of a surprise, because I remembered pages and pages in which Zola enthusiastically praised the seminal figure of the Impressionist movement. I couldn't help telling him so.

"'Oh,' he replied, 'I was young, I was looking everywhere for ammunition to defend the ideas on which my books were based. Manet seemed a natural for my support because of his care to choose contemporary subjects and his stress on realism. But, to

tell you the truth, I always found his work a little disconcerting... Besides, I can't really get excited about painting'" (from *L'Européen,* November 1, 1902, as reprinted in *Le Symbolisme, anecdotes et souvenirs,* Paris (Léon Vanier), 1903, p. 191-192).

M.H.

Provenance

Given by Manet to Zola, about 1868; the gift of Madame Emile Zola to the Musée du Louvre, subject to the terms of a life interest.

Exhibitions

1868 Paris, Salon, no. 1660
1883 Paris, Ecole des Beaux-Arts, *Portraits du Siècle,* no. 304
1884 Paris, Ecole des Beaux-Arts, *Manet,* no. 42
1903 Paris, Ecole des Beaux-Arts, *Exposition des Impressionnistes,* no. 33
1928 Paris, Galerie Bernheim-Jeune, *Manet,* no. 6
1928 Berlin, Galerie Matthiesen, *Manet,* pl. 22
1932 Paris, Orangerie des Tuileries, *Manet,* no. 30
1933 Berlin, Cologne, Frankfurt
1934 Venice, Biennale
1937 Warsaw and Prague, *Exposition de la peinture française de Manet à nos jours*
1938 Lyon, *d'Ingres à Cézanne,* no. 42
1939 Belgrade, Musée du Prince Paul, and Zagreb, Musée des Beaux-Arts, *La Peinture française au XIXᵉ siècle,* no. 71
1941 Montpellier, Musée Fabre, May-June 1941, *Centenaire de Frédéric Bazille*
1952 Paris, Bibliothèque Nationale, *Zola,* no. 87
1952 Paris, Orangerie des Tuileries, *Hommage à Manet*
1970-1971 Leningrad and Moscow, *Impressionnistes français*
1971 Madrid, Museo Espanol de Arte Contemporaneo, *Los impressionistas franceses,* no.40
1972 Munich, Haus der Kunst, *Welt Kulturen und Moderne Kunst,* no. 648 (illus.)

Selected Bibliography

P. Jamot, G. Wildenstein, M. L. Bataille, *Manet* [catalogue raisonné of the paintings and pastels], Paris, 1932, no. 146, fig. 149;
T. Gautier, *Le Moniteur Universel,* May 11, 1868;
L. Leroy, *Le Charivari,* May 29, 1868;
Paul Mantz, *L'Illustration,* June 6, 1868;
Grangedor, *Gazette des Beaux-Arts,* June 1868, p. 520;
T. Duret, *Histoire d'Edouard Manet et de son œuvre, avec un catalogue des peintures et des pastels,* Paris, 1902, no. 93 (edition of 1919, no. 93, pl. XIII; edition of 1926, pl. XIII);
G. Rouchès, *Beaux-Arts,* November 1, 1925;
C.V. Wheeler, *Manet, an essay,* Washington, 1930;
A. Tabarant, *Manet, Histoire catalographique,* Paris, 1931, no. 132;
R. Huyghe, *Amour de l'Art,* 1932, p. 165-184;
M.L. Bataille, "Le Centenaire d'Edouard Manet," *Beaux-Arts,* May 25, 1932;
S.L. Faison, "Manet's Portrait of Zola," *Magazine of Arts,* XLII, May 1949, p. 162-168;
J.C. Sloane, "Manet and History," *The Art Quarterly,* summer 1951;
H. and J. Adhémar, "Zola," *Arts,* December 12-18, 1952, p. 10;
N. Gösta Sandblad, *Manet, Three Studies in Artistic Conception,* Lund (Sweden), 1954, fig. 30;
G. Bataille, *Manet,* Geneva, 1955, p. 20;
H. Adhémar in *Musée du Louvre, catalogue des peintures, pastels, sculptures impressionnistes,* Paris, (Musées Nationaux), 1958, p. 106, no. 200;
J. Adhémar, "Le cabinet de travail de Zola," *Gazette des Beaux-Arts,* November 1960, p. 285-292 (illus. p. 286);
M. Roskill, *Van Gogh, Gauguin and the Impressionist Circle,* London, 1969, p. 59;
H. and J. Adhémar, "Le critique d'art," *Zola,* Paris, 1969, p. 58;
D. Rouart and S. Orienti, *Tout l'œuvre peint de Manet,* Paris, 1970, no. 118, p. 97 (illus.);
J. Rewald, *The History of Impressionism* [fourth edition], New York, 1973, p. 186, 188, 189 (illus.), 207.

Edouard Manet

The Balcony

1868-1869
Signed, lower right :
 Manet
Oil on canvas
H. 67, w. 49 in. (170 × 124.5 cm.)

Caillebotte Bequest, 1894;
to the Musée du Luxembourg,
 Paris, 1896
to the Musée du Louvre, 1929
 Galerie du Jeu de Paume
R.F. 2772

Manet's first idea for *The Balcony* presented itself in 1868 in the form of a small sketch (see P. Jamot, G. Wildenstein, M.L. Bataille, *Manet,* Paris, 1932, no. 152) done at Boulogne-sur-Mer and once in the collection of John Singer Sargent. The finished version was later painted in Paris, at the Batignolles studio where amateur models were used as stand-ins for the figures depicted in the sketch. In the center is Berthe Morisot; this was the first of many times that Manet painted his future sister-in-law. When *The Balcony* was done he had known her only a few months. To her left is the violinist Fanny Claus, who in 1869 married the painter and sculptor Pierre Prins, a close friend of Manet's. (In the sketch, Berthe Morisot and Fanny Claus are transposed.) In the center is the landscape artist Antoine Guillemet (who in 1882 influenced the Salon jury to reconsider Cézanne's rejected entry). The young man in the shadow in the left background is Leon Koella-Leenhoff, Madame Manet's son.

The source for the composition of *The Balcony* is apparently Goya's *Majas on a Balcony,* 1810-1815 (The Metropolitan Museum of Art, New York, The H.O. Havemeyer Collection, 29.100.10), but Manet has been quite free with the Goya, using it more as a point of departure than as an exact model. Goya's *Majas on a Balcony* exists in several versions, but Manet could have seen the one in the Salamanca sale, June 3-6, 1867. As J. Adhémar noted (*Bulletin des Musées de France,* no. 10, December 1935, p. 155-156), the Salamanca sale had generated a lot of excitement, and it was the only opportunity for Manet to have seen the Goya.

Few of Manet's works reject so systematically a sense of depth or flatten the figures into shallow space. There is no deformation of perspective, and there is no attempt at modeling. *The Balcony*

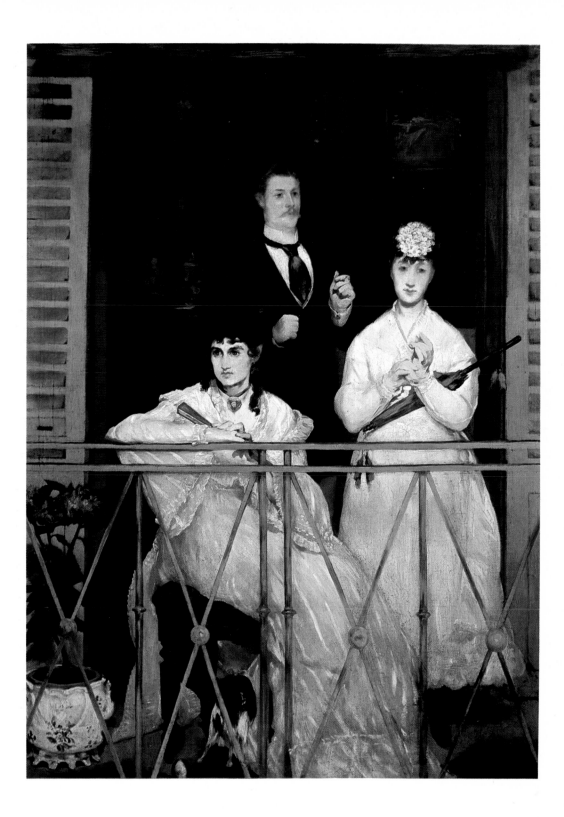

in "the triumph of flatness and shallow space" ["le triomphe de la silhouette et du plan"] (R. Huyghe, *L'Amour de l'art,* 1932, p. 181).

Manet's picture is also a triumph of the deliberate rejection of meaning. Manet handles figures as if they were objects in a still life; he deprives them of all emotional content and refuses them a full range of expression and feeling as conveyed through outward appearance and gesture, means used by painters and graphic artists, including Ingres and Delacroix, throughout the history of art. He rejected the traditional expressive devices but did not replace them with others. Perhaps similar to Manet's indifference to the figures themselves, or at least his apparent indifference, is René Magritte's substitution of coffins for figures in a picture of 1950 which he titled, with mischievous delight, aware of the paradox, *Perspective* (Musée des Beaux-Arts, Ghent; see P. Walberg, *R. Magritte,* Brussels, 1965, p. 88). Riopelle (a contemporary French-Canadian painter), standing before *The Balcony,* a picture that he loves, said, "If a real tie were put in the painting, it would be no less a shock than the blue one against the green that you see now" (P. Schneider, *Les Dialogues du Louvre,* Paris, 1973, p. 199).

The Balcony was not well received. Berthe Morisot wrote, "I look more peculiar than ugly. It seems that people asking about it have used the words *femme fatale* to describe me" (see E. Moreau-Nélaton, *Manet raconté par lui-même,* I, Paris, 1926, p. 108). Louis Leroy and Albert Wolff, well known for their scathing criticism of a movement that they never understood, vindictively attacked the picture. Louis Leroy ended an article in *Le Charivari* (May 6, 1869) saying, "Every time I pass before Manet's *Balcony with a Green Railing,* my brow unknits and I laugh." Wolff preached mockingly to Manet, in whom he recognized "the indisputable qualities of a painter; but ask him how... an artist arrived at this coarse art, in which details like the green shutters of the balcony bring him down to the level of house painters. It's obviously exasperating" (*Le Figaro,* May 20, 1869). In a biting parody of the picture, the caricaturist Bertall changed the figures into ridiculous puppets. Another caricaturist, Robida, although he left the composition intact, added a caption below, "White is beautiful indeed, for those who don't use any other colors," which was an attack on Manet's restricted palette (the picture is dominated by blacks and whites combined with a conspicuously bright green : shutters, railing, ribbon, and parasol).

The Balcony probably inspired Van Dongen's *Woman on the Balcony* (Musée de l'Annonciade, Saint-Tropez).

A sketch by Bazille after *The Balcony* exists in the Cabinet des Dessins, Musée du Louvre.

M.H.

Provenance

Remained in Manet's studio, where it hung near *Olympia* (see E. Bazire, *Manet*, 1884, p. 128); Paris, auction of the artist's estate, February 4-5, 1884, no. 2, sold for 3000 francs; bought by Gustave Caillebotte, who hung it in his dining room at Genevilliers in the position of greatest honor (according to P. Renoir, in conversation); Caillebotte Bequest, 1894; accessioned by the Musée du Luxembourg, 1896; transferred to the Louvre, 1929.

Exhibitions

1869 Paris, *Salon des artistes vivants*, no. 1616
1869 Brussels, *Exposition des Beaux-Arts*, no. 754
1884 Paris, Ecole des Beaux-Arts, *Manet*, no. 52
1928 Berlin, Galerie Matthiesen, *Manet*, no. 32
1932 Paris, Orangerie des Tuileries, *Manet*, no. 32
1952 Paris, Orangerie des Tuileries, *Hommage à Manet*

Selected Bibliography

P. Jamot, G. Wildenstein, M.L. Bataille, *Manet* I, 1932, p. 136, no. 150, with a bibliography through the date of publication, to which the following should be added :
Tony Révillon, *La Petite Presse*, May 4, 1869;
Louis Leroy, *Le Charivari*, May 6, 1869;
Albert Wolff, *Le Figaro*, May 20, 1869;
De Fomartin, *L'Univers*, June 7, 1869;
Castagnary, *Le Siècle*, June 1869;
J. Leymarie, "Pierre Prins et ses amis," *L'Amour de l'Art*, December 1945, p. 193 f.;
A. Tabarant, *Manet et ses œuvres*, Paris, 1947, no. 141;
Pierre Prins et l'époque impressionniste (by Prins's son), Paris, 1949, p. 49;
H. Adhémar in *Musée du Louvre, catalogue des peintures, pastels, sculptures impressionnistes*, Paris (Musées Nationaux), 1958, no. 202;
P. Courthion, "La Genèse et les personnages du *Balcon* de Manet," *L'Œil*, no. 188-189, September 1970, p. 20 f.;
D. Rouart and S. Orienti *Tout l'œuvre peint de Manet*, Paris, 1970, no. 121, p. 98 f.

Edouard Manet

Boating

1874
Signed, lower right : *Manet*
Oil on canvas
H. 38¼, w. 51¼ in.
 (97.1 × 130.2 cm.)

The H.O. Havemeyer Collection
Bequest of Mrs. H.O.
 Havemeyer, 1929
The Metropolitan Museum
 of Art 29.100.115

Boating was painted during the summer of 1874 when Manet, Renoir, and Monet were working together in Argenteuil. It fully embraces the Impressionist idiom; the high key of the palette, the practice of plein-air painting, the raised viewpoint that causes the horizon to rise and block the background, the overt use of a scene from modern life (as opposed to camouflaging a contemporary subject, such as *Olympia* or *Woman with a Parrot,* within a larger, if somewhat obscured art-historical tradition), the compositional influence of the Japanese print (i.e., the abrupt cropping of the composition at the edges, and the insertion of a diagonal across an upper corner), and the "close-up" format are all attributes that place Manet solidly within the mainstream of Impressionism in 1874. In a review of the Salon of 1879 J.K. Huysmans immediately recognized the pictorial qualities for which *Boating* remains significant : "The bright blue water continues to exasperate a number of people... Manet has never, thank heavens, known those prejudices stupidly maintained in the academies. He paints, by abbreviations, nature as it is and as he sees it. The woman, dressed in blue, seated in a boat cut off by the frame as in certain Japanese prints, is well placed, in broad daylight, and her figure energetically stands out against the oarsman dressed in white, against the vivid blue of the water. These are indeed pictures the like of which, alas, we shall rarely find in this tedious Salon" (quoted in George Heard Hamilton, *Manet and His Critics,* New York, 1969, p. 216-217).

In the entry for Manet's *Woman with a Parrot* (no. 19), it is noted that the horizontal floor plane merges with the vertical of the background, resulting in a flattening of the picture space and a tendency for everything to come forward toward the picture plane. In *Boating* a similar effect is achieved by the surface of the water, which rises from the left foreground to the top of the picture,

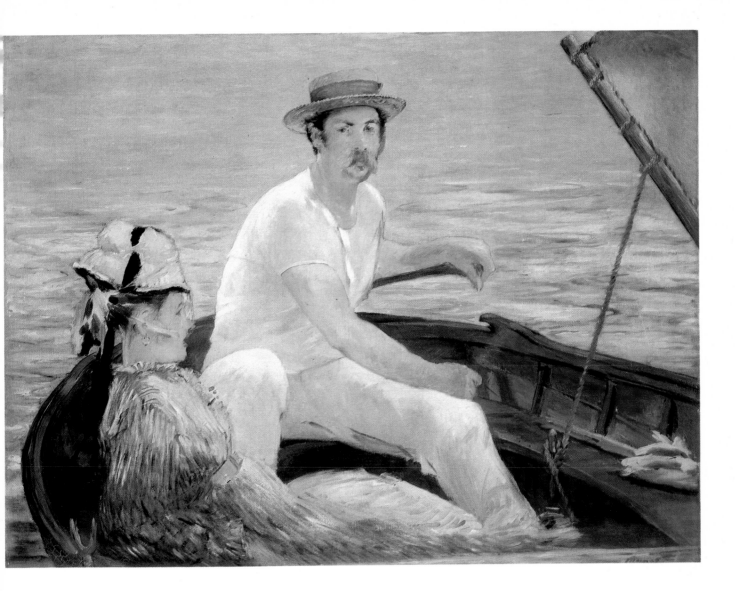

entirely masking the composition from behind. The more tentative spatial treatment of *Woman with a Parrot* is replaced here by authority and clarity of purpose : note, for example, the rope extending from the boom to the cleat at the right side of the painting. Pentimenti and X'rays reveal that originally the man at the tiller (probably Manet's brother-in-law, the Dutch painter Rodolphe Leenhoff) held the rope in his right hand; by altering the direction of the rope Manet removed a cue to logical perspective and thereby further emphasized the flatness of the picture space.

Although *Boating* is a thoroughly Impressionist picture and bears the influence of Monet and Renoir, Manet chose to exhibit it in the Salon of 1879, not in an Impressionist exhibition. Evidently he hoped instead for the official recognition and cachet that would result from being accepted by the Salon jury.

C.S.M.

Provenance

Victor Desfossés, Paris (acquired at the Salon of 1879, still in his possession in 1889); Durand-Ruel, Paris; H. O. Havemeyer, New York (before 1902 [?]); Mrs. H.O. Havemeyer, New York (1907-1929).

Exhibitions

1879 Paris, Salon, no. 2011
1884 Paris, Ecole des Beaux-Arts, *Exposition des œuvres d'Edouard Manet*, no. 76.
1889 Paris, *Exposition centennale de l'art français*, no. 498
1913 New York, Durand-Ruel, *Loan Exhibition of Paintings by Edouard Manet*, no. 13
1933 Philadelphia, Pennsylvania Museum of Art, *Manet and Renoir (Pennsylvania Museum Bulletin*, XXIX, 1933, p. 17)
1966-1967 Philadelphia Museum of Art and of Chicago Art Institute, *Edouard Manet*, no. 125

Selected Bibliography

P. Jamot, G. Wildenstein, M.L. Bataille, *Manet*, Paris, 1932, I, p. 149, no. 244, II, pl. 87, fig. 176;
L. Gonse, "Manet" *Gazette des Beaux-Arts*, 1884, p. 146;
J. Lethève, *Impressionnistes et symbolistes devant la presse*, Paris, 1959, p. 105;
A.C. Hanson, *Edouard Manet*, exhibition catalogue, Philadelphia Museum of Art and Art Institute of Chicago, 1966-67, p. 142-143, no. 125, fig. 125, and detail;
C. Sterling and M.M. Salinger, *French Paintings, a Catalogue of the Collection of the Metropolitan Museum of Art*, New York, 1967, III, p. 45-47, ill.;
J. Mathey, *Graphisme de Manet*, Paris, I, 1961, p. 33, no. 135, fig. 135 (calls this ink drawing a study for *Boating*);
A. de Leiris, *The Drawings of Edouard Manet*, Berkeley and Los Angeles, 1969, p. 125, no. 429 (disputes Mathey no. 135, relates to *Boating* another drawing, ill. in E. Waldmann, *Edouard Manet*, Berlin, 1923, p. 89).
D. Stang, verbally, 1972, observes that the man's right hand originally held the sheet and that a faint trace of this position is still evident on the water and on the boat;
J. Rewald, *The History of Impressionism*, New York, 1973, ill. p. 360.

Edouard Manet

The Père Lathuile Restaurant

Signed, lower left : *Manet, 1879*
Oil on canvas
H. $36\frac{1}{4}$, w. $44\frac{1}{8}$ in.
 (92.1 × 112.1 cm.)

Musée des Beaux-Arts
 Tournai, Belgium

Le Père Lathuile was a restaurant Manet visited occasionally on the Avenue de Clichy near the Café Guerbois. The restaurant's sign is clearly visible in a well-known lithograph[1] of the period reproducing Horace Vernet's *Marshall Moncey at the Clichy Tollgate* of 1814 (see Charles Sterling and Hélène Adhémar, *Musée National du Louvre, peinture, école française XIXe siècle*, Paris, 1958-61, IV, no. 1976); the publicity no doubt benefited the café. In 1879 Manet decided to paint the owner's son, Louis Gauthier-Lathuile, in a cavalry uniform and seated with the actress Ellen André. After a few sittings, Manet changed his mind and painted the young man in civilian clothes, probably to avoid inviting comparison with the genre subjects of Roybet and Meissonier. In addition to the costume change, Ellen André was replaced by Judith French, a relative of the composer Jacques Offenbach.

For a long time Manet was not entirely persuaded by the avant-garde experiments of his young Impressionist friends, especially those who gathered at the Café Guerbois and who had adopted him, somewhat against his will, as their leader. But by 1874 he had fully accepted the Impressionist idiom and given up dark brown shadows for open-air painting. In *The Père Lathuile Restaurant* the lighting is soft overall and the shadows are bluish or pink; the brushstrokes are quick, light, and visible. Manet, however, remains faithful to certain of his stylistic characteristics : asymmetry, crowding, elusive perspective, and no sky.

The alliance, sometimes difficult, between Manet and the Impressionists, of which this picture is a characteristic example, resulted in renewed sharp critical attacks at about the time the public was adjusting to his earlier style. When Manet exhibited *The Père Lathuile Restaurant* beside his portrait of Antonin Proust in the Salon of 1880, the latter, which is closer to his earlier style, gave the critics a pretext to attack the former. Paul Mantz wrote :

[1] H. de Balzac mentions this print as hanging in a dining room in a hotel in Provins in his *Pierrette.*

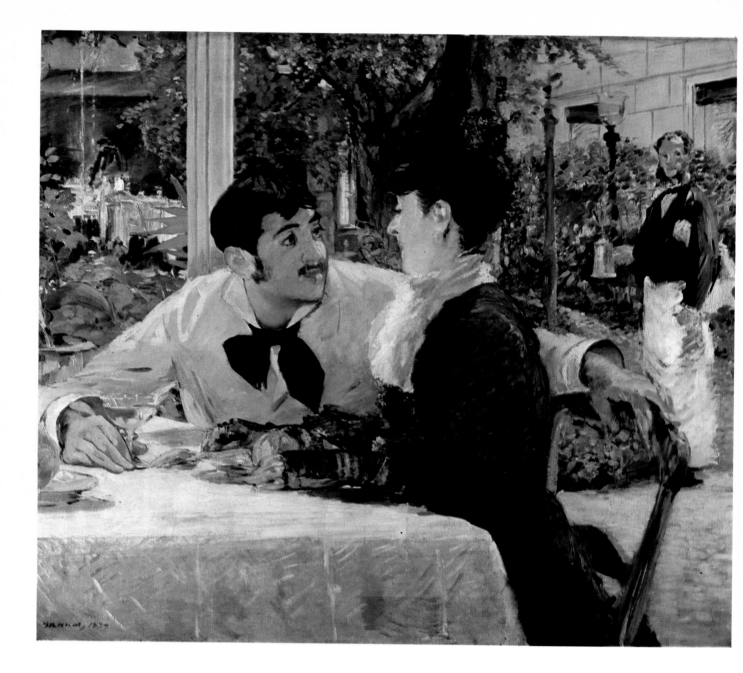

"Taking shelter behind his portrait of M. Proust, M. Manet suddenly unleashed his devices on us and offered us a plein-air scene of the most worrisome variety... for reasons not explained, the young man has blue hair. The young woman has no idea how inelegant she is... let us forget this nightmare." Four years later, when the picture was shown in a memorial exhibition for Manet, Josépin Péladan, the future Rosicrucian, also objected : "The luncheon at Père Lathuile's has some air in it; the distance between the background and the table is approximately correct, but it is impossible to accept that the young man's tie is as important as the woman's complexion; this tie clashes against the pale pure colors as harshly as the famous red cap in the picture by Valentin in the museum in the Vatican" ("Manet's Methods," *L'Artiste*, February 1884, p. 114).

However, *The Père Lathuile Restaurant* was defended by Emile Zola and J.K. Huysmans (Huysmans was, at that time, best known as the novelist who had lionized Gustave Moreau in his *A Rebours*.) In fact, Huysmans eloquently defended his preference of *The Père Lathuile Restaurant* to the portrait of Antonin Proust : "The young man and woman are superb. This canvas catches the eye because it is so clear and bright; it shines among all these official paintings which turn rancid as soon as one sees them. This is the modernism that I have spoken about ! People eating lunch in real light, in the open air... life shown as it is, without exaggeration" (*La Réforme*, July 1, 1880, reprinted in *L'Art Moderne*, Paris, 1883, p. 155-156).

M.H.

Provenance

(1879-80, Gauthier-Lathuile refused to buy this picture from Manet); in Manet's estate sale, February 4-5; 1884, no. 6; collection of Théodore Duret (in Duret sale, Paris, March 19, 1894, no. 257); Von Cutsen Collection; bequeathed by Von Cutsen to Guillaume Charlier; bequeathed by Charlier to the Musée des Beaux-Arts, Tournai.

Exhibitions

1880 Paris, Salon, no. 2451
1880 Ghent, *Triennial Exhibition*, no. 571
1884 Paris, Ecole des Beaux-Arts, *Manet*, no. 94
1895 Paris, Durand-Ruel Gallery, *Manet*, no. 10
1922 Brussels, Musée Royal des Beaux-Arts de Belgique, *Exposition d'Art Français*, no. 22

1932 London, *Exhibition of French Art*, no. 417
1932 Paris, Orangerie des Tuileries, *Manet*, no. 69
1937 Paris, *Chefs-d'Œuvre de l'Art Français*, no. 361
1964 Munich and Lisbon, *From Delacroix to Cézanne*

Selected Bibliography

P. Jamot, G. Wildenstein, and M.L. Bataille, *Manet*, I, Paris, 1932, no. 325, p. 160, and II, no. 190 (illus.), with a bibliography through the date of publication to which the following should be added :
E. Zola, *Le Voltaire*, 1880;
J. Péladan, "Le procédé de Manet," *L'Artiste*, February 1884,

T. Duret, *Histoire d'Edouard Manet*, Paris, 1906, p. 220-221;
M. Deri, *Die Mene Malerei*, Leipzig, 1921, p. 11;
J.E. Blanche, *Propos de Peintre, de David à Delacroix*, Paris, 1927, p. 145;
P. Collin, *Manet*, Paris, 1932, p. 51;
A. Tabarant, *Manet et ses œuvres*, Paris, 1947, p. 317 (illus.), 352-353, 380-381;
L'Amour de l'Art, June 1947, illus.;
J. Rewald, *Histoire de l'Impressionnisme*, Paris, 1955, p. 100;
M. Bodelsen, "Early Impressionist Sales 18/4-1894 in the light of some unpublished procès-verbaux," *Burlington Magazine*, June 1968, p. 331-351;
D. Rouart and S. Orienti, *Tout l'œuvre peint de Manet*, Paris, 1970, p. 110, no. 217, color pl. XL-XLI;
Catalogue du Musée de Tournai, 1971, pl. 18.

Claude Monet

Study for *Déjeuner sur l'herbe*

Signed and dated, lower left :
 Claude Monet 66
Oil on canvas
H. 51¼, w. 73 in. (130 × 181 cm.)

Pushkin Museum of Fine Arts
 Moscow
Inv. no. 3307; acquired 1918

This is a highly finished sketch for the largest and most important painting of Monet's early period. It is especially interesting in that the final version was left unfinished and now survives in two fragments : one that includes the three standing figures at the left (Musée du Louvre, Galerie du Jeu de Paume, R.F. 1957-7, oil on canvas, H. 13 ft. 6 in., w. 4 ft. 11 in. [418 × 150 cm.]) and one showing the central part of the original composition (Eknayan Collection, Paris, oil on canvas, H. 8 ft. 2½ in, w. 7 ft. 1½ in. [248 × 217 cm.]). The right-hand section is evidently lost. On the basis of the dimensions of the surviving fragments and the reduced proportions of the present study, we may conclude that the finished version measured about 14 ft. 10½ in. × 19 ft. 4½ in. (460 × 600 cm.) before it was cut apart. It could have competed in size with the largest pictures of the Salons, including the immense "machines" of Ingres, Delacroix, and Courbet. Monet may have intended *Déjeuner sur l'herbe* as a reply to Manet's painting of the same title that caused such furor at the Salon des Refusés of 1863. Possibly Monet wished to accomplish what Zola had called — apropos of Manet — "the dream of every painter : to put life-size figures into a landscape" (E. Zola, "Edouard Manet," *Revue du XIXᵉ Siècle,* January 1, 1867, reprinted in *Mes Haines, Œuvres complètes,* Paris, 1928; see also *Emile Zola — Salons,* edited and annotated by F. Hemmings and R.J. Niess, Paris and Geneva, 1969, p. 96).

Without waiting for the opening of the 1865 Salon, for which two of his seascapes had been accepted, Monet left Paris in early April for Chailly-en-Bière, a village on the edge of the Fontaine-bleau Forest he had visited several times before. His letters to Bazille, with whom he had been sharing a studio in Paris since the beginning of the year, record the development of *Déjeuner sur*

l'herbe (see G. Sarraute, "Contribution à l'étude du Déjeuner sur l'herbe de Monet," *Bulletin de Laboratoire du Musée du Louvre,* no. 3 [June 1958], p. 50-51). Despite letters from Monet pressing Bazille to come to pose for the picture, Bazille did not arrive in Chailly until late August, the date scheduled for the first sketches.[1] Monet painted studies of Bazille in the open air, and later wrote : "I worked the way everyone did at the time, by small studies from life, and I composed the whole picture in my studio" (Duc de Trévise, "Pélerinage à Giverny, II," *Revue de l'Art Ancien et Moderne* I [February 1927], p. 122). Only one of the resulting small, quick studies is known to have survived (The National Gallery of Art, Washington, D.C., Ailsa Bruce Mellon Collection, oil on canvas, H. $37\frac{1}{2}$, w. 27 in. [94 × 70 cm.]). Bazille is recognizable in this sketch of the two figures at the left; the other person is Camille, who married Monet in 1870. The two are almost identical to their counterparts in the Pushkin Museum's sketch, but they were significantly changed in the final composition (the Jeu de Paume fragment). The changes establish the Moscow picture as a preparatory study and not — as some authors have suggested in view of the 1866 date it bears — a reduced replica of the final composition.[2]

After these studies for individual parts of the composition, Monet determined its final form, realized in the Moscow sketch. Because Bazille appears at least four times (on the extreme left; in the center middle ground; lying on the right in the foreground; and standing against the tree), and because he is known to have left Chailly toward the end of September 1866, the Moscow study was probably finished at about the same time.

About mid-October Monet returned to Paris and started the full-scale picture. He worked on it through the winter and intended to submit it for the 1866 Salon. However, he changed his mind at the last moment and ultimately abandoned the final version; according to Gustave Geffroy, this was because of criticism by Courbet. Monet probably signed the Pushkin Museum's picture in 1866, at the time he put aside the full-scale version.

Excellent studies elsewhere treat Monet's transfer of the composition into a larger scale and the formal significance of his revisions. But his modification of the leftmost seated figure, whose face is turned full to the picture plane, warrants mention : he is young and clean-shaven in the Moscow sketch, but he is heavier, apparently older, and bearded in the final version. Hélène Adhé-

[1] By this time Monet had probably already roughly worked out the composition for *Déjeuner sur l'herbe;* he seems to have made separate studies for the landscape, without the figures. Two landscapes showing the Bas-Bréau road (Ordrupgaard Museum, Copenhagen, and Musée du Louvre, Galerie du Jeu de Paume, R.F. 1672) are strongly analogous to what can be considered the first idea for the composition : a drawing published in 1958 by G. Sarraute (see Selected Bibliography, the article by Sarraute, p. 48; the drawing is in the Collection of Mr. and Mrs. Paul Mellon, Upperville, Virginia : charcoal on blue-gray paper, H. 13, w. 6 in. [31 × 47 cm.]).

[2] G. Sarraute has published a charcoal study for the female figure in a gray dress; describing in detail the embroidery on the sleeves and the bodice (see G. Sarraute, "Deux dessins inédits de Monet," *Revue du Louvre,* 1962, no. 2, p. 91-92).

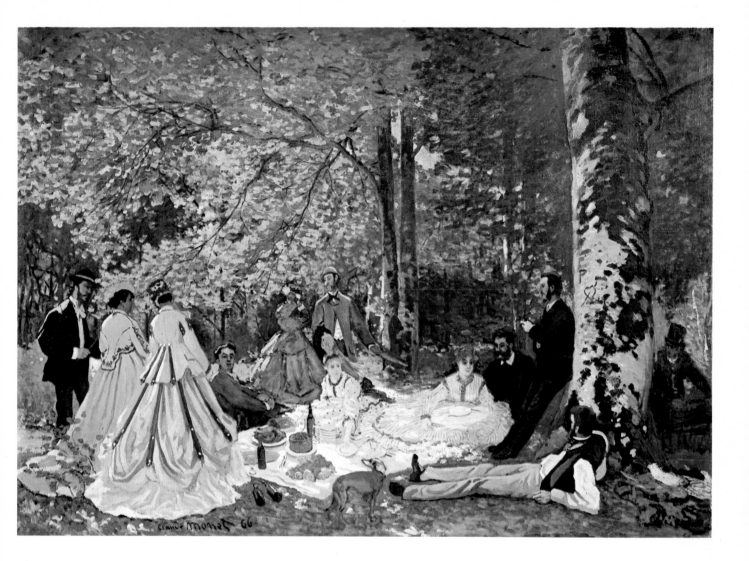

mar has noted his striking resemblance to Courbet. Perhaps Monet wished to tie Courbet to this statement of modernism, because he, as well as Manet, had had a decisive influence on Monet's artistic development.

A.D.

Provenance

Collection of Jean-Baptiste Faure, Paris; bought by Durand-Ruel February 12, 1901; Cassirer (dealer), Berlin, February 12, 1901; Sergei Shchukin Collection, Moscow (see J. Toughenhold, "La Collection Française de S. Schoutkine," *Apollon,* 1914, I-II, p. 8); appropriated in 1918 for the newly created Museum of Modern Western Painting; Museum of Modern Western Art, Moscow, 1928-1948; Pushkin Museum of Fine Arts, Moscow, 1948.

Exhibitions

1866-1867 Perhaps at the premises of the dealer Latouche (see John Rewald, *The History of Impressionism* [fourth edition], New York, 1973, p. 193, note 20; because of its smaller size, it was probably the Moscow sketch, rather than the final version of Monet's *Déjeuner sur l'herbe* that was shown at Latouche's gallery)

Selected Bibliography

J. Isaacson, *Monet, "Le Déjeuner sur l'herbe,"* New York, 1972 (see especially pages 18, 20-31, 59-66 vis-à-vis the Moscow sketch; there is also a critical bibliography; Isaacson also discusses a study for the full composition in an unpublished sketchbook in the Musée Marmottan [p. 24,100]);
G. Geffroy, *Claude Monet, sa vie, son temps, son œuvre,* I, Paris, 1924, p. 39-40, and II, p. 105 (Geffroy identifies the bearded figure in the final version as "Lambron, the painter of undertakers' assistants"; there is no known portrait of Lambron for comparison, however, and Geffroy's probable misidentification of the figure presumed to be Courbet in the final version likely stems from his assumption [knowledge?] that Lambron posed for the sketch.)
M. Elder, *A Giverny chez Claude Monet,* Paris, 1924, p. 27;
Duc de Trévise, "Le Pélerinage à Giverny II," *Revue de l'Art Ancien et Moderne,* LI (February 1927), p. 121-122;

R. Régamey, "La formation de Claude Monet," *Gazette des Beaux-Arts,* 1927 (I), p. 69, 76-78;
G. Poulain, *Bazille et ses amis,* Paris, 1932, p. 50-51, 56-57 (note 1), 58-59;
John Rewald, *The History of Impressionism* (fourth edition), New York, 1973, p. 119;
H. Adhémar, "Modifications apportées par Monet a son Déjeuner sur l'herbe de 1865 à 1866," *Bulletin du Laboratoire du Musée du Louvre,* no. 3 (June 1958), p. 37-45;
G. Sarraute, "Contribution à l'étude du Déjeuner sur l'herbe de Monet," *Bulletin du Laboratoire du Musée du Louvre,* no. 3 (June 1958), p. 46-51;
D. Rouart, "A propos des œuvres datées de Claude Monet," *Bulletin du Laboratoire du Musée du Louvre,* no. 4 (September 1959), p. 62-63;
W.C. Seitz, *Claude Monet,* New York, 1960, p. 66;
I. Sapego, *Claude Monet* [in French], Leningrad, 1969;
M. Roskill, "Early Impressionism and the fashion print," *Burlington Magazine* CXII/807 (June 1970), p. 392;
K.S. Champa, *Studies in Early Impressionism,* New Haven and London, 1973, p. 4-6, 7-8.

25 Claude Monet

Women in the Garden

About 1866-67
Signed, lower right :
 Claude Monet
Oil on canvas
H. $100\frac{1}{2}$, w. $80\frac{3}{4}$ in.
 (255 × 205 cm.)

Musée du Louvre
 Galerie du Jeu de Paume
R.F. 2773, acquired in 1921

 With *Women in the Garden,* probably begun in the summer of 1866, Monet returned to the ambiance of *Déjeuner sur l'herbe* (see no. 24) : life-size figures in a landscape. For the earlier picture Monet followed traditional working methods : reduced sketches and studies followed by the full-scale execution of the definitive composition in the studio, although study of the subject had, up to this point, taken place in the open air.

 However, for *Women in the Garden* Monet decided to paint outdoors directly from the subject, a difficult undertaking in view of the large dimensions of the picture. He devised a trench in the garden into which he could lower the picture in order to work on the upper part. He hoped to avoid thereby the difficulties that caused the failure of his *Déjeuner sur l'herbe* and to assure a logically consistent composition. As in the earlier work Camille posed successively for the four female figures; indeed, the seated figure shaded by a parasol wears the same dress as the leftmost woman in the Pushkin Museum's sketch for *Déjeuner sur l'herbe.* The striped and spotted dresses are also quite similar in the two pictures; Monet probably also used the sketches and drawings made for *Déjeuner sur l'herbe* for *Women in the Garden.*

 In 1937 G. Poulain published two photographs taken on the Bazille estate near Montpellier showing Bazille's young cousins in positions similar to those in *Women in the Garden* (see Selected Bibliography). The article argues that from its inception *Women in the Garden* was intended for Bazille, who, according to Poulain, had shown the photographs to Monet to use for the painting. This suggestion has been generally rejected in favor of another : the influence of contemporary fashion illustrations, a possibility advanced by Mark Roskill in 1970 (see Selected Bibliography). In fact, earlier studies had often pointed out the isolation and stiffness of the individual figures. The compositional practices of contem-

porary fashion illustration may explain these peculiarities. A well-known example lends support to the argument: about 1871 Cézanne copied the same kind of illustrations. While they provided factual information about contemporary fashion, their linear and decorative qualities suited Monet's wish to simplify modeling and compress the picture space. Like the often-cited influence of Japanese prints, fashion illustrations are no doubt only one of several influences on Monet's style.

We learn in a letter from Dubourg to Boudin, dated February 2, 1867 (see G. Jean-Aubry, *Eugène Boudin*, Paris, 1922, p. 64), that Monet left Ville d'Avray in the fall of 1866 and took the enormous, unfinished *Women in the Garden* to Le Havre : "Monet is always around, working on huge canvases, in which there are some admittedly fine points, but which I believe are below his usual standard, or at least less successful than his famous *Robe* [*Camille*, 1866, exhibited in the Salon of 1866, now in the Kunsthalle, Bremen], which was understandably and deservedly a success. He is working on a picture ten feet high and with a proportionate width : the figures are slightly less than life size — they are elegantly dressed women gathering flowers in a garden — and he started the picture from life on the spot..." *Women in the Garden* must have been finished by the spring when it was submitted to the Salon jury.

The looseness of execution, the crisp contours of the radiant silhouettes, almost without volume, combined with the relative flatness of the garden foliage, were apparently the reasons for the rejection of *Women in the Garden* by the Salon jury in 1867. Even Manet (according to G. Geffroy's much later and possibly erroneous account) is said to have criticized the picture. In any case Zola wrote : "I have seen some strikingly original work by Claude Monet. Last year a picture of his was rejected : a figure piece — women in light summer dresses picking flowers along the paths of a garden; the sun falls directly on their brilliant white skirts; the tree casts warm shadows like textile patterns on the path and across the brilliant white dresses. The result is quite singular. To dare to do something like that — to cut in two the material of the dresses with light and shade and to rightly place these women in a carefully kept flower garden — one must have a particular fondness for one's period."

A.D.

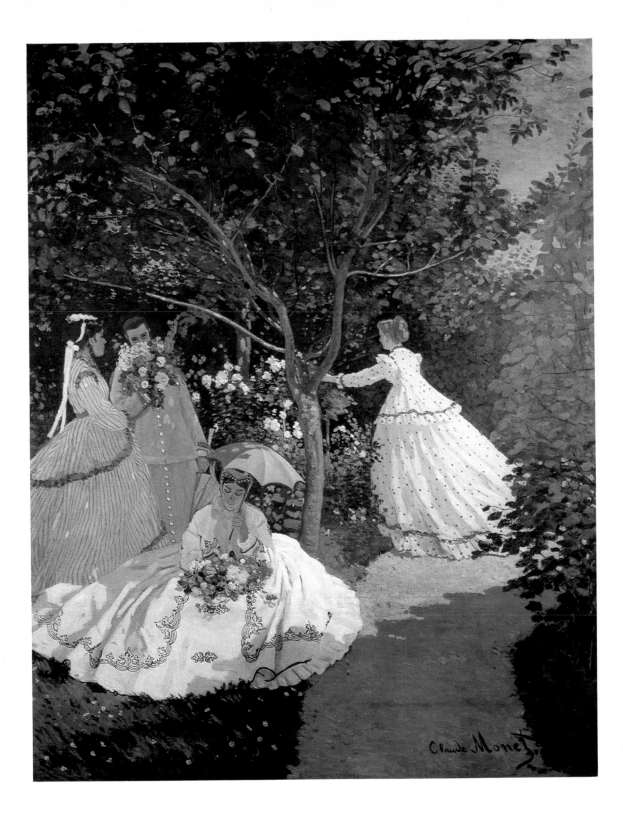

Provenance

Painted for Bazille, who acquired it in 1867 for 2500 francs and paid in monthly installments of 50 francs (see Duc de Trévise, "Le Pèlerinage de Giverny II," *Revue de l'Art Ancien et Moderne*, LI [February 1927], p. 121-123, mentioning the sum 100 francs while other authors, including G. Poulain, *Bazille et ses amis*, Paris, 1932, p. 72, indicate 50 francs a month); remained in Bazille's family after his death, 1870; Bazille's father exchanged it for a *Portrait of Bazille* by Renoir, 1876 (the portrait is now in the Musée du Louvre, Galerie du Jeu de Paume, R.F. 2448), which Manet owned — later, during a momentary quarrel with Monet, Manet returned *Women in the Garden* to Monet in exchange for one of his own pictures; acquired from Monet by the French government in 1921 for 200,000 francs.

Exhibitions

1867 Refused for the Salon of 1867, but possibly exhibited at the premises of the dealer Latouche, where Manet, among others, may have seen and criticized it (concerning the different views about this see John Rewald, *The History of Impressionism* [fourth edition], New York, 1973, p. 193, note 20)

1924 Paris, Galerie Georges Petit, January 4-18, *Claude Monet*

Selected Bibliography

E. Zola, "Mon Salon IV, les Actualistes," *L'Evénement Illustré*, May 24, 1868 (reprinted in L. Venturi, *Les Archives de l'Impressionnisme*, II, Paris and New York, 1939, p. 275);
A. Alexandre, *Claude Monet*, Paris, 1921, p. 47;
G. Geffroy, *Claude Monet*, I, Paris, [edition of 1924], p. 47-49, 107 (he notes wrongly that *Women in the Garden* was painted in Argenteuil);
R. Régamey, "La Formation de Claude Monet," *Gazette des Beaux-Arts*, 1927 (no. 1), p. 70, 78;
G. Poulain, *Bazille et ses amis*, Paris, 1932, p. 72-73, 81, 101 (note 1);
G. Poulain, "L'Origine des femmes au jardin de Claude Monet," *Amour de l'Art*, 18 (March 1937), p. 89-92;
O. Reuterswärd, *Monet*, Stockholm, 1948, p. 36, 118;
G. Bazin, *Trésors de l'Impressionnisme au Louvre*, Paris, 1958, p. 100;
H. Adhémar in *Musée du Louvre, catalogue des peintures, pastels, sculptures impressionnistes*, Paris, 1958, no. 228;
W.C. Seitz, *Claude Monet*, New York, 1960, p. 70;
M. Roskill, "Early Impressionism and the fashion print," *Burlington Magazine*, CXII, no. 807 (June 1970), p. 391;
A. Boime, *The Academy and French Painting in the XIX Century*, London, 1971, p. 64;
J. Isaacson, *Monet, "Le Déjeuner sur l'herbe,"* New York, 1972, p. 24, 50, 57, 80-88, 112-113 (notes 92-93);
K.S. Champa, *Studies in Early Impressionism*, New Haven and London, 1973, p. 10-14 (draws attention to an unfinished sketch partly painted over by a *Jeune garçon nu* by Bazille in a French private collection; see Champa's fig. 14);
John Rewald, *The History of Impressionism* [fourth edition], New York, 1973, p. 150, 166-168, 193 (note 20).

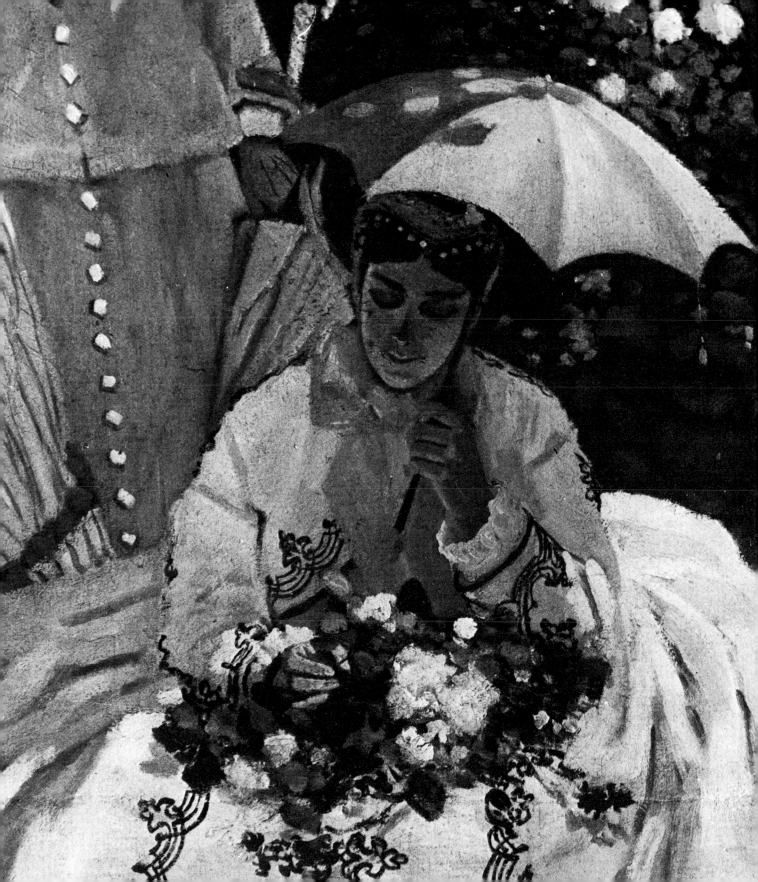

26 Claude Monet

Terrace at Sainte-Adresse

About 1866-1867
Signed, lower right :
Claude Monet
Oil on canvas
H. 38⅝, w. 51⅛ in.
 (98.1 × 129.7 cm.)

The Metropolitan Museum.
 of Art, Purchase, 1967,
 with special contributions
 and purchase funds
 given or bequeathed by friends
 of the Museum, 67.241

Two years before painting *Terrace at Sainte-Adresse*, Monet wrote : "I am thinking up terrific things for myself when I go to Sainte-Adresse..." (quoted in Linda Nochlin, *Impressionism and Post-Impressionism 1874-1904, Sources and Documents*, Englewood Cliffs, 1966, p. 31). Indeed *Terrace at Sainte-Adresse* is a "terrific thing"; it is the first of Monet's paintings to effectively realize many of the goals of Impressionism.

As in Whistler's *Courbet at Trouville* of 1865 (Isabella Stewart Gardner Museum, Boston), Monet has taken a high point of view in order to look down into and across a scene. The result is an emphasis on foreground and middle ground, causing a reduction in the amount of visible sky (compare, for example, the entirely different make-up of Courbet's *The Calm Sea*, 1869, The Metropolitan Museum of Art, 29.100.566), and a tendency for the ground plane to tilt toward the picture plane.

The compressed picture space caused by the vantage point is brought to further effect by an emphasis on the flattening rather than the modeling power of light, a process characterized in the context of *Women in a Garden* (no. 25) by Kermit Champa as the "counterpoint of flat shapes and brilliant colors" (Kermit S. Champa, *Studies in Early Impressionism*, New Haven and London, 1973, p. 13). The "counterpoint" of *Terrace at Sainte-Adresse* depends on a twofold use of color, described by Champa while discussing Monet's *Fishing Boats* of mid-1865 (The Hillstead Museum, Farmington) : "Relying on precedents recently discovered in Japanese prints, he juxtaposed flat areas of color and tone to evoke a particular character of light and atmosphere and to define the specifics of the subject as well. Monet relies on the oppositions of both graded and contrasting colors to generate the particular impact he desires. In this way he departs from the more tonal orientation

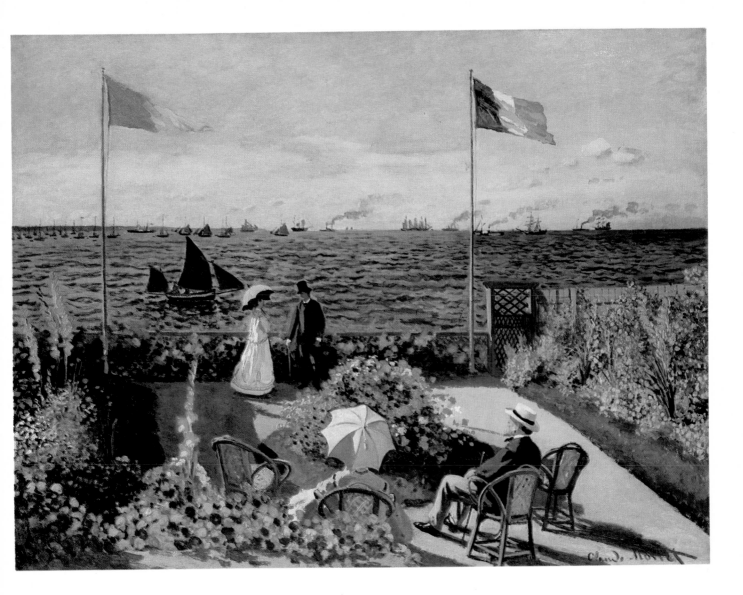

of contemporary works by Manet, with their emphasis on contrasts of paint texture and color value" (Champa, p. 3).

The simplifications in form throughout *Terrace at Sainte-Adresse* are dictated by the need to translate visual sensations into exaggerated optical effects. Monet had, as Champa notes, begun to move in this direction during the previous year : "He pushes colors to intensities which the scene itself would only have suggested" (Champa, p. 5). Exaggerations in color, form, and spatial composition are made for purely aesthetic reasons, with the result that everything in the painting appears closer than normal to the picture plane. Thus the red poppies, the umbrellas, the flags, and the horizon line seem to be on or near the picture surface. Remarks by Champa about Monet's *Women in a Garden* are equally applicable here : "The complete picture stands as a brilliant demonstration of the flattening rather than the modeling quality of intense natural light as it defines forms of various sorts. It is this quality which Monet chooses to develop in the absence of volume and space definition" (Champa, p. 11).

Although *Terrace at Sainte-Adresse* depicts a specific time of day, time of year, and place (John Rewald, *The History of Impressionism,* New York, 1973, p. 153, identifies the site as the property of the artist's family, and the figure in the right foreground as Monet's father), Monet has obviously already begun to pursue the formal pictorial interests, inextricably tied to color and light, that increasingly occupied his attention. The advanced character of the picture is underscored by its similarities to Cézanne's many versions of *The Bay of Marseilles Seen from l'Estaque* (e.g., no. 8), the earliest example of which dates from about ten years after *Terrace at Sainte-Adresse.* Furthermore, the use of a similar clear, flattening light is one of the reasons for Pissarro's success in *Jallais Hill, Pontoise* (no. 33) of 1868.

C.S.M.

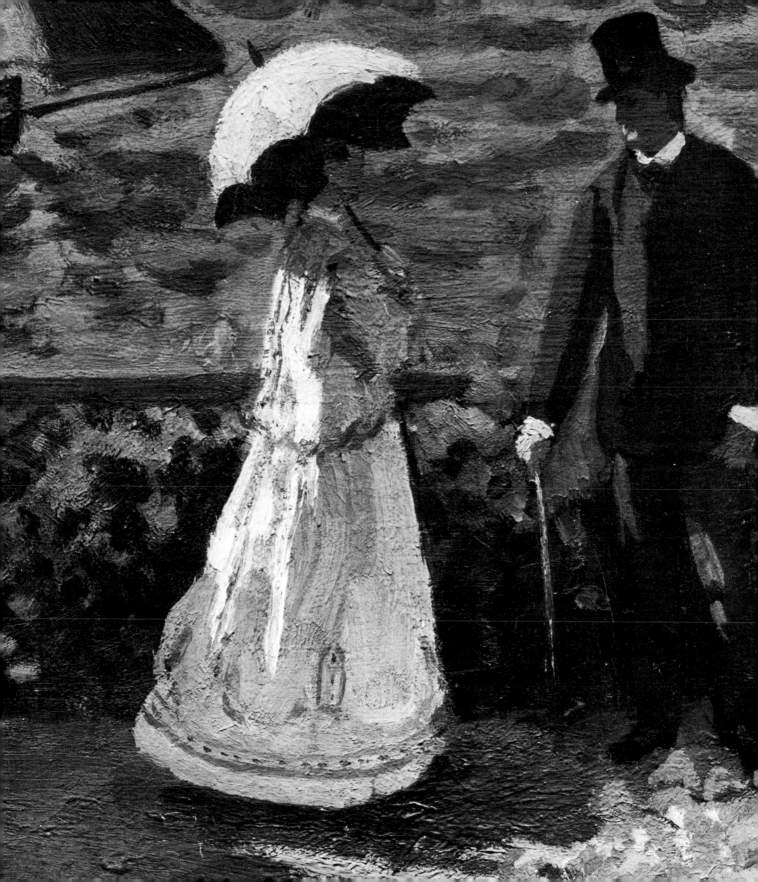

Provenance

Victor Frat (bought from the artist for 400 francs about 1868); Mme. Veuve Frat, Montpellier (sold to Durand-Ruel for 27,000 francs in 1913); Durand-Ruel, Paris and New York, 1913-1926; Reverend and Mrs. Theodore Pitcaim, Bryn Athyn, Pennsylvania (bought for $ 11,000 in 1926; sale, London, Christie's, Dec. 1, 1967, no. 26, to Agnew for £ 588,000).

Exhibitions

1879 Paris, 28, avenue de l'Opéra, *La Quatrième exposition de peinture*, no. 157 (as *Jardin à Sainte Adresse*, 1867, lent by M. Frat)
1914 New York, Durand-Ruel, March 7-21, no. 1 (see sale catalogue, Christie's, London, Dec. 1, 1967)
1915 San Francisco, *Panama-Pacific International Exposition, Department of Fine Arts*, I, p. 204, no. 2811, ill. opp. p. 186
1940 New York, World's Fair, *Masterpieces of Art, 1500-1900*, no. 321
1945 New York, Wildenstein, *Claude Monet*, no. 6
1952 Zurich, Kunsthaus, *Claude Monet*, no. 8
1952 Paris, Wildenstein, *Claude Monet*, no. 6
1952 The Hague, Gemeentemuseum, *Claude Monet*, no. 7
1955 Paris, Orangerie des Tuileries, *Chefs-d'œuvre des collections américaines*, no. 40
1960 New York, Museum of Modern Art, *Claude Monet, Seasons and Moments*, no. 2

Selected Bibliography

R. Koechlin, "Claude Monet," *Art et décoration*, LI, February 1927, p. 36;
R. Régamey, "La Formation de Claude Monet," *Gazette des Beaux-Arts*, 1927, p. 70, 78-79;
J. Rewald, "Monet Serves his Home Village," *Art News*, XLIV, May 1945, p. 20-21, ill., and *The History of Impressionism*, New York, 1946, p. 134-135, ill.;
J. Richardson, *Claude Monet*, exhibition catalogue, Arts Council of Great Britain, Tate Gallery, London, and Royal Scottish Academy, Edinburgh, 1957, p. 20;
W. Seitz, *Claude Monet*, New York, 1960, p. 72-73, ill. in color;
R. Cogniat, *Monet and his World*, London, 1966, p. 7-8, ill.;
R. Gimpel, *Diary of an Art Dealer*, New York, 1966, p. 152;
C.M. Mount, *Monet*, New York, 1966, p. 143, 405, 407;
Catalogue of La Terrasse à Sainte Adresse by Claude Monet..., sale, Christie, Manson & Woods, London, Dec. 1, 1967, ill. in color;
M.M. Salinger, "Windows Open to Nature," *Metropolitan Museum of Art Bulletin*, n.s., XXVII, Summer 1968, p. 3, ill. opp. p. 1, color detail on cover;
D. Sutton, *Claude Monet, the Early Years*, exhibition catalogue, Lefevre Gallery, London, 1969, p. 12, ill.;
D. Cooper, "The Monets in the Metropolitan Museum," *Metropolitan Museum Journal* 3, 1970, p. 281, 284-285, 300, 302, 305, fig. 4;
K.S. Champa, *Studies in Early Impressionism*, New Haven and London, 1973, p. 13-15, 17, 18, 20, 30, pl. 5;
E. Fahy and F. Watson, *The Wrightsman Collection*, V, 1973, p. 144;
J. Rewald, *The History of Impressionism*, New York, 1973, p. 152-153, ill.

27

Claude Monet

La Grenouillère

1869
Signed lower right :
Claude Monet
Oil on canvas
H. 29$\frac{3}{8}$, w. 39$\frac{1}{4}$ in.
(74.6 × 99.7 cm.)

The H.O. Havemeyer Collection
Bequest of Mrs. H.O.
Havemeyer, 1929
The Metropolitan Museum
of Art 29.100.112

During the time that *La Grenouillère* was painted, Monet and Renoir were living near one another in Saint-Michel, not far from Bougival. They often visited La Grenouillère, a boat-rental and swimming spot with a café on a covered raft floating in the Seine. On September 25, 1869, Monet wrote to Bazille : "I do have a dream, a painting, the baths of La Grenouillère for which I've done a few bad rough sketches, but it is a dream. Renoir, who has just spent two months here, also wants to do this painting" (quoted in Linda Nochlin, *Impressionism and Post-Impressionism 1874-1904, Sources and Documents,* Englewood Cliffs, 1966, p. 33).

Kermit Champa notes that there are actually six known examples of the subject, separable into three pairs of one picture by each artist (Champa, *Studies in Early Impressionism,* New Haven and London, 1973, p. 63-66). Champa identifies the Metropolitan's Monet and Stockholm's Renoir as the second of the three pairs and underscores their importance : "The two pairs of paintings of identical views by both artists are clearly the most important and climactic efforts of the campaign..." (Champa, p. 63). Nochlin, too, emphasizes their significance : "At this point, often considered crucial for the emergence of impressionist formal qualities *per se,* the styles of Monet and Renoir were almost indistinguishable" (Nochlin, p. 33, note 8).

Pursuing interests earlier defined in *Terrace at Sainte-Adresse* (no. 26) and *Women in a Garden* (no. 25), Monet continued to underplay the capacity of color to model form and define space in *La Grenouillère*. The tension caused by the ambiguity of representational and formal concerns results from a delicate balance of the *what* and the *how* of the painting. Monet concentrates on repetitive elements — the ripples in the water, foliage, boats, and the human figure — to weave a fabric of brushstrokes which, although emphatically brushstrokes, retain a strong descriptive

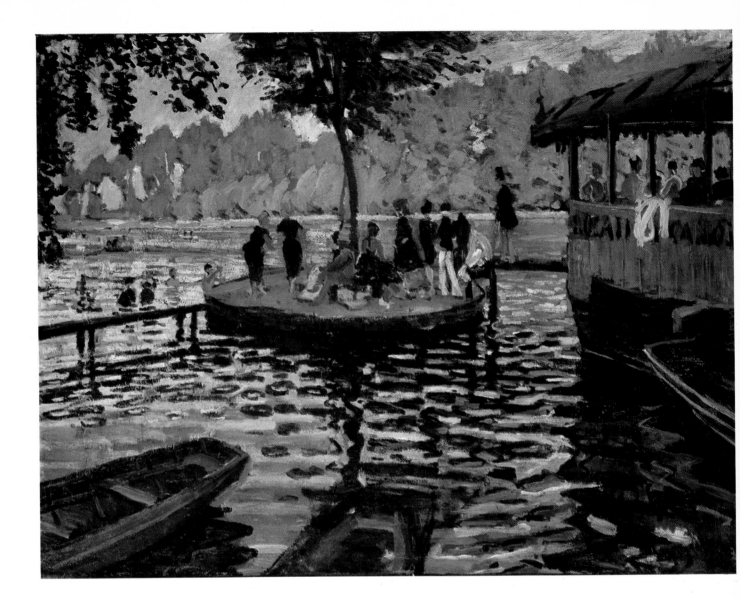

capacity. However, close inspection of certain details — the figures in the water farthest to the left, the foliage, or the reflections and ripples in the water — reveals that the brushstroke is sometimes nearly "detached" or almost free of a descriptive function. There is clearly a tendency toward abstraction within a framework that is still representational.

The New York Monet and the Stockholm Renoir show how differently the same scene could be perceived and interpreted. Inevitably this raises the question of the relation of Realism to Impressionism. If Impressionism was basically a naturalistic record of the sensation of light, we must either place Renoir and Monet, in 1869, outside of traditional ideas about Impressionism, or current ideas must be rethought.

In discussing the similarities and differences in Renoir's and Monet's treatments of La Grenouillère, Champa writes that "...the question of color looms as a basic and irreconcilable issue," and raises the question of the Impressionist painter as a maker rather than an imitator of appearances : "It is not enough to say simply that the two painters perceived color differently at the time they sat painting side by side for the second two pairs of works at La Grenouillère. In actual fact each saw what he wanted to see or, more accurately, each made what he wanted from what he saw. Neither 'recorded' what he saw in a purely transcriptive sense. Seated side by side, each was aware of what the other was doing, and each certainly knew why he was proceeding as he was. Their respective paintings do not represent alternative views of the same natural spectacle" (Champa, p. 64).

The composition of *La Grenouillère* belongs to a type that Monet returned to throughout the seventies : a view beyond the near foreground and across the space of the middle ground that is blocked behind, usually by trees. The resulting structure permits the painter to concentrate on "the envelopment, the same light spread over everywhere" (Monet, October 7, 1890, quoted in Nochlin, p. 34) contained by the seemingly fortuitous composition. The continued occasional use of this formula suggests that Monet had already, in 1869 and before, begun to choose subjects according to the needs of his formal interests.

In 1869 Monet had decided not to exhibit in the Salon; *La Grenouillère* was probably painted at a time when he chose to worry no longer about satisfying the needs of a Salon jury. As Champa indicates, Monet's decision was of considerable importance : "Once

the Salon jury had forced (or left) Monet to go it alone, the breach between academic and avant-garde painting in France was complete. The avant-garde proceeded to develop along lines which it defined for itself" (Champa, p. 62). The ramifications of Monet's decision were reinforced two years later : "...Paul Durand-Ruel contracted to purchase and exhibit their [Monet's and Pissarro's] works. In other words, the owner of a private gallery seized the initiative in judging and marketing works of art, no longer relying on the Salon for authorization. Durand-Ruel took up the cause of the avant-garde as a commercial enterprise and, after a decade of financial uncertainty, proved the feasibility of that exclusive alliance between private galleries and the avant-garde which has continued to develop down to the present day" (Champa, p. 62).

C.S.M.

Provenance

Possibly Charles Ephrussi, Paris (in 1889); Durand-Ruel, Paris (until 1897); H.O. Havemeyer, New York (1897-1907); Mrs. H.O. Havemeyer, New York (1907-1929; cat., 1931, p. 152-153, ill.).

Exhibitions

1876 Paris, Galeries Durand-Ruel, 11, rue Le Peletier, *La 2ᵉ exposition de peinture*, (as *Les Bains de la Grenouillère*, possibly this version)

1889 Paris, Galerie Georges Petit, *Claude Monet, A. Rodin*, no. 9 (*La Grenouillère, Bougival*, 1869, lent by Charles Ephrussi, possibly this version)

1930 New York, Metropolitan Museum, *The H.O. Havemeyer Collection*, no. 82

1949 Manchester (N.H.), Currier Gallery of Art, *Monet and the Beginnings of Impressionism*, no. 38

1952 The Hague, Gemeentemuseum, *Claude Monet*, no. 14

1957 Edinburg, Royal Scottish Academy, and London, Tate Gallery, *Claude Monet*, no. 16

1970 New York, Wildenstein, *One Hundred Years of Impressionism, a Tribute to Durand-Ruel*, no. 7

Selected Bibliography

C. Sterling and M.M. Salinger, *French Paintings, a Catalogue of the Collection of the Metropolitan Museum of Art*, New York, 1967, III, p. 126-127, ill.;
D. Sutton, *Claude Monet, the Early Years*, exhibition catalogue, Lefevre Gallery, London, 1969, p. 12-13, ill.;
C.R. Baldwin, "The Salon of 1872," *Art News*, LXXI, May 1972, p. 21, ill.;
D. Cooper, "The Monets in the Metropolitan Museum," *Metropolitan Museum Journal* 3, 1970, p. 281, 282, 286-287, 302, 303, 304, 305, fig. 6;
K.S. Champa, *Studies in Early Impressionism*, New Haven and London, 1973, p. 63, 65-66;
J. Rewald, *The History of Impressionism*, New York, 1973, p. 227-230, ill.

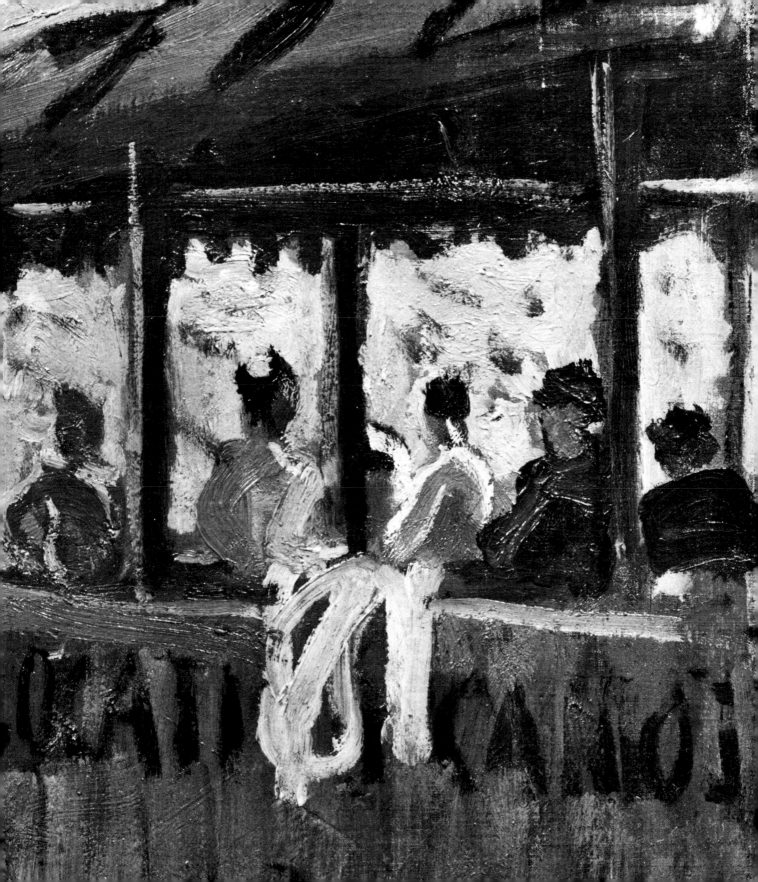

Impression

Signed and dated, lower left :
 Claude Monet, 72
Oil on canvas
H. 19$\frac{7}{8}$, w. 25$\frac{3}{4}$ in. (50.4 × 65.4 cm.)

Académie des Beaux-Arts
 Musée Marmottan, Paris
Bequest of Donop de Monchy
Inv. 4014

[1]Oil on canvas, h. 19$\frac{5}{8}$, w. 24 in. (50 × 61 cm.). The dimensions are close but not exactly the same. The painting proposed by Rewald was in the auction organized by the Impressionists and held at the Hôtel Drouot, March 24, 1875; it was no. 8 in the catalogue and titled *Sunrise (Seascape)* [*Soleil levant (Marine)*]. Rouart purchased it at the auction for 175 francs (see the official record of the sale as published by M. Bodelsen, p. 355, without commentary, in the article cited in the Selected Bibliography). The painting reappeared in the Henri Rouart sale (December 9-11, 1912, Paris) and was purchased by Durand-Ruel for 13,100 francs on behalf of the family in whose collection it remains today (see *Gazette de l'Hôtel Drouot,* no. 132 [December 10, 1912]). In the 1912 sale its title was *Morning in the Port of Le Havre (Matinée dans le Port du Havre);* in the preface to the sale catalogue Arsène Alexandre said simply, "...by Monet, he (Rouart) owned... various different kinds of landscapes, notably the *Boats in the Fog (Bateaux dans la brume)* which

The first Impressionist exhibition opened on April 15, 1874, at the studio of the photographer Nadar, at 34 Boulevard des Capucines. One of the pictures exhibited by Monet, no. 98 in the catalogue, was a canvas titled *Impression, Soleil Levant (Impression, Sunrise).* Using Monet's title, the critic Louis Leroy coined the term "Impressionist" in a review, "L'Exposition des Impressionnistes," which appeared in *Le Charivari* on April 25, 1874. Leroy could not have foreseen the ramifications of his choice of words, intended in fact to be derisive. In 1877 E. Littré included it in the supplement of his dictionary; *impressionniste* was officially accepted into the language.

The painting from the Musée Marmottan shown here has been traditionally identified as the work described in Leroy's article. The first author to specifically identify *Impression* with the first Impressionist exhibition seems to have been G. Geffroy in 1893 (see Selected Bibliography). Other earlier references, including Leroy's, are not specific; some authors mention a "soleil levant" (sunrise) and others refer to a "soleil couchant" (sunset). Students of Impressionism became more aware of the problem when, in 1955, at the suggestion of Daniel Wildenstein, John Rewald brought forward an overlooked painting in a private collection in Paris (see *History of Impressionism* [fourth edition], New York, 1973, p. 316, illus.). The picture identified by Rewald (Monet : *Impression, Sunrise* [Le Havre]) has the same date and nearly the same dimensions[1] as the Musée Marmottan painting; the subject, too, is nearly identical. This work will be designated here by the name of its first owner, Henri Rouart.

Rewald's thesis was considered and subsequently accepted by R. Niculescu (1966; see Selected Bibliography) and M. Bodelsen (1968; see Selected Bibliography). However, in a re-examination of the problem in 1970 (see Selected Bibliography), Niculescu

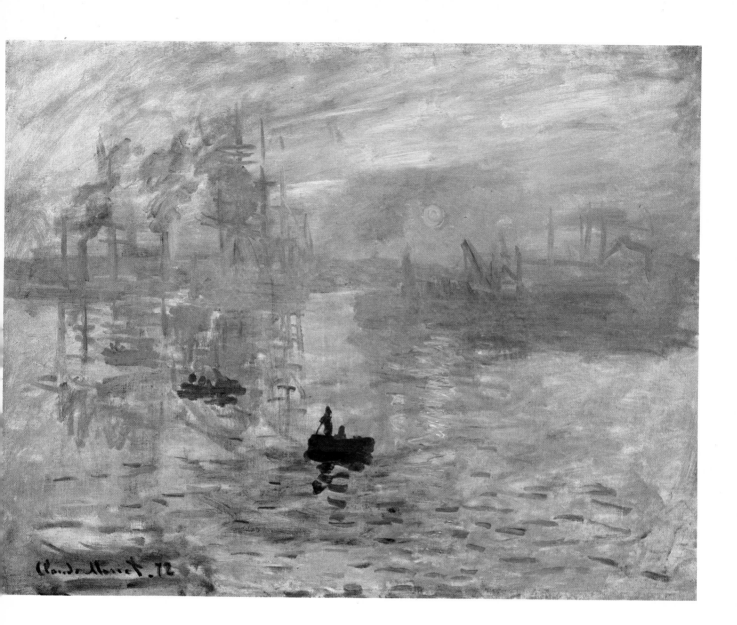

are the essence of Impressionism — its definition and accomplishment."

As John Rewald indicates (*The History of Impressionism*, New York, 1973, p. 339, note 23), this picture originally measured at least one and three-sixteenths inches more in height and width; in fact, the borders of the canvas are painted, and to the lower right there is even a signature, *Claude Monet*, painted in a blue harmonizing with the overall effect of the painting. The canvas was most likely made smaller by the artist himself, since he signed it a second time (in gray, lower left) to replace the signature that was no longer visible. The second signature was mentioned in the catalogue for the Rouart sale, 1912. The present dimensions are the same as those recorded in the catalogue of the sale (March 24, 1875) organized by the Impressionists themselves; if we can trust the 1875 sale catalogue, it is evident that Monet reduced the size of the picture before the sale.

returned to the traditional point of view; W.C. Seitz had already argued in favor of that position in 1960 (see Selected Bibliography). The articles by Bodelsen and Niculescu provide a detailed record of the provenance of both pictures. Recently most critics have simply affirmed the traditional identification in favor of the work in the present exhibition.

Firm and final identification of the picture in the 1874 exhibition will not be possible until further evidence is uncovered. However, as R. Niculescu notes, the article by Gustave Geffroy (1893) seems to justify a choice in favor of the Marmottan painting, because Geffroy knew Monet well and also knew the collector Georges de Bellio, the second owner of the picture (see Provenance); he also probably knew Henri Rouart and his collection. Rouart, in fact, belonged to the group that originated Impressionism and was himself a painter and one of the first admirers of Monet's work. If the Rouart picture was not the notorious Monet in the first Impressionist exhibition, it is unlikely that Geffroy, who was generally accurate in his facts, would have mistakenly identified it. Evidence from another source is also noteworthy : in 1906 Théodore Duret, one of the first critics to defend the Impressionists, cited the Marmottan picture as the work that was the basis of the movement's name.

Finally, several other sources must be mentioned. Paul Durand-Ruel, as quoted by Lionello Venturi (see Selected Bibliography), remembered a "seascape with setting sun." Claude Monet, according to Guillemot (see Selected Bibliography), said in reference to the title, "Just put *Impression*." The problem is perhaps traceable to the catalogue for the first Impressionist exhibition : Renoir's brother, Edmond, the editor for the catalogue-checklist, may have added *soleil levant* as a more accurate and detailed description, without noting that in the painting itself the sun seems to be setting, not rising.

A.D.

Provenance

Acquired by Hoschedé after the first Impressionist exhibition, but the details of the purchase are not known; *Vente judiciaire des Tableaux modernes et anciens... composant la Collection Hoschedé*, Paris, Hôtel Drouot, June 5-6, 1878, no. 55, titled *L'Impression, (soleil couchant)*; bought for 210 francs by Georges de Bellio; after de Bellio's death, January 26, 1894, the picture passed to M. and Mme. E. Donop de Monchy (Mme. E. Donop de Monchy was de Bellio's daughter), who in 1938 left it temporarily with the Musée Marmottan; to the Musée Marmottan in 1957 in the Donop de Monchy Bequest.

Exhibitions

1874 Paris, 35 Boulevard des Capucines (Nadar's studio), April 15-May 15, *Société anonyme des artistes peintres, sculpteurs, graveurs, etc., Exposition de 1874*, no. 98
1883 Paris, Durand-Ruel Gallery, March 1-25, *Claude Monet*, no. 40, titled *Impression* and in the collection of Georges de Bellio
1889 Paris, Galeries Georges Petit, *Monet - Rodin*, no. 16, titled *Impression, 1872* and noted as belonging to Georges de Bellio
1931 Paris, Galerie Rosenberg, May 18 - June 27, *Œuvres importantes de grands maîtres du XIXᵉ siècle*, no. 56
1937 Warsaw and Prague, *Peinture française de Manet à nos jours*, no. 20
1945 Paris, Wildenstein and Company, April 11 - May 12, *Claude Monet*
1952 Paris, Galerie des Beaux-Arts, *Claude Monet*, no. 25
1957 Paris, Musée Jacquemart-André, *Le Second Empire, de Winterhalter à Renoir*, no. 212
1958 Stockholm, Nationalmuseum, *Fem Seklet Fransk Konst*, no. 155
1970 Paris, Durand-Ruel Gallery, January 24 - February 28, *Claude Monet*, no. 7
1973 Tokyo, Kyoto, and Fukuoka, March 30 - July 29, *Claude Monet*, no. 6

Selected Bibliography

L. Leroy, "L'Exposition des impressionnistes," *Le Charivari*, April 25, 1874, p. 80 :
"... What is the subject of this painting ? Check the booklet."
"— *Impression, Sunrise*."
"— *Impression*, I was sure of it. I was just saying to myself that, since I was impressed, there had to be some impression in the picture... and what freedom, what ease in the workmanship! Wallpaper in its formative state is more finished than this seascape !" (Leroy's article is reprinted, with some deletions, in John Rewald, *The History of Impressionism* [fourth edition], New York, 1973, p. 318-320.)

J. Castagnary, "Exposition du Boulevard des Capucines — Les Impressionnistes," *Le Siècle*, April 29, 1874, p. 3 : "...They are *impressionists* in the sense that they paint not landscapes but rather the sensation produced by the landscape. The word itself [i.e., impression] has entered their vocabulary; it is not a landscape but instead an impression that one calls the *Sunrise* by M. Monet..."

M. de Montifaud, "Exposition du Boulevard des Capucines," *L'Artiste*, May 1874, p. 308-309 : "...the impression of a *Sunrise* has been dealt with by the immature hand of a schoolboy who spreads pigment for the first time across whatever surface."

E. Chesneau, "A côté du Salon, II, Le Plein Air, Exposition du Boulevard des Capucines," *Paris-Journal*, May 7, 1874, p. 2 : "...I hardly even stopped in front of *Impression* (Sunrise on the Thames)..."

A. Beaujean (ed.), *Dictionnaire de la langue française, abrégé du dictionnaire de E. Littré*, Paris 1875 (Hachette) : "IMPRESSIONIST. A painter who breaks with academic training and attempts to paint effects, impressions of things, adj. *impressionist* principles."

T. Taboureux, "Claude Monet," *La Vie Moderne* (June 12, 1880), cited in Lionello Venturi, *The Archives of Impressionism* II, Paris and New York, 1939, p. 339-340 : "I [Monet] am and I wish always to be an Impressionist. It is I who invented the word, or at least because of a picture I exhibited I provided a reporter from *Le Figaro* with the opportunity to create a sensation. He had some success, as you see."

G. Geffroy, "L'Impressionnisme," *Revue Encyclopédique*, III/73 (December 15, 1893), column 1221 : "Monet unintentionally provided the name [Impressionism] [without meaning to] when he exhibited (now in the de Bellio collection), titled *Impression*, a sunset on the water" [quoted by R. Niculescu (1970), see below].

M. Guillemot, "Claude Monet," *Revue Illustré* (March 15, 1898) : "...I had something I painted from my window in Le Havre : the sun in the fog and in the foreground some masts sticking up. They wanted to know its title for the catalogue, [because] it couldn't really pass for a view of Le Havre. I replied, 'Use *Impression*.' Someone derived Impressionism from it and that's when the fun began."

W. Dewhurst, *Impressionist Painting*; London, 1904, p. 26 : "Claude Monet named one of his pictures, a sunset, exhibited in the Salon des Refusés, "impressions."

T. Duret, *Histoire des Peintres Impressionnistes*, Paris, 1906, p. 83 : "Monet has, therefore, reached the point of freeing from the actual scene a wide range of tones, the actual impressions. Almost inevitably he titled a picture that depicts the sun in the fog over the sea *Impression, Sunrise* [*Impression, soleil levant*]¹ (¹This painting is now [1906] in the collection of Mr. Donop de Monchy.) It was only natural that as a result the word *Impression* took on a new meaning and provided a perfect name for Monet's new art."

L. Dimier, "Sur l'époque véritable du mot d'impressionnisme," *Bulletin de la Société d'Histoire de l'Art Français*, II (1927), p. 40-41 : this articles cites unpublished recollections of Antonin Proust concerning Manet, who asserted that the expression [Impressionism] was used among the artists well before the 1874 exhibition [the first Impressionist exhibition]. It was, nevertheless only after 1874 that the word took on the meaning that describes the movement.

L. Venturi, *The Archives of Impressionism II*, Paris and New York, 1939, in the chapter "Mémoires de Paul Durand-Ruel," p. 200 : "Une Marine au soleil couchant (A Seascape with Sunset) also appeared in the catalogue and was titled *Impression*. With the aim of embarrassing the Impressionist circle, the press appropriated the title and invented the word 'impressionist,' the name by which the group is still known."

O. Reuterswärd, *Monet*, Stockholm, 1948, p. 65, identifies the Marmottan picture as no. 98 in the catalogue of the first Impressionist exhibition, 1874; J. Leymarie, *Impressionism I*, Geneva, 1959, p. 106, calls the Marmottan picture the one in "the first group exhibition."

L. Degand and D. Rouart, *Claude Monet*, Geneva, 1958, p. 54, accept the Marmottan picture as the one in the first Impressionist exhibition.

M. Sérullaz, *Les Peintres Impressionnistes*, Paris, 1959, p. 5-6, 71, favors the Marmottan picture as the one in the first Impressionist exhibition and cites the article by L. Dimier (see above).

C. Richebé, "Claude Monet au Musée Marmottan," Institut de France — Académie des Beaux-Arts, 1959-60, p. 113-115, and *Supplément au catalogue du Musée Marmottan, Collection Donop de Monchy*, Paris, 1965, no. 710 : in the latter, Richebé publishes letters from Monet to Georges de Bellio concerning Monet during the years 1875-80 and considers the Marmottan painting *L'Impression, soleil levant*; W.C. Seitz, *Monet*, New York, 1960, p. 92 : Seitz, too, acknowledges the Marmottan picture as the one in the first Impressionist exhibition.

C.M. Mount, *Monet*, New York, 1966, p. 225-226, 245, 415-416 : a wide-ranging discussion of the possibilities for the identities of the pictures identified as the famous *Impression...*, no. 98, in the first Impressionist exhibition.

D. Wildenstein, *Monet — Impressions*, Lausanne, 1967, p. 38.

M. Bodelsen, "Early Impressionist Sales 1874-94, in the light of some unpublished procès-verbaux," *The Burlington Magazine* CX/783 (June 1968), p. 335 : she publishes, without commentary, the official records of the auction organized by the Impressionists, March 24, 1875, in which Rouart acquired for 175 francs *Soleil levant (marine)*, no. 8 in the sale catalogue, and, p. 340, the records of the Hoschedé sale of June 6, 1878, in which de Bellio acquired for 210 francs a *l'Impression, soleil couchant*, no. 55 in the catalogue. Bodelsen further concludes, p. 339, that the Marmottan Museum's *Impression, sunset*, could not be no. 98 in the catalogue of the first Impressionist exhibition and cites Rewald's identification of the Rouart picture.

R. Niculescu, "Georges de Bellio," *Revue Roumaine d'Histoire de l'Art*, I, 1964 [1966], no. 2, p. 263-264, and "Georges de Bellio, l'ami des impressionnistes I," *Paragone* 247 (September 1970), p. 32, 53, and "Georges de Bellio, l'ami des impressionnistes II," *Paragone* 249 (November 1970), p. 62-63 (no. 68), in which Niculescu discusses the history of the problem and concludes by ruling in favor of the Marmottan picture because of the Geffroy article (see above).

F. Daulte and C. Richebé, *Monet et ses amis*, Paris, 1971, no. 5 : the authors favor the Marmottan painting.

D. Wildenstein, *Monet*, Milan, 1971, p. 28 : the Marmottan picture is illustrated with the caption, "Impression, setting sun, 1873 (dated 1872)," but there is no commentary.

D. Rouart and J.D. Rey, *Monet — Nymphéas*, Paris, 1972, p. 87, support the Marmottan picture as the one in the first Impressionist exhibition.

John Rewald, *The History of Impressionism* [fourth edition], New York, 1973, p. 289, 317 (illus.), 339 (note 23), 413 : Rewald's analysis of the issue is contained in note 23, p. 339 : "There exists some confusion as to the identity of the painting *Impression, soleil levant*, exhibited in 1874. It has generally been assumed (the first editions of the present book also asserted this) that the picture which was to become the origin of the word 'impressionism' was the one belonging to G. de Bellio. Yet this canvas does not feature the 'pointing shipmasts in the foreground' mentioned by the artist, and the sun seems to be setting rather than rising.

Moreover, Monet — who never showed the same picture twice in the group exhibitions — listed in the catalogue of the fourth show in 1879 : *Effet de brouillard, impression*, owned by M. de Bellio. This work [the Marmottan picture] thus cannot have been the one exhibited in 1874. The painting shown that year in the first group exhibition must have been another view of a similar subject, also painted in 1872 (reproduced p. 316 [in Rewald]). This latter canvas, originally $21\frac{1}{4} \times 25\frac{5}{8}$ [54×65 cm.], was subsequently reduced by Monet and is now the same size as the de bellio [sic] *Impression*, that is, $19\frac{1}{2} \times 25\frac{1}{2}$ in. [49.5×64.6 cm]. Information courtesy of Daniel Wildenstein, New York. At the Hoschedé sale of 1878, at which de Bellio purchased his *Impression*, the picture was catalogued as *L'Impression. Soleil couchant;* see Bodelsen *op. cit.*"

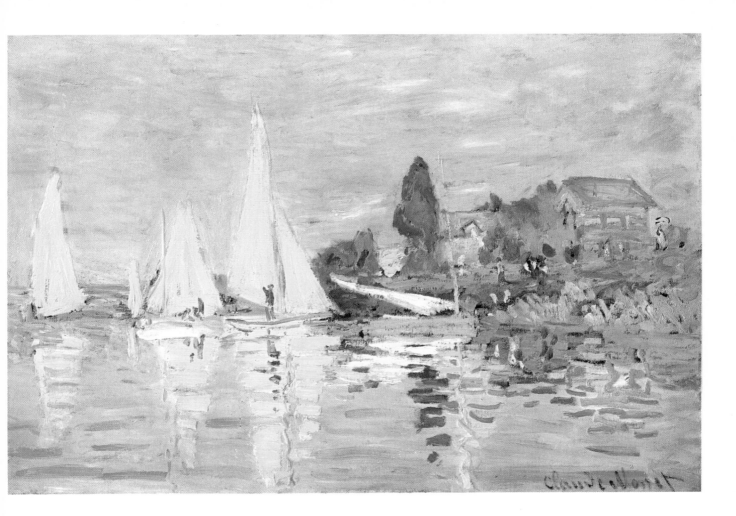

Claude Monet

Sailboats at Argenteuil

About 1872
Signed, lower right :
Claude Monet
Oil on canvas
H. 18$\frac{7}{8}$, w. 28$\frac{3}{4}$ in. (48 × 73 cm.)

Caillebotte Bequest, 1894;
to the Musée du Luxembourg,
 Paris, 1896;
to the Musée du Louvre, 1929
 Galerie du Jeu de Paume
R.F. 2778

In 1870 the Franco-Prussian war forced Monet to take refuge in London. There Daubigny introduced him to Paul Durand-Ruel, who was to become the dealer for Monet as well as the other Impressionists. After a brief trip to Holland in late 1871, Monet returned to France and settled in Argenteuil where he lived until the beginning of 1878. Throughout this period the Seine provided Monet with his principal themes. *Sailboats at Argenteuil* cannot be dated exactly, but it was probably done in 1872. Monet translated with the greatest economy the clear and direct sensation of color-saturated light. The uncomplicated composition emphasizes horizontals and the play between landscape elements and their reflections. Every element in the picture — sails, trees, houses — is treated only as a color component in the composition. The broken brushstrokes intensify the color contrasts : red-green, blue-green, blue-white, etc. The shimmering water is as radiant as the sky.

Sailboats at Argenteuil may have been painted from the "bateau-atelier" that Monet had had built for himself; a painting of 1874 by Manet (Neue Pinakothek, Munich) shows Monet painting on the boat. In fact, it was Monet who encouraged Manet to go to Argenteuil and persuaded him to take up plein-air painting and a lighter palette (see no. 22, Manet's *Boating,* 1874).

It is not known if *Sailboats at Argenteuil* was shown in any of the Impressionist exhibitions. Paintings of the same subject belonging to B.G. Faure were in the second Impressionist exhibition, 1876; two, belonging to Manet, were in the third Impressionist exhibition, 1877; the present picture was in the collection of the painter Gustave Caillebotte, who must have been attracted by a subject that he had painted himself.

A.D.

Exhibitions

1917 Barcelona, *Exposition d'Art Français,* no. 807
1918 Geneva, *Exposition d'Art Français,* no. 304
1928 Berlin, Galerie Tannhauser, *Claude Monet,* no. 21
1931 Paris, Orangerie des Tuileries, *Monet,* no. 34
1934 Venice, XXVIIIe Exposizione Biennale Internazionale d'Arte, no. 34
1939 Belgrade, *Art Français,* no. 82
1940-1941 Paris, Orangerie des Tuileries, *Monet - Rodin,* no. 48
1952 Zurich, Kunsthaus, *Monet,* no. 26
1965 Lisbon, The Gulbenkian Foundation, *Un Século de pintura francesa,* no. 100

Selected Bibliography

H. Adhémar in *Musée du Louvre, catalogue des peintures, pastels, sculptures impressionnistes,* Paris (Musées Nationaux), 1958, no. 234;
G. Bazin, *Trésors de l'Impressionnisme au Louvre,* Paris, 1958, p. 131.

Claude Monet

Boulevard des Capucines, Paris

1873
Signed, lower right :
Claude Monet
Oil on canvas
H. 31¼, w. 23¼ in. (79.5 × 59 cm.)

Nelson Gallery of Art -
 Atkins Museum
 Kansas City, Missouri
Gift of the Kenneth A. and
 Helen F. Spencer Foundation

The view from an elevated vantage point, a device that Monet first used to great advantage in *Terrace at Sainte-Adresse* (no. 26), the continued use of the loosely descriptive brushstroke discussed in connection with *La Grenouillère* (no. 27), and what Monet later in his career called "the envelopment, the same light spread over everywhere" (Monet, October 7, 1890, quoted in Linda Nochlin, *Impressionism and Post-Impressionism 1874-1904, Sources and Documents,* Englewood Cliffs, 1966, p. 34) are the characteristics combined here to realize a fully mature Impressionist painting.

Boulevard des Capucines, Paris was painted from the studio of the photographer Nadar, who lent the same premises in 1874 for the first Impressionist exhibition (John Rewald, *The History of Impressionism,* New York, 1973, p. 313). Monet's acquaintance with Nadar makes it natural that he would have been aware of developments in early photography. In fact, the high horizon line, the view from above, and the blurred figures suggest familiarity with the work of the photographer Adolphe Braun (see Aaron Scharf, "Paintings, Photography, and the Image of Movement," *The Burlington Magazine* CIV/710 [May, 1962], p. 190; and Aaron Scharf, *Art and Photography,* Baltimore, 1969, p. 130). Although these pictorial devices are sometimes characteristic of early photography, they are also found in Japanese prints, which were popular among the painters of the Impressionist circle.

Boulevard des Capucines, Paris met with a generally poor response from the public and the critics (Rewald, p. 318). Louis Leroy's famous review, "L'Exposition des impressionnistes," appeared in the satirical journal *Le Charivari* on April 25, 1874, ten days after the opening of the first Impressionist exhibition. The movement probably got its name from Leroy's title, which was based in turn on the discussion of two paintings in the exhibition, *Impression, Sunrise (Le Havre)* and *Boulevard des Capucines, Paris.*

Leroy referred derisively to the latter as a typical example of "impression," recounting a conversation he had with an academic landscapist, Joseph Vincent :

> Unfortunately, I was impudent enough to leave him [Joseph Vincent] too long in front of the *Boulevard des Capucines,* by the same painter [Monet].
> "Ah-ha!" he sneered in Mephistophelian manner. "Is that brilliant enough, now! There's impression, or I don't know what it means. Only be so good as to tell me what those innumerable black tongue-lickings in the lower part of the picture represent?"
> "Why, those are people walking along," I replied.
> "Then do I look like that when I'm walking along the Boulevard des Capucines? Blood and thunder! So you're making fun of me at last?"
> "I assure you M. Vincent..."
> "But those spots were obtained by the same method as that used to imitate marble : a bit here, a bit there, slapdash, any old way. It's unheard of, appalling. I'll get a stroke from it, for sure" (quoted in Rewald, p. 320).

If there is a keynote in *Boulevard des Capucines, Paris* it is, besides the "tongue-lickings" described by Joseph Vincent, the cluster of pinks at the right, interpreted by most as balloons but barely recognizable as such. The precedence of formal interests over representational elements foreshadows Maurice Denis's famous statement of nearly twenty years later : "Remember that a painting — before it is a battlehorse, a nude woman, or some anecdote — is essentially a flat surface covered with colors assembled in a certain order" (quoted in Linda Nochlin, *Impressionism and Post-Impressionism 1874-1904, Sources and Documents,* Englewood Cliffs, 1966, p. 187).

Aaron Scharf points out that at least one critic, Ernest Chesneau, responded positively to *Boulevard des Capucines, Paris.* Although today the picture is admired for its precocious abstract qualities, Chesneau, "an avowed enemy of photography," singled it out for its realism : "...never has the amazing animation of the public thoroughfare, the ant-like swarming of the crowd on the pavement and the vehicles in the roadway, the movement of the trees in the dust and light along the boulevard; never has the

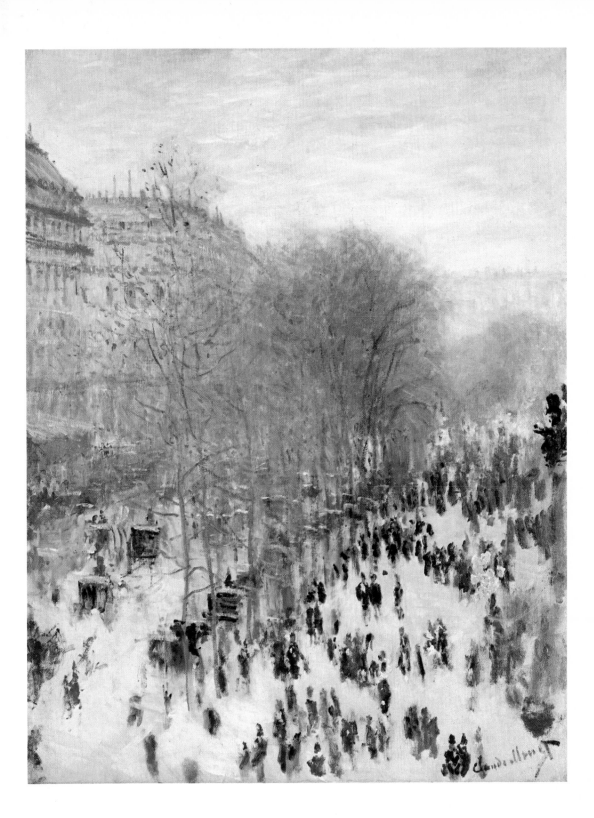

elusive, the fleeting, the instantaneity of movement been caught in its incredible flux, and fixed, as it is in this extraordinary... *Boulevard des Capucines*" (quoted in Scharf, *Art and Photography*, p. 129).

A second version of *Boulevard des Capucines, Paris* (private collection, Paris) exists in a horizontal format. It is not known which one was included in the first Impressionist exhibition since dimensions were not provided in the listing of pictures in 1874. Furthermore, the remarks in Leroy's article are applicable to both pictures.

<div align="right">C.S.M.</div>

Provenance

Mme. de Meixmoron de Dombasle of Dienay, near Dijon; E.B. Workman, London; Mr. and Mrs. Marshall Field, New York (before 1945?); Engene Victor Thaw and Co., New York (1972).

Exhibitions

1874 Paris, 35, boulevard des Capucines, *Société anonyme des artistes peintres, sculpteurs, graveurs, etc.,* no. 97
1945 New York, Wildenstein, *Claude Monet,* no. 17
1970 New York, Wildenstein, *One Hundred Years of Impressionism : a Tribute to Durand-Ruel,* no. 18

Selected Bibliography

E. Chesneau, *Paris Journal,* May 7, 1874, and L. Leroy, "L'Exposition des impressionnistes," quoted in J. Lethève, *Impressionnistes et symbolistes devant la presse.* Paris, 1959, 65-67, 69-70; "The Salon of 1874," unsigned letter from Paris, May 25, 1874, in *Appleton's Journal,* June 20, 1874 (see J. Rewald, *The History of Impressionism,* 1973, p. 326);
J. Rewald, *The History of Impressionism,* New York, 1946, p. 258, 261, 263, ill. opp. p. 258;
W.C. Seitz, *Claude Monet,* New York, 1960, color ill., frontispiece, with commentary;
A. Scharf, "Painting, Photography and the Image of Movement," *Burlington Magazine,* CIV (May 1962), p. 190, fig. 9;
C.M. Mount, *Monet,* New York, 1966, p. 245-246;
A. Scharf, *Art and Photography,* Baltimore, 1968, p. 129, 131-132, fig. 108, 110 (detail);
D. Sutton, *Claude Monet, the Early Years,* exhibition catalogue, Lefevre Gallery, London, 1969, p. 15;
J. Rewald, *The History of Impressionism,* New York, 1973, p. 320, 322, 324, 326, 340, note 30, ill. in color p. 321.

Claude Monet

Parisians Enjoying the Parc Monceau

Signed and dated,
 lower right : *Claude Monet 78*
Oil on canvas
H. 28⅝, w. 21⅜ in.
 (72.7 × 54.3 cm.)

The Metropolitan Museum
 of Art
Purchase, Mr. and Mrs.
 Henry Ittelson Jr. Fund,
 1959, 59.142

This painting is one of two views by Monet of the Parc Monceau in the Metropolitan Museum of Art (cf. Charles Sterling and Margaretta Salinger, *French Painting, a Catalogue of the Metropolitan Museum of Art,* Volume III [New York], 1967, p. 128). The park is situated on the Boulevard des Courcelles; it was designed in the late eighteenth century by Carmontelle for Philippe d'Orléans in the picturesque manner of the so-called English garden.

In *Parisians Enjoying the Parc Monceau* Monet continues to focus his attention on an enclosed volume of space filled with color-bearing light, a compositional formula that first appeared in the late sixties (e.g. *La Grenouillère,* no. 27) and was used to advantage in *Boulevard des Capucines, Paris* (no. 30) : "It should go without saying that he did not choose a subject or a vantage point at random, and that while the choice was being made a pictorial solution was already forming in his mind" (William Seitz, *Claude Monet,* 1960, p. 26).

The overall dissolution of form by light and the increasing autonomy of the brushstrokes are typical of Monet in the seventies; however, the pooling of light on the grass and path in the foreground produces a patterning that is rare in Monet's work up to this time. He had preferred instead the soft-focus effect resulting from the small, even brushstroke and gentle contrasts between areas of light and shadow, as in *The Parc Monceau* of 1876 in the Metropolitan Museum (59.142). The two-dimensional effect in the picture of 1878 suggests a willingness to experiment, albeit tentatively, with pictorial ideas originating in *Women in a Garden* (no. 25) of 1867, described by Champa as "...a brilliant demonstration of the flattening rather than the modeling quality of intense natural light as it defines forms of various sorts. It is this quality which

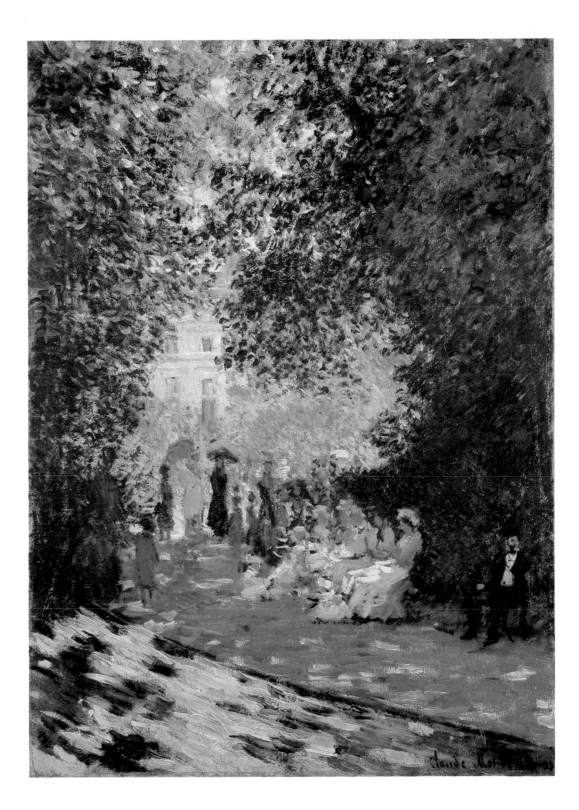

Monet chooses to develop in the absence of volume and space definition" (Kermit Champa, *Studies in Early Impressionism*, New Haven and London, 1973, p. 13).

The flatness in the foreground conflicts with the space behind. Monet is on the verge of a stylistic conflict of interests that took him nearly a decade to resolve. During the eighties he experimented with many motifs and variations in style to overcome the contradictions that began to appear in the late seventies. By the nineties he had discovered subjects that provided the beginnings of a solution to the conflict between two- and three-dimensional interests in his work.

Parisians Enjoying the Parc Monceau was included in the fourth Impressionist exhibition in 1879, the year that "Impressionist" was dropped from the title : "After having originally been the one who started the group on its exhibitions, Monet had little by little abandoned active participation in the preparation of these shows, which had been taken over by the more or less opposed factions of Renoir and Degas. But Caillebotte would not allow his friend to abstain altogether. While Monet did not even leave Vétheuil to look after his own interests, Caillebotte took care of everything, borrowed pictures from Monet's collectors, looked after the frames, wrote eager letters and tried to rouse his friend's courage" (John Rewald, *The History of Impressionism*, New York, 1973, p. 421-423).

C.S.M.

Provenance

Probably Georges de Bellio, Paris (1879-after 1889); Durand-Ruel, Paris; Georges Bernheim, Paris (until c.1930); Alfred Lindon, Paris (c.1930-1948); Mme. Alfred Lindon, Paris (1948-1959); Jacques Lindon, New York (1959).

Exhibitions

1879 Paris, 28, avenue de l'Opéra, *La 4e exposition de peinture*, no. 152. (possibly this picture, lent by M. de Bellio)
1889 Paris, Galerie Georges Petit, *Claude Monet, A. Rodin*, no. 36 (possibly this picture, lent by M. de Bellio)
1931 Paris, Orangerie des Tuileries, *Claude Monet*, no. 47
1935 Paris, Galerie Durand-Ruel, *Claude Monet*, no. 26
1959 Paris, Galerie Durand-Ruel, *Claude Monet*, no. 21

Selected Bibliography

C. Sterling and M.M. Salinger, *French Paintings, a Catalogue of the Collection of the Metropolitan Museum of Art*, New York, 1967, III, p. 129, ill.;
D. Cooper, "The Monets in the Metropolitan Museum," *Metropolitan Museum Journal* 3, 1970, p. 288-290, ill.

Berthe Morisot

The Cradle

1873
Oil on canvas
H. 21⅝, w. 18⅛ in. (55 × 46 cm.)

Musée du Louvre,
 Galerie du Jeu de Paume
R.F. 2849, acquired 1930

In 1874 Berthe Morisot decided to exhibit several works, including *The Cradle*, with the Société Anonyme des Artistes, Peintres, Sculpteurs, Graveurs, etc., Exposition de 1874; in joining the show at 35 Boulevard des Capucines in the studio of the photographer Nadar she allied herself with the Impressionist group rather than with the official Salon, where she had submitted successfully since 1864.

The Cradle was unquestionably inspired by the painter's sister, Edma Pontillon, whose daughter, Blanche, was the model for the sleeping child. The painting combines boldness of composition, owing much to Manet, with a discreet and subtle sensitivity implicit in the subject matter itself. The critical and public reaction to this work was restrained, even favorable compared to the attacks Monet and Cézanne suffered. "Nothing could be truer or at the same time more touching than this young mother, who, although dressed in a shoddy way, bends over a cradle into which our view of a pink child is muted by a pale cloud of muslin," wrote Jean Prouvaire in *Le Rappel,* April 20, 1874. Some critics insisted on scoffing at the free handling that gives the picture so much of its charm; for example, Louis Leroy wrote in *Le Charivari* on April 25, 1874, about another painting by Morisot in the same exhibition : "Don't talk to me about Miss Morisot! That young lady doesn't bother herself reproducing a lot of useless detail. When she wants to paint a hand, she just makes as many brushstrokes lengthwise as there are fingers and that's the end of it" (John Rewald, *The History of Impressionism* [fourth edition], New York, 1973, p. 322). However, these attacks did not discourage Berthe Morisot; the following year she participated in the auction (March 24, 1875) organized by the Impressionists. In later years she participated in all of the group's exhibitions except that of 1879, shortly after the birth of a child.

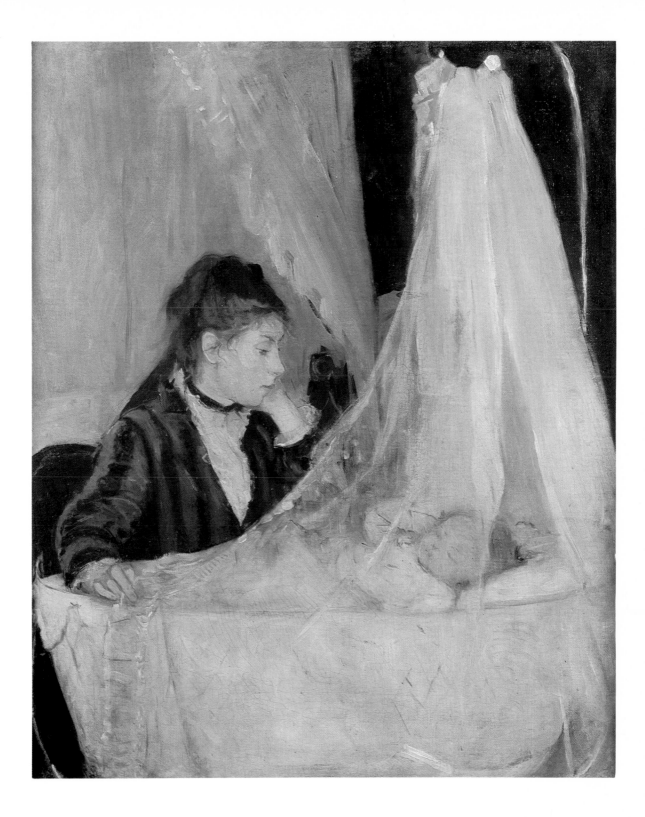

Monet painted the same subject in 1867 when his son Jean was born (Collection of Mr. and Mrs. Paul Mellon, Upperville, Virginia).

A.D.

Provenance

Madame Pontillon, née Edma Morisot, Berthe's sister, Mme. Forget née Blanche Pontillon, the artist's niece, the child sleeping in the picture; Musée du Louvre (for 300,000 francs), 1930.

Exhibitions

1874 Paris, 35 boulevard des Capucines (Nadar's studio), *Société Anonyme des Artistes Peintres, Sculpteurs, Graveurs, etc. —*, Exposition de 1874 (first Impressionist exhibition), no. 104
1896 Paris, Durand-Ruel Gallery, March 5-21, *Berthe Morisot*, no. 42 (as belonging to Mme. Pontillon)
1902 Paris, Durand-Ruel Gallery, April 23 - May 10, *Berthe Morisot*, no. 40
1919 Paris, Bernheim-Jeune Gallery, November 7 - 22, *Cent Œuvres de Berthe Morisot*, no. 7
1929 Paris, Bernheim-Jeune Gallery, May 6-24, *Berthe Morisot*, no. 21 (as belonging to Mme. Forget)
1932 Paris, Orangerie des Tuileries, *Acquisitions du Louvre*, no. 102
1945 Paris, Musée du Louvre, *Chefs d'Œuvre de la Peinture*, no. 110
1970-1971 Leningrad, Moscow, and Madrid, *Impressionnistes Français*, no. 53

Selected Bibliography

M.L. Bataille and Georges Wildenstein, *Berthe Morisot, catalogue des peintures, pastels, et aquarelles*, Paris, 1961, no. 25;
L. de Lora, "Exposition libre des peintres," *Le Gaulois*, April 18, 1874;
J. Prouvaire, *Le Rappel*, April 20, 1874;
A. Fourreau, *Berthe Morisot*, Paris, 1925, p. 36;
P. Jamot, *Bulletin des Musées de France* (August 1930), p. 158-159;
M. Angoulvent, *Berthe Morisot*, Paris, 1933, p. 46-47, and p. 119, no. 33;
G. Bazin, *Trésors de l'Impressionnisme au Louvre*, Paris, 1958, p. 147;
H. Adhémar in *Musée du Louvre, Catalogue des peintures, pastels, et sculptures impressionnistes*, Paris, 1958, no. 286.

33 Camille Pissarro

Jallais Hill, Pontoise

Signed and dated, lower
 right : *C. Pissarro, 1867*
Oil on canvas
H. $34\frac{1}{4}$, w. $45\frac{1}{4}$ in.
 (87 × 114.9 cm.)

The Metropolitan Museum
 of Art, Bequest of William
 Church Osborn, 1951
 51.30.2

As Sterling and Salinger observe, *Jallais Hill, Pontoise* "is the chief work of Pissarro's earliest, pre-Impressionist style and shows traces of Corot and also of Courbet, whose influence is especially evident in the use of deep greens against the vivid blue of the sky" (Charles Sterling and Margaretta Salinger, *French Paintings, a Catalogue of the Metropolitan Museum of Art,* Volume III [New York], 1967, p. 5). Although it is a pre-Impressionist work, it has many Impressionist characteristics. For example, the clear light does not reveal much precise detail; the figures on the road are faceless, their treatment typifying the simplifications throughout; the broad treatment of the grasses, the road, and the foliage in the foreground foreshadows the interest in the generalized appearance of things that Louis Leroy derisively labeled "impression" in his review of the first Impressionist exhibition (cf. Monet, *Impression,* no. 28, and *Boulevard des Capucines, Paris,* no. 30). Moreover, the outside leaves of the shrubbery at the right that seem to be unattached, and the white walls of the houses in the valley that tend to bleach out details such as windows, indicate an interest in optical and chromatic effects that anticipate Impressionism in its fully developed form in the seventies.

Simplifications and modifications of the scene are found throughout the picture; although in 1867 Pissarro was beyond the schematizations of Corot, who allowed Pissarro to name him as one of his teachers (cf. John Rewald, *The History of Impressionism,* New York, 1973, p. 101), he was not as adventurous as Monet. Indeed, Pissarro did not entirely capitalize on the possibilities offered in *Jallais Hill, Pontoise* even though he was working with an ideal early Impressionist composition — a view from above looking down into and across an expanse blocked at the back. He chose, instead, a style more realist, more Courbet-like, than Impressionist.

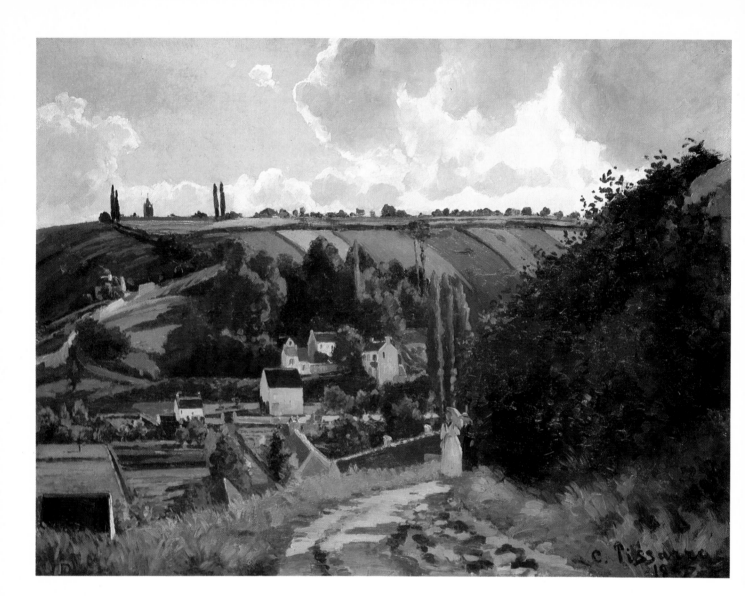

The emphasis on broad, flat areas of color, as in the pattern of fields on the hillside, is typical of advanced painting in the sixties (e.g. Monet, *Terrace at Sainte-Adresse,* no. 26; Monet, *La Grenouillère,* no. 27; and Manet, *The Fifer,* 1866, Musée du Louvre, R.F. 1992). Kermit Champa notes that Pissarro and Monet, in 1866-1867, had attained a similar level of formal achievement : "Pissarro moved in... two palette-knife pictures to a point of coincidence with the contemporary art of Monet — a point of coincidence which he may or may not have recognized. Both painters discovered almost simultaneously that a uniform field of brushstrokes (or palette-knife strokes) possessed everything necessary for the development of successful realist paintings. While the field emphasized the flatness of the picture plane to a considerable degree, it offered a sure means of pictorial organization. The kind of organization implied by this field stressed continuity. It did not provide hierarchical arrangment and emphasis in the same way as traditional composition, but it permitted, because of the regularity of intervals between its internal parts, an unprecedented development of color and color value. Through this development, relative accents of volume and space could be achieved optically rather than by measurement or position" (Kermit Champa, *Studies in Early Impressionism,* New Haven and London, 1973, p. 75). Furthermore, Champa suggests that Pissarro incorporated the advanced effects of his palette-knife paintings "into large paintings that would be acceptable to the tastes of the Salon jury" (Champa, p. 75).

Pissarro seems to have succeeded in blending traditional ideas with those of the avant-garde : *Jallais Hill, Pontoise* was accepted and exhibited in the Salon of 1868; it seems also to have been included in the sixth Impressionist exhibition.

C.S.M.

Provenance

Durand-Ruel, Paris; William H. Holston, New York (in 1929); William Church Osborn, New York (from 1929).

Exhibitions

1868 Paris, Salon, no. 2015
1881 Paris, 35 Boulevard des Capucines, 6e *Exposition de peinture,* no. 72 (possibly *Jallais Hill, Pontoise : Paysage pris sur le vieux chemin d'Ennery, près Pontoise,* see Venturi, *Les Archives de l'impressionnisme,* 1939, II, p. 9)
1914 Paris, Galerie Manzi et Joyant, *Rétrospective Camille Pissarro,* no. 5
1934 Chicago, Art Institute of Chicago, *A Century of Progress,* no. 260
1941 New York, Metropolitan Museum, *French Painting from David to Toulouse-Lautrec,* no. 96
1945 New York, Wildenstein, *Camille Pissarro,* no. 20

Selected Bibliography

L.R. Pissarro and L. Venturi, *Camille Pissarro,* Paris, 1939, I, p. 20, 85, no. 55, II, pl. 10, no. 55;
J. Rewald, *Camille Pissarro,* New York, 1963, p. 70-71, ill. in color;
C. Sterling and M.M. Salinger, *French Paintings, a Catalogue of the Collection of the Metropolitan Museum,* New York, 1967, III, p. 15-16, ill.;
L.R. Furst, "Zola's Art Criticism," *French 19th Century Painting and Literature* (U. Finke, ed.), Manchester, 1972, p. 176-178, ill.;
K.S. Champa, *Studies in Early Impressionism,* New Haven and London, 1973, p. 75-76, fig. 107;
E. Fahy and F. Watson, *The Wrightsman Collection,* New York, V, 1973, p. 150;
J. Rewald, *The History of Impressionism,* New York, 1973, ill. p. 186.

34 Camille Pissarro

Hoarfrost

Signed and dated, lower left :
 C. Pissarro, 1873
Oil on canvas
H. 25½, w. 36⅝ in. (65 × 93 cm.)

Musée du Louvre
 Galerie du Jeu de Paume
Bequest of
 Eduardo Mollard, 1972
R.F. 1972-28

In his review of the 1874 Impressionist exhibition, written in the form of dialogue between an academic landscape painter (Joseph Vincent) and the author, Louis Leroy wrote : "Assuming the most naïve expression, I led him before Pissarro's *Ploughed Field*. At the sight of this formidable landscape, the good fellow thought that the lenses of his glasses were dirty. He wiped them carefully and put them back on his nose.

'In the name of Michallon! [an early 19th century French landscape painter]' he said, 'What's that ?'

'You see, it's hoarfrost on deeply ploughed fields.'

'Those are furrows ? That is hoarfrost ?... But those are palette scrapings spread evenly on dirty canvas. It has neither head nor tail, neither top nor bottom, neither front nor back.'

'Maybe, but the impression is there.'

'Well, it's a funny kind of impression' (Louis Leroy, "Exposition des Impressionnistes," *Le Charivari*, April 25, 1874).

Despite its maliciousness, this passage sums up quite well what Pissarro was trying to achieve in this picture. It would be difficult to find a landscape more commonplace, more devoid of inherent charm, but equally difficult to find one more suited to a delicate and diverse interpretation of the shimmering light on the ground and in the air. Here only light is important; one forgets the deliberate neglect of subject matter. "This light, this color... Pissarro absorbs them in, and then imbues the sky, the earth, and the peasants with them... the uncontrollable vibration of the haze," wrote F. Fagus in his symbolist interpretation of Pissarro's style (*La Revue Blanche*, 1898).

Because of the influence of Turner, whose work he had seen in London in 1871, and because he and Monet had been working together, by 1874 Pissarro had completely eliminated browns and blacks from his palette and was mixing color directly on the

177

canvas. Looked at closely such a picture is only a series of irregular, illegible strokes. It recalls what Diderot said about Chardin, "We understand nothing about this magic; these are thick layers of color applied one over the other, the effects of which intermingle above and below. In other instances one would think that a vapor had been blown onto the canvas, or that it had been sprayed with a light foam... Draw near, and everything blurs, flattens and dissolves; step back, and everything forms and comes together again" (Diderot, *Salon de 1763*).

The other Impressionists sought the play of light and reflections mainly in the atmosphere and on water, but Pissarro preferred to find them on the earth. The earthy character of Pissarro's art is often correctly emphasized; he concentrated on rural Ile-de-France subjects, and only later in his development included purely urban landscapes of Paris and Dieppe. He and Gauguin proceeded through life along quite different paths : Gauguin was born on the rue Notre-Dame de Lorette in the center of Paris, and thought only about running away, far from the streets of the city; Pissarro, on the other hand, who was born on a faraway island in the Danish Caribbean, was only comfortable in the countryside of the Ile-de-France or along the Avenue de l'Opéra.

M.H.

Provenance

J.B. Faure, Paris; Dr. Eduardo Mollard, Paris.

Exhibitions

1874 Paris, 35 Boulevard des Capucines (Nadar's studio, April 15-May 15, *Société anonyme des artistes peintres, sculpteurs, graveurs, etc.*, Exposition de 1874, no. 137
1904 Paris, Durand-Ruel Gallery, *Pissarro*, no. 24
1926 Paris, Durand-Ruel Gallery, *Pissarro*, no.13

Selected Bibliography

L. Leroy, *Le Charivari*, April 25, 1874, p. 79; P. Burty, *La République Française*, April 25, 1874; L.R. Pissarro and L. Venturi, *C. Pissarro*, Paris, 1939, p. 107, no. 203, illus. p. 203 (plate 41); *Gazette des Beaux-Arts* (February 1973), no. 1249; H. Adhémar, *Revue du Louvre et des Musées de France*, 1973, no. 4-5, illus.

35 Pierre-Auguste Renoir

La Grenouillère

1869
Signed, lower left : *A. Renoir*
Oil on canvas
H. 26, w. 33$\frac{7}{8}$ in. (66 × 86 cm.)

Lent by the Nationalmuseum,
 Stockholm, Sweden

The Grenouillère was a restaurant on the Seine between Chatou and Bougival where people could dance and go swimming and boating. It had been popular with Parisians for about ten years when Georges Bibesco took Renoir there, and Renoir returned often with Monet, who was then living in Bougival. During the summer of 1869 the two painters often worked together, and three pictures of La Grenouillère by each have survived; the best known are the present picture and the Metropolitan Museum's Monet (no. 27). (For a discussion of the six pictures and their interrelationships, see Kermit Champa, "Monet and Renoir at La Grenouillère," *Studies in Early Impressionism*, New Haven and London, 1973, p. 56-66.)

This kind of subject matter was considered distinctly "modern," the term used by Baudelaire and Huysmans to describe such pictures; nevertheless, all six Grenouillère canvases continue a traditional theme having its origins in the *fêtes galantes* of the eighteenth century, and in Huet and Courbet earlier in the nineteenth century and later on. Furthermore, Champa compares the Grenouillère pictures to Watteau's *Embarkation from Cythera* (Musée du Louvre). But it is Manet's style that Renoir here most closely approximates, especially as in Manet's *Music in the Tuileries* of 1860-1863 (National Gallery of Art, London) and works painted at Boulogne in 1869, like *The Departure of the Steamboat "Folkestone"* (two versions, in the Art Institute of Chicago and the Reinhart Collection, Winterthur, Switzerland). As these pictures are exactly contemporary with Renoir's and Monet's *Grenouillères*, one cannot speak of influence; it is more a question of similar preoccupations. Manet had become more interested in working out of doors and was therefore approaching the subject matter and style of his younger fellow painters.

At the time he painted *La Grenouillère*, Renoir was interested

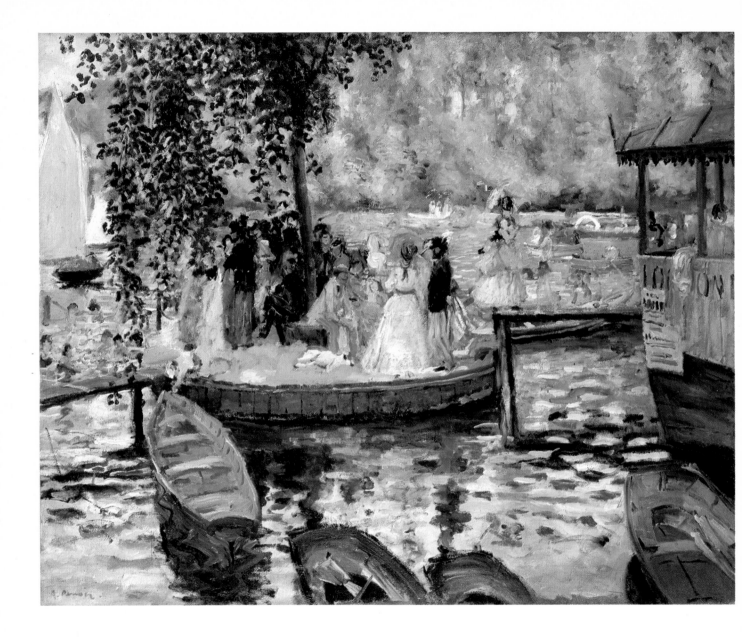

in the problem of integrating people into a landscape. The Impressionists tended to reduce figures to silhouettes (see no. 34) or to emphasize the human element at the expense of the environment (no. 37), but in *La Grenouillère* Renoir balances the figures with their surroundings. In *La Grenouillère* the figures are concentrated on the island, and it is only the boats that break up the otherwise rather rigid composition formed of rhythmic vertical and horizontal lines.

La Grenouillère is evidence that by 1869 Renoir had abandoned traditional techniques and subjects. His treatment of light and the loose handling of paint constitute a fully mature Impressionist style. There are no longer blacks and browns in the shadows, but pastel tones are found everywhere; generous, clearly visible brushwork fills the composition — not just in the water, where it is most obvious — and firm contours give way to the vibration of the light. This last characteristic marks the strongest point of difference between Renoir and Monet : the latter contrasted the foreground and the islet, which are in shadow, with the background, in full sunlight. In Renoir's *La Grenouillère* a consciously even light unifies the picture space.

M.H.

Provenance

Anonymous gift, 1924.

Exhibitions

1877 Paris, Third Impressionist Exhibition, no. 186
1883 Paris, Durand-Ruel Gallery, *Renoir*, no. 35
1892 Paris, Durand-Ruel Gallery, *Renoir*, no. 10
1917 Barcelona, *French Art*, no. 824
1933 Paris, Orangerie des Tuileries, *Renoir*, no. 29
1945 Paris, Musée du Louvre, *Les Chefs-d'Œuvre de la Peinture Française*
1946 Baden-Baden, *Französische Impressionisten und ihre Zeitgenossen*, no. 32

Selected Bibliography

F. Daulte, *Auguste Renoir, Catalogue raisonné de l'œuvre peint*, Lausanne, 1971, no. 209 (illus. in color), with an extensive bibliography to which the folowing should be added :
G. Rivière, *L'Impressionniste*, April 5, 1877;
C.O. Squarr, *Le Courrier de France*, April 6, 1877;
P. Sébillat, *Le Bien Public*, April 7, 1877;
Le Moniteur Universel, April 8, 1877;
L'Homme libre, April 12, 1877;
La République Française, April 15, 1877;
R. Bollec, *Les Beaux-Arts illustrés*, April 23, 1877;
M. de Montifaud, *L'Artiste*, May, 1877, p. 234, 343;
G. Rivière, *L'Artiste*, November, 1877;
G. Geffroy, "L'Impressionnisme," *La Revue Encyclopédique*, no. 73, December 15, 1893;
G. Geffroy, *La Vie Artistique*, IV, Paris, 1894, p. 125;

T. Duret, *Histoire des Peintres Impressionnistes*, Paris, 1906, p. 133;
G. Mauclair, *Un siècle de peinture française*, 1930, p. 140;
M. Drücker, *Renoir*, Paris, 1944, pl. 39;
F. Jourdain, *Le Moulin de la Galette*, Paris, 1947;
G. Mauclair, *De Baudelaire à Bonnard*, Geneva, 1949, p. 26, illus.;
J. Leymarie, *La Peinture Française III : le XIX^e siècle*, Geneva, 1962, p. 194, illus.;
Blunden, *Journal de l'Impressionnisme*, Geneva, 1970, p. 134, illus.;
F. Daulte, *Auguste Renoir*, Milan, 1972, p. 32-33, illus. in color;
K.S. Champa, *Studies in Early Impressionism*, New Haven and London, 1973, p. 43;
John Rewald, *The History of Impressionism* [fourth edition], New York, 1973, p. 383, 388, 392, 433, 450.

Pierre Auguste Renoir

Dancing at the Moulin de la Galette, Montmartre

Signed and dated, lower right :
 Renoir 76
Oil on canvas
H. 51½, w. 68⅞ in (131 × 175 cm.)

Caillebotte Bequest, 1894;
to the Musée du Luxembourg,
 Paris, 1896;
to the Musée du Louvre, 1929
 Galerie du Jeu de Paume
R.F. 2739

When it was exhibited for the first time in 1877, *Dancing at the Moulin de la Galette* provoked the usual outraged response from most critics, yet a few Parisian journalists recognized its genius and were moved to take it seriously. Some of them even understood Renoir's intentions : "In looking carefully, one will understand what the artist wanted to do : his aim was to show the effect of strong sunlight falling through foliage on the figures sitting under the trees. The round splotches are meant to represent the shadows cast by the leaves" (Roger Ballu, *Les Beaux-Arts Illustrés,* April 23, 1877). Charles O. Squarr wrote : "A strong harsh light falls from the sky through the transparent green leaves, tinges blond hair and pink cheeks with gold, gleams on the ribbons of the girls, and fills the picture space with a happy light reflected even in the shadows" (*Le Courrier de France,* 1877). Curiously, Georges Rivière, a friend and defender of Renoir, who appears on the right in the picture, seated at the table with the painter Norbert Goeneutte, was more concerned with the subject matter and modernity of the picture than with the light effects Renoir was seeking : "It is a page of history, a valuable record of life in Paris, and completely truthful" (*L'Impressionniste,* 1877). The exhibition of the picture at the Durand-Ruel Gallery in 1883 and its acquisition by the Musée du Luxembourg in 1896 assured its renown. "The admirable *Moulin de la Galette...* [is] perhaps the artist's masterpiece. I do not understand those who have maligned this lovely canvas as a mass of horrors. I see in it the poetry of Paris, the charm of the quarter, the enchanting faces of young girls elated for the moment by the promise of life, with all the determination of young people who are naïve, in love, and dancing in the sun. The man who gave life to this scene is a great painter and a great poet" (Gustave Geffroy, *Le Journal,* February 16, 1897).

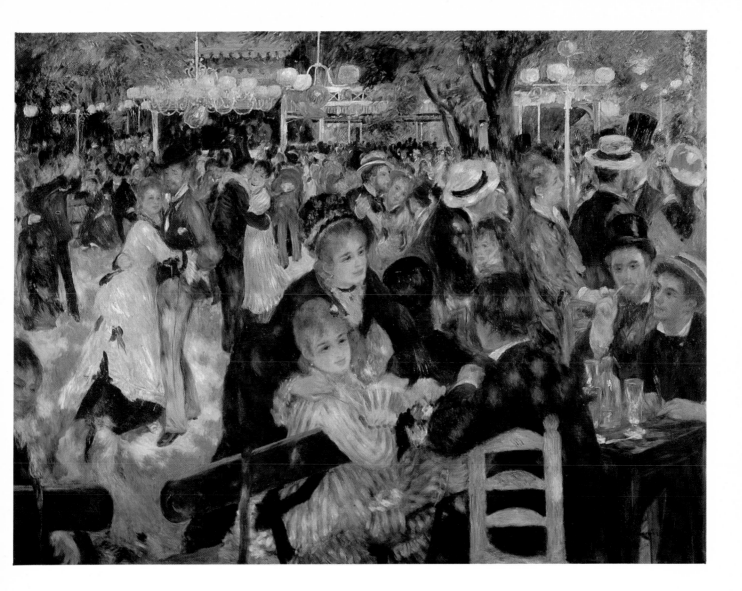

Dancing at the Moulin de la Galette was to be a seminal work for Renoir and the Impressionist movement. Its status as a "masterpiece" was established even in a time when "masterpiece" recurred frequently in the vocabulary of the art critics. There is reason to believe that Renoir himself wanted it considered such : unlike Monet, whose *Women in the Garden* of 1865-1866 did not dictate the look of his future work, and Sisley and Pissarro, who in the mid-sixties were painting on small canvases and directly from life, Renoir was very conscious of his own ambition in undertaking such a relatively large work with numerous figures, and the final version was preceded by preliminary studies and at least two full sketches. The first (Wilhelm and Henry Hansen Foundation, Copenhagen; see Daulte, I, no. 207) shows the composition nearly finished but with its background more open; the second (collection of John Hay Whitney, New York; see Daulte, I, no. 208) is only slightly different from the final picture.

According to Georges Rivière, the picture was painted entirely in situ at a Montmartre dancing spot that took its name from one of the last surviving Paris windmills; on Sunday afternoons the artists and local residents went there to dance. Every day the painter's friends helped him carry the canvas from his studio on nearby Rue Cortot (related by Daulte in regard to the Whitney sketch).

Dancing at the Moulin de la Galette was the successful culmination of Renoir's studies of reflected light effects and colored shadows. The sunlight, filtered through the foliage, determines the areas of light and shade, especially on faces and clothes. Unlike the other Impressionists, Renoir emphasizes the human figure and, here, figures in motion. His attitude is fundamentally different from that of Monet, Sisley, and Pissarro, whose subjects are typically either still or moving only slightly. Renoir's approach is not based on observation alone, but also on the reconstruction of a scene of movement, of which he selects and isolates a particular instant. Monet dealt with the ephemeral but Renoir recreated the spontaneous.

The composition is organized around a loose spiral beginning in the left foreground, following the diagonal of the picture plane, and finally disappearing in the right background. Perhaps because of an unconscious association or the similarity of the subjects, Renoir's composition is close to that of Rubens's *Kermesse.*

Manet's *The Bar at the Folies-Bergère* of 1881 (Collection of the

Courtauld Institute, London) is similar to *Dancing at the Moulin de la Galette* in several ways too difficult to dismiss as coincidence : the same broken blue and mauve harmonies in an atmosphere of diffused light, the same contrast between the women's light-colored clothes and the men's dark suits, the same lamp globes, and even the juxtaposition of two rare complementary colors : absinthe green and orange.

Picasso's debt to *Dancing at the Moulin de la Galette* is clear in a work with the same title (The Guggenheim Museum, Thannhauser Collection, New York; see Daix-Boudaille-Rosselet, *Picasso Bleu et Rose,* Neuchatel, 1966, p. 29); the composition is nearly identical but reversed.

Dufy, too, was fascinated by Renoir's picture and in 1943 did several variations on it from memory (see J. Lassaigne, *Raoul Dufy,* Geneva, 1954, p. 83). He had already shown that he was inspired by the Renoir in a number of earlier works.

<div align="right">M.H.</div>

Exhibitions

1877 Paris, 3ᵉ *Exposition de la Peinture* (third Impressionist exhibition), no. 186
1883 Paris, Durand-Ruel Gallery, *Renoir,* no. 35
1892 Paris, Durand-Ruel Gallery, *Renoir,* no. 10
1917 Barcelona, *French Art,* no. 824
1933 Paris, Orangerie des Tuileries, *Renoir,* no. 29
1945 Paris, Musée du Louvre, *Les Chefs d'Œuvre de la Peinture Française*
1946 Baden-Baden, *Französische Impressionisten und ihre Zeitgenossen,* no. 32.

Bibliography

M. Drücker, *Renoir,* Paris, 1944, pl. 39;
F. Jourdain, *Le Moulin de la Galette,* Paris, 1947;
F. Daulte, *Auguste Renoir, Catalogue Raisonné de l'œuvre Peint,* Lausanne, I, 1971, no. 209, rep. col., with extensive bibliography to which the following should be added :
G. Rivière, *L'Impressionniste,* April 5, 1877;
C. O. Squarr, *Le Courrier de France,* April 6, 1877;
P. Sébillat, *Le Bien Public,* April 7, 1877;
Le Moniteur Universel, April 8, 1877;
L'Homme libre, April 12, 1877;
La République Française, April 15, 1877.
R. Bollec, *Les Beaux-Arts illustrés,* April 23, 1877;
M. de Montifaud, *L'Artiste,* May 1877, p. 234, 343;
G. Rivière, *L'Artiste,* November 1877;
G. Geffroy, "L'Impressionnisme," *La Revue Encyclopédique,* no. 73, December 15, 1893;
G. Geffroy, *La Vie Artistique,* IV, Paris, 1894, p. 125;
T. Duret, *Histoire des Peintres Impressionnistes,* Paris, 1906, p. 133;
G. Mauclair, *Un siècle de peinture française,* 1930, p. 140;
De Baudelaire à Bonnard, Geneva, 1949, p. 26, rep. p. 26.
J. Leymarie, *La Peinture Française, tome III. Le XIXᵉ siècle,* Geneva, 1962, p. 194, rep. p. 194;
Blunden, *Journal de l'Impressionnisme,* Geneva, 1970, p. 134, rep.;
F. Daulte, *Auguste Renoir,* Milan, 1972, rep. col. p. 32-33;
K.S. Champa, *Studies in Early Impressionism,* New Haven and London, 1973, p. 43;
J. Rewald, *History of Impressionism,* 4th ed. New York 1973, p. 385.

37 Pierre Auguste Renoir

Torso of a Woman in the Sun

About 1875-76
Signed, lower right : *Renoir*
Oil on canvas
H. 31½, w. 24 in (81 × 65 cm.)

Caillebotte Bequest, 1894
to the Musée du Luxembourg,
 Paris, 1896;
to the Musée du Louvre, 1929
 Galerie du Jeu de Paume
R.F. 2740

Unlike most of the Impressionists, Renoir did little pure landscape painting and concentrated on portraiture and the human figure. This picture, included by Renoir himself in the second Impressionist exhibition, is the consummation of his studies of light playing on the human body in the open air; the sunlight, filtered by the trees, produces a mottled effect, ranging from pale pink to purplish blue over the model's skin seen against an undefined background. Moreover, garments and skin are treated as irregular splashes of color without contour, anticipating the late works of Pierre Bonnard. *Torso of a Woman in the Sun* is a forthright denial of local color in favor of a wide range of reflected light effects, and as such it was particularly badly received by the critics. Albert Wolff, who was a consistently vicious critic of the Impressionists, commented in *Le Figaro* on April 3, 1876 : "Try to explain to M. Renoir that a woman's torso is not a head of decomposing flesh covered with green and purple patches, which are the sign of advanced putrefaction in a corpse."

Renoir, capable of carefully individualized portraits, preferred to emphasize here the effects of light instead of the specific characteristics of Anna Lebœuf, the model. We know from other pictures that she had refined features, but here we are shown an inexpressive figure deprived of all gracefulness by the random play of the light and shadow. This picture is an early example of the dehumanization of the painted figure — a process even more noticeable in Degas — that culminated in the final disassembling of the features by the Cubists.

M.H.

Exhibitions

1876 Paris, *La 2ᵉ Exposition de Peinture* (second Impressionist Exhibition), no. 212
1883 Paris, Durand-Ruel Gallery, *Renoir*, no. 33
1892 Paris, Durand-Ruel Gallery, *A. Renoir*, no. 11
1918 Madrid
1919-1920 Toulouse
1942 Albi, *Peinture Française*

Selected Bibliography

F. Daulte, *Auguste Renoir*, Lausanne, 1971, no. 201, with a bibliography through the year of publication to which the following should be added :
A. Pathey, *La Presse*, March 31, 1876;
A. Wolff, *Le Figaro*, April 3, 1876;
E. Blémont, *Le Rappel*, April 9, 1876;
L. Enault, *Le Constitutionnel*, April 10, 1876;
A. Vollard, *Renoir*, Paris, 1920, p. 79;
P. Jamot, "Renoir," *Gazette des Beaux-Arts*, November 1923, p. 257-281, and December 1923, p. 361-368;
F. Fosca, *Renoir*, Paris, 1923, p. 17;
L. Stein, *Renoir*, Paris, 1928, illus.;
C. Kunstler, *Renoir, peintre fou de couleur*, Paris, 1941;
M. Drücker, *Renoir*, Paris, 1944, pl. 55;
J. Leymarie, *Manet et les Impressionnistes*, Paris, 1948, illus.;
W. Balzer, *Der Französisches Impressionismus*, Dresden, 1958, p. 72, pl. XIII;
J. Lassaigne, *L'Impressionnisme*, Lausanne, 1966, illus. p. 6;
Jardin des Arts, no. 210, May 1972, p. 46-47, illus.

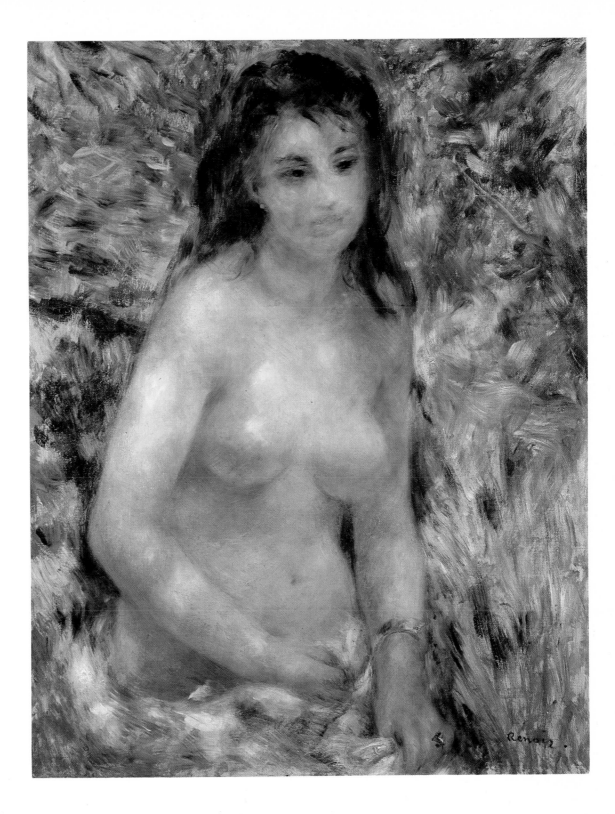

Pierre Auguste Renoir

Madame Charpentier and Her Children

Signed and dated,
 lower right : *Renoir 78*
Oil on canvas
H. 60½, w. 74⅞ in
 (153.7 × 190.2 cm.)

The Metropolitan Museum
 of Art
Purchase, Wolfe Fund, 1907
 07.122

Renoir chose not to exhibit in the fourth Impressionist exhibition in 1879, the year in which the word "Impressionist" was dropped from the group's title (John Rewald, *The History of Impressionism,* New York, 1973, p. 421). Sisley, Cézanne, and Berthe Morisot also decided not to exhibit. Mary Cassatt wrote to a friend, "There are so few of us that we are each required to contribute all we have. You know how hard it is to inaugurate anything like independent action among French artists, and we are carrying on a despairing fight and need all our forces, as every year there are new deserters" (Rewald, p. 421). Although Impressionist exhibitions continued until 1886, by 1879 it was obvious that serious problems had arisen from the artists' differing aesthetic inclinations and financial motives; a passage from a note by Sisley to the critic Duret is revealing : "It is true that our exhibitions have served to make us known and in this have been very useful to me, but I believe we must not isolate ourselves too long. We are still far from the moment when we shall be able to do without the prestige attached to official exhibitions. I am, therefore, determined to submit to the Salon. If I am accepted — there are possibilities this year — I think I'll be able to do some business..." (Rewald, p. 421). Sisley was rejected, but Renoir was accepted and exhibited, with great success, *Madame Charpentier and Her Children.*

Renoir's success in the Salon of 1879 marks the beginning of the sort of official prestige and financial success hoped for by Sisley. Not only was the portrait accepted for the Salon, but the prominence of the sitters meant patronage of a very desirable sort. Georges Charpentier, the publisher of Zola, Maupassant, and Daudet, and his wife occupied an important position in the intellectual life of Paris, and their house on the Rue de Grenelle served as the

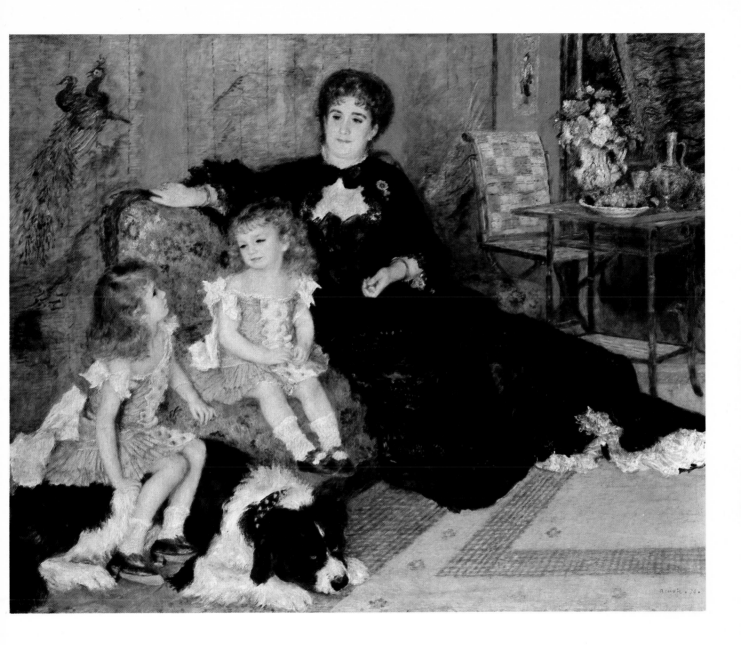

setting for a *salon*, "...at which all leading figures of French letters and politics appeared, occasionally joined by artists. According to Edmond de Goncourt's diary, Gambetta highly appreciated these *soirées* because the Charpentiers succeeded in an undertaking until then unknown in France (though not unusual in England), that of 'assembling and bringing into contact people of different opinions who respect and appreciate other people while maintaining their own views'" (Rewald, p. 382-384).

In *Le Temps Retrouvé* (1929), Marcel Proust recalled having seen *Madame Charpentier and Her Children* in the Charpentier house (Rewald, p. 419 ; also see Charles Sterling and Margaretta Salinger, *French Paintings, a Catalogue of the Metropolitan Museum of Art*, Volume III, New York, 1967, p. 149). Rewald notes that Proust "was particularly receptive to 'the poetry of an elegant home and the exquisite gowns of our time' which Renoir had rendered." The love of the period for Japanese art and décor is reflected throughout the room; the children are brushed, scrubbed and groomed to perfection; the dog tolerates the child on his back with the good nature of a stuffed animal; and Madame Charpentier, in her Worth dress, is as picture-perfect as the still life in the background.

The faces and hands of the sitters are finished to a greater degree, in the sense of plasticity, than the rest of the picture. One is forced to wonder why Renoir has retreated somewhat from his high Impressionist style. The Charpentier portrait introduces qualities of modeling and plasticity inconsistent with the directions of other works of this period : "Thus, although his paintings of the seventies and early eighties like the *Moulin de la Galette* (1876) [no. 36] and the *Luncheon of the Boating Party* (c. 1881) [The Phillips Collection, Washington, D.C.] are completely Impressionistic in their diaphanous brushwork and in the quivering evanescence of the iridescent light and transparent shadow in which the charming, informally grouped figures are bathed, by the mid-eighties, Renoir began to suffer grave doubts about his, and Impressionism's, lack of form and composition — doubts which eventually led to a crisis and to Renoir's subsequent return, after a trip to Italy in 1881-1882, to a more disciplined kind of drawing and modeling and to a stricter formal treatment : what has been called his 'dry' or 'harsh' period" (Linda Nochlin, *Impressionism and Post-Impressionism 1874-1904, Sources and Documents*, Englewood Cliffs, 1966, p. 45). The sources of Renoir's shift away from a

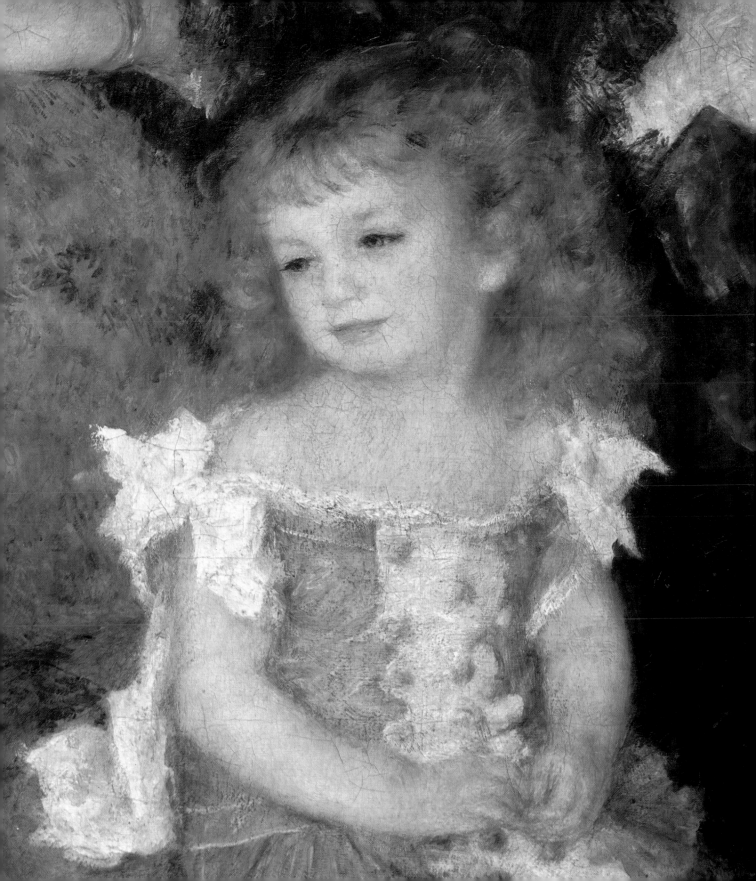

"completely Impressionistic" style are in the Charpentier portrait, painted during a time when Renoir broke with the Impressionists and reintroduced traditional pictorial values in order to satisfy the needs of a commissioned work and, more importantly, the Salon jury.

<div align="right">C.S.M.</div>

Provenance

Georges Charpentier, Paris (bought from Renoir for 1000 francs in 1878), until 1907 : sale, Paris, Hôtel Drouot, April 11, 1907, no. 21, 84,000 francs to Durand-Ruel, for the Metropolitan Museum.

Exhibitions

1878 Paris, Salon, no. 2527 (as Mme G.. C... et ses enfants

1886 Brussels, Les XX, *La Troisième exposition annuelle, Renoir,* no. 2 (lent by Georges Charpentier)

1892 Paris, Durand-Ruel, *Renoir,* no. 110 (as *Portrait* lent by Georges Charpentier)

1900 Paris, Bernheim-Jeune, *Renoir,* no. 17 (as *En Famille*).

1901 Paris, Petit-Palais, *Exposition de l'enfance,* no. 1111

1904 Brussels, la Libre Esthétique, *Exposition des peintres impressionnistes,* no. 129 (lent by Georges Charpentier)

1937 New York, Metropolitan Museum, *Renoir,* no. 22.

Selected Bibliography

C. Bigot, in *Revue Blanche,* 1879, quoted in J. Lethève, see below, p. 108;

J. Lethève, *Impressionnistes et symbolistes devant la presse,* Paris, 1959, p. 106;

C. Sterling and M.M. Salinger, *French Paintings, a Catalogue of the Collection of the Metropolitan Museum of Art,* New York, III, p. 149-152, ill.;

F. Daulte, *Auguste Renoir,* Lausanne, 1971, I, p. 42 (ill. detail in color), no. 266, color pl. 266, p. 411;

J. Rewald, *The History of Impressionism,* New York, 1973, p. 419, 424, 428, 580, ill. p. 420.

Dance in the City
Dance in the Country

Dance in the City
Signed and dated,
 lower right : *Renoir 83*
Oil on canvas
H. 71, w. 35 in. (180 × 90 cm.)

Durand-Ruel Collection, Paris

Dance in the Country
Signed and dated,
 lower left : *Renoir 83*
Oil on canvas
H. 71, w. 35 in. (180 × 90 cm.)

Durand-Ruel Collection, Paris

"About 1883, there was a kind of break in my work. I had come to the end of Impressionism and I arrived at the conclusion that I knew neither how to paint nor draw. In a word, I was at an impasse." So Renoir said in looking back at his career (quoted in A. Vollard, *Renoir*, Paris, 1920, p. 135).

During the winter of 1881-82 Renoir was in Italy. He immersed himself in the work of Raphael and the frescoes from Pompei and stayed for a while with Cézanne, who by then had already begun to abandon Impressionism. Renoir admired Cézanne and must surely have been influenced by his rejection of the pure Impressionist style. *Dance in the City* and *Dance in the Country*, painted only a few months apart, are among the first important works to signify a fundamental change in his art. Like *Dancing at the Moulin de la Galette* (no. 36), these are large, ambitous paintings that required lengthy posing and were preceded by preparatory sketches and studies. *Dance at Bougival* (Museum of Fine Arts, Boston; Daulte I, no. 438) is thought to be a first version of *Dance in the Country*, but it has a fuller composition and the two principal figures are transposed. Renoir considered *Dance in the Country* interesting enough to make two etchings based on it (see J. Leymarie and M. Melot, *Les Gravures des Impressionnistes*, Paris, 1971, nos. 2, 3).

Compared to earlier works, the present pictures are distinguishable by their clarity of contour. Although not as defined as the forms in the *Grandes Baigneuses* of 1887 (Philadelphia Museum of Art), the long development of which began shortly after the two *Dance...* pictures, these contours are far more precise than in works of the preceding decade. Although Renoir's contours here are not as cursive as in Gauguin's after 1888 or in the work of Suzanne Valadon, who posed for these pictures, the shapes are

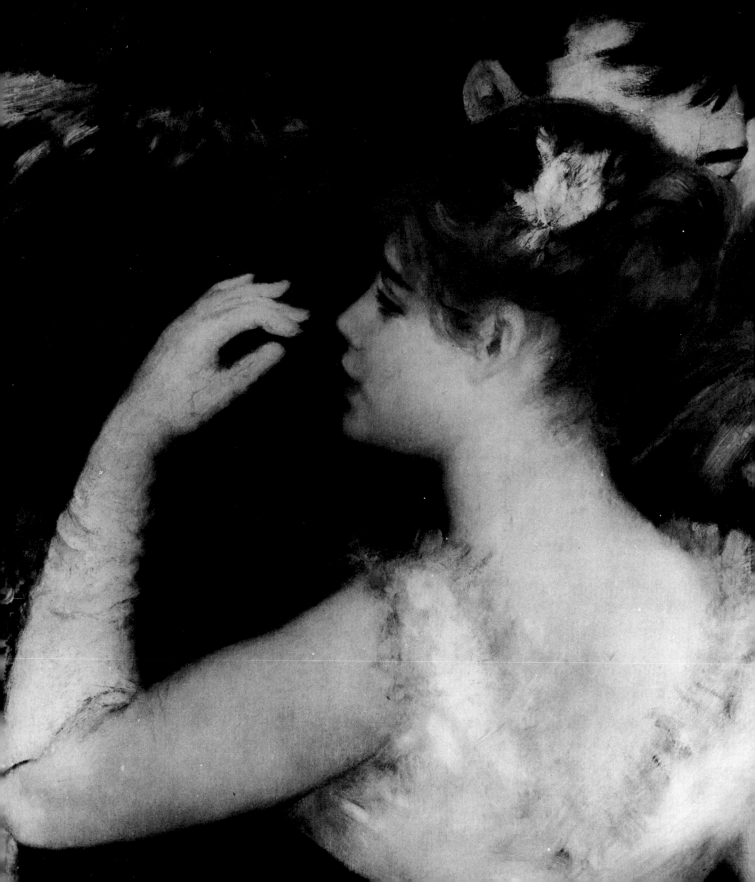

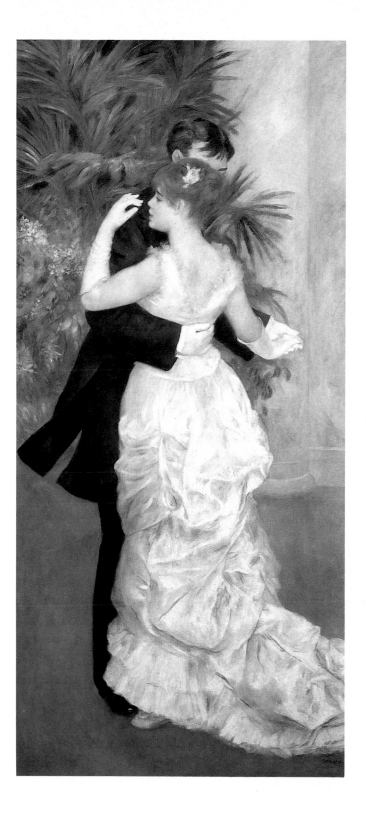

distinct areas of flat color. The modeling is tempered by uniform, neutral light, nearly identical in the indoor and open-air scenes. There is neither a sense of reflected light nor an impasted paint surface; the painted canvas is smooth, even, and porcelainlike, as an Ingres often is. With this pair of pictures Renoir's break with the so-called *Dancing at the Moulin de la Galette* period is complete.

Dance in the City and *Dance in the Country* are pendants, as is evident in their dimensions and style. In each Renoir reduced his subject to essentials : the evening clothes of the couple and the green plants in the "city" version, the abandoned table and the arbor in the other. Though the lady at the ball seems more rigid than her counterpart in the country tavern, one would be foolish to explain it in terms of class differences. It is more likely an echo of a "couples" theme that appeared as early as 1868 in Renoir's *Sisley Couple* (The Wallraf-Richartz Museum, Cologne; Daulte no. 34) or in the couples in the middle ground of *Dancing at the Moulin de la Galette*. Moreover Renoir clearly intended the country and city dance canvases to reflect contemporary, everyday life, in contrast to Degas's pictures of professional dancers from the effete world of the theater and the stage. Perhaps Renoir wanted to compete with the elegant and mundane subjects of Manet, Tissot, and Stevens, and the portraits of fashionable women so well represented in the official Salons. By the mid-eighties even official painting had begun to be influenced by Impressionist handling of light, making it possible for a conservative Impressionist and a liberal academician to share the middle ground.

Paul Lhôte, one of Renoir's friends, and Suzanne Valadon, who posed for Renoir, Degas, and Puvis de Chavannes before she became a painter herself, modeled for *Dance in the City*. Paul Lhôte, again, and Madame Renoir, according to Daulte, posed for *Dance in the Country*. According to Tabarant, however, Suzanne Valadon posed for both (see A. Tabarant, "Suzanne Valadon et ses souvenirs de modèle," *Bulletin de la Vie Artistique,* 1921, p. 627). M. Drücker offers yet another opinion, asserting that it is Madame Renoir in *Dance in the City* and Suzanne Valadon in *Dance in the Country* as well as in *Dance at Bougival*. Comparisons with faces in known portraits indicate Suzanne Valadon in *Dance in the Country* and Madame Renoir in *Dance in the City*. Suzanne Valadon's recollection that she posed for both (see A. Tabarant) is possibly explained by her having modeled for *Dance at Bougival,* in which the model's face is unfortunately not clear enough to identify.

M.H.

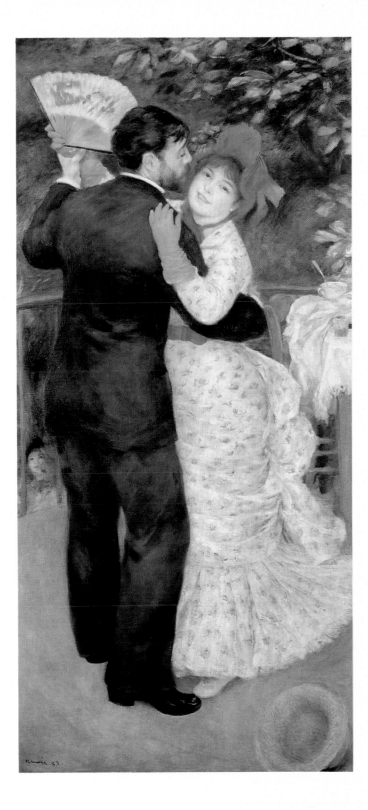

Provenance

Renoir to Durand-Ruel, August 25, 1891, for
7500 francs.

Exhibitions

1883 Paris, Durand-Ruel Gallery, *Renoir*, no. 26
1892 Paris, Durand-Ruel Gallery, *Renoir*, p. 81
1904 Brussels, La Libre Esthétique, *Exposition des Peintres Impressionnistes*, no. 32
1905 London, The Grafton Galleries, *Pictures by Boudin... Renoir, etc.*, no. 242
1912 Paris, Bagatelle, *La Musique, La Danse*, no. 105
1920 Paris, Durand-Ruel Gallery, *Renoir*, no. 1
1932 Paris, Durand-Ruel Gallery, *Quelques Œuvres importantes de Manet à van Gogh*, no. 41
1933 Paris, Orangerie des Tuileries, *Renoir*, no. 69, illus., plate XLII
1937 Paris, Palais National des Arts, *Chefs d'Œuvres de l'art français*, no. 398, pl. 85
1939 New York, Durand-Ruel Gallery, *Loan Exhibition of Portraits by Renoir*, no. 7
1964 Stockholm, Nationalmuseum, *La Douce France*, no. 41, illus.
1969 Paris, Durand-Ruel Gallery, *Renoir intime*, no. 16, illus.
1973 Art Institute of Chicago, *Paintings by Renoir*, no. 43, illus.
1974 Paris, Durand-Ruel Gallery, *Cent ans d'Impressionnisme*, no. 52

Selected Bibliography

F. Daulte, *Auguste Renoir*, Lausanne, 1971, no. 440, illus. in color; with a complete bibliography through the date of publication to which the following should be added :
M. Drücker, *Renoir*, Paris, 1944, p. 205;
J. Maxon, *Paintings by Renoir*, Chicago, 1973, no. 43, illus.

Alfred Sisley

The Bridge at Villeneuve-la-Garenne

Signed and dated,
 lower left : *Sisley 1872*
Oil on canvas
H. 19½, w. 25¾ in
 (49. 5 × 65.4 cm.)

The Metropolitan Museum
 of Art, Gift of Mr. and Mrs.
 Henry Ittelson Jr., 1964
 64.287

In 1864 when Charles Gleyre stopped teaching at the Ecole des Beaux-Arts, Sisley, Monet, Renoir, and Bazille were suddenly without even a nominal instructor. Two years later, Sisley's first Salon entries reflected the influence of Corot and Daubigny. By the early seventies he was working in a mature Impressionist manner, typical of which is *The Bridge at Villeneuve-la-Garenne*.

Sisley's style from 1870 is close to that of Monet, Renoir, and Pissarro. In the present picture the riverside subject, the treatment of the surface of the water, the transparency of the colored shadows, and the highly keyed chalky palette are typical of the first years of fully developed Impressionism. However, Sisley is distinguishable by his use of a brushstroke more precise in its description of form than that of most other Impressionists. He also defines spaces that resist the flattening effects that appealed to the others, especially Monet. In *The Bridge at Villeneuve-la-Garenne* the clear progression of the bridge into space conflicts with the flattening effect of the clear bright light. Sisley has joined an Impressionist brushstroke and palette to a traditional conception of space. It is difficult to know the degree to which Sisley is an Impressionist, or, to phrase the issue negatively, the degree to which Sisley has applied the *look* of Impressionism to a more traditional concept of landscape. Whatever the case, Sisley avoided the pitfalls of a rising round plane, patterning, or other devices for flattening the picture space.

Sisley exhibited in the first Impressionist exhibition, and in three of the next seven. Durand-Ruel was the first to recognize the quality of Sisley's work, but the artist was neither a critical nor a financial success at any time during his career. Like Degas's *The Dance Class* (no. 17) and *Carriage at the Races* (no. 13), *The Bridge at Villeneuve-la-Garenne* was once in the collection of J.B. Faure; however, as Sterling and Salinger indicate, "Although

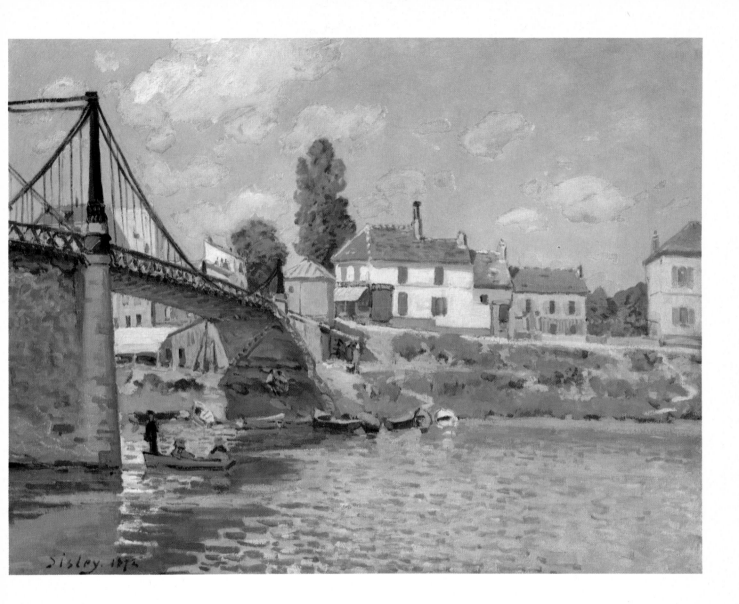

203

Faure, Doctor de Bellio, Doctor Viau, the restaurateur Eugène Murer, the editor Georges Charpentier, and the critic Théodore Duret were all sympathetic to Sisley, acquiring pictures by him and giving him financial help and encouragement, he was repeatedly in debt and in 1886 in desperation considered learning to make fans. In the spring of 1869 Durand-Ruel, who had opened a gallery in New York two years before, held a one-man showing there of works of Sisley" (Charles Sterling and Margaretta Salinger, *French Paintings, a Catalogue of the Metropolitan Museum of Art,* Volume III, New York, 1967, p. 118).

C.S.M.

Provenance

Durand-Ruel, Paris (bought from the artist for 200 francs in 1872) until 1873; Jean-Baptiste Faure, Paris (bought from Durand-Ruel for 360 francs in 1873); Alfred Bergaud, Paris (until 1920; sale, Paris, Galerie Georges Petit, Mar. 1-2, 1920, no. 56, 37,200 francs to Gérard frères); Gérard frères, Paris (from 1920); Fernand Buisson, Paris (by 1930); Sam Salz, New York; Mr. and Mrs. Henry Ittleson, Jr., New York (by 1957).

Exhibitions

1917 Paris, Galerie Georges Petit, *Exposition d'œuvres de Alfred Sisley,* no. 54 (as *Village de la Garenne, environs de Paris*)
1961 New York, Paul Rosenberg & Co., *Loan Exhibition of Paintings by Alfred Sisley,* no. 3

Selected Bibliography

F. Daulte, *Alfred Sisley, Catalogue raisonné de l'œuvre peint,* Lausanne, 1959, p. 24, no. 37, ill. in color opp. p. 16;
C. Sterling and M.M. Salinger, *French Paintings, a Catalogue of the Collection of the Metropolitan Museum,* New York, 1967, III, p. 119-120, ill.;
J. Rewald, *The History of Impressionism,* New York, 1973, p. 290, frontispiece in color.

42 Alfred Sisley

The Flood at Port-Marly

Signed and dated
 lower left : *Sisley 76*
Oil on canvas
H. 23⅝, w. 32 in. (60 × 81.2 cm.)

Musée du Louvre
 Galerie du Jeu de Paume
Camondo Bequest, 1908
R.F. 2020

On January 22, 1899, Camille Pissarro wrote to his son Lucien : "It is said that Sisley is quite sick. He is a fine and a great artist. In my opinion he ranks among the greatest. I've been looking at works by him that are of rare importance and beauty; among them there is a *Flood* which is a masterpiece" *(Camille Pissarro, Lettres à son fils Lucien* [John Rewald, ed.], Paris, 1950, p. 465).

It is not known if Pissarro's reference was to the present or to another version of the theme. In any case, this tribute to Sisley warrants quotation, especially because Sisley, impoverished and slighted throughout his career, died a week after Pissarro's letter was written.

In 1876 Sisley was living in Marly-le-Roi, quite close to Port-Marly, which was flooded that year by the rising waters of the Seine. In *Flood at Port-Marly* there is none of the drama that a Romantic painter would have emphasized; Sisley is content with the familiar forms of a house and trees, given an unusual sense of place by the shimmering flood water and the cloudy, gray sky. The subject provided Sisley with a series of pictures; an example dated 1872 (see Selected Bibliography, Daulte, no. 22; Collection of Paul Mellon, Upperville, Virgina) is quite close to the Jeu de Paume picture. The same site reappears in two pictures of 1876 : 1) a painting traditionally titled *Port-Marly Before the Flood* (see Selected Bibliography, Daulte, no. 235); 2) *The Flood at Port-Marly* (*L'Inondation à Port-Marly,* formerly Santamarina Collection, Buenos Aires, sold at Sotheby's, London, April 2, 1974, no. 16; see Daulte [Selected Bibliography], no. 235). Two smaller versions of the subject, both titled *A Boat During the Flood* and dated 1876, are in the Musée des Beaux-Arts, Rouen (see Daulte, no. 237) and the Musée du Louvre, Galerie du Jeu de Paume (R.F. 2021; see Daulte, no. 239).

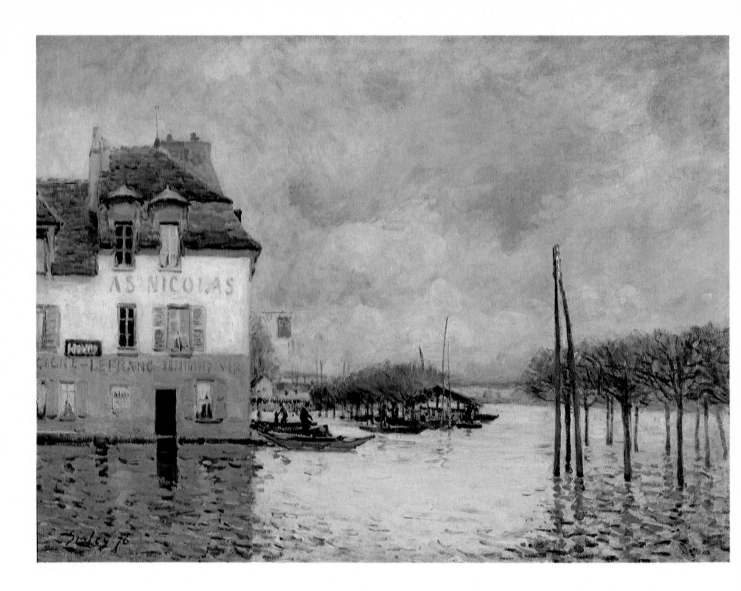

In never attempting to paint the human figure Sisley is apparently unique among the Impressionists. There are figures in his paintings, but they only serve as live silhouettes, structural devices, to punctuate the composition. Sisley's subject seems always to have been the sky, the properties of light reflected by water, snow, or the gold-colored stonework of houses. His unobtrusive and sensitive pictures were hardly noticed by his contemporaries. After Sisley's death (January 29, 1899) the present canvas was one of the first works by the artist to bring a price at auction. Entering the Musée du Louvre in the Camondo Bequest, 1908, it helped considerably to enhance, albeit belatedly, Sisley's reputation.

A.D.

Provenance

Legrand Collection, Paris? (see catalogue of the second Impressionist exhibition, 11 rue le Peletier, Paris, 1876, no. 244; for a condensed version of the catalogue see L. Venturi, *Les Archives de l'Impressionnisme*, II, Paris and New York, 1939, p. 257-259); Paindeson Collection, Paris (see catalogue for the Tavernier sale, Galerie Georges Petit, March 6, 1900, no. 68); Pellerin Collection, Paris (see *Tableaux de Besnard, Cazin...* [exhibition catalogue], Paris [Galerie Georges Petit], 1899, no. 63); Adolphe Tavernier sale, Galerie Georges Petit, Paris, March 6, 1900, no. 68; purchased in the Tavernier sale by Comte Isaac Camondo for 45,150 francs, according to Camondo's personally annotated copy of the sale catalogue, now in the Bibliothèque du Louvre, Paris) — the high price caused a sensation because during his lifetime Sisley had sold little work at low prices; the Camondo Bequest, 1908; entered the Musée du Louvre, 1911; on exhibition, 1914.

Exhibitions

1876 Paris, possibly the second Impressionist exhibition *(Société anonyme des artistes peintres, sculpteurs, graveurs etc., 2e Exposition de Peinture,* 11 rue le Peletier, April, no. 244, titled *Inondations à Port-Marly* and noted as belonging to M. Legrand)

1899 Paris, Galerie Georges Petit, February 16 - March 8, *Tableaux par P.A. Besnard, J.C. Cazin, C. Monet, A. Sisley, and F. Thaulow,* no. 63, titled *L'Inondation (Marly)*

1970-1971 Leningrad, Moscow, Madrid, *Impressionnistes Français,* no. 67

Selected Bibliography

F. Daulte, *Alfred Sisley*, Paris, 1959, no. 240, with a complete bibliography to which the following should be added :

G. Geffroy, *Sisley*, Paris, 1923, p. 23, 30;

P. Jamot, *La Peinture au Musée du Louvre, Ecole Française, XIX^e siècle* (troisième partie), Paris, n.d. [1928], p. 38;

L. Reidemeister, *Auf den Spuren der Maler der Ile de France*, Berlin, 1963, p. 100-101.

Biographie

Jean Frédéric Bazille

(1841-1870)

Bazille arrived in Paris from Montpellier in 1862. He enrolled in Gleyre's studio and became friendly with Cézanne, Guillaumin, Sisley, Zola, Solari, Monet, and Renoir — especially the latter two. Courbet strongly influenced him, but Manet's effect was even stronger; at the same time he was interested in the work of Boudin, Corot, and Théodore Rousseau. In 1865 he posed for Monet's celebrated *Déjeuner sur l'herbe* (no. 24) and frequented the Café Guerbois.

In 1867 he purchased Monet's *Women in the Garden* (no. 25) and became one of the first collectors of Impressionist paintings. His artist friends owed much to his generous, although often dispassionate, aid that helped them to cope with the practical difficulties that arose during the early years of the Impressionist movement.

The emphasis on light, open-air subjects, and the use of a highly keyed palette make Bazille one of the pioneers of Impressionism. His promising career was abruptly halted, however, in 1870; he volunteered for military service in the Franco-Prussian war and was subsequently killed in action at Beaune-la-Rolande (Loiret).

Work by Bazille was exhibited in the Salons of 1866, 1868, 1869, and 1870.

Louis Eugène Boudin

(1824-1898)

Boudin was the son of a sea captain and was born on the coast at Honfleur (Normandy). During his youth in Le Havre he sold artists' supplies and met Troyon, Isabey, and Millet, all of whom advised or influenced the young painter. He was also deeply impressed by the art of Corot and Courbet, but the painter who had the strongest effect on him was Jongkind.

After a grant from the city of Le Havre to study in Paris for three years, Boudin returned to Le Havre to begin a career as a marine painter. By the late fifties he had made a name for himself as a particularly fine painter of skies. He traveled up and down the coast painting beach scenes, ports, fishermen at work, and the middle class at leisure or on holiday.

Boudin was Monet's first serious teacher in Le Havre, and introduced him to plein-air painting. He undoubtedly helped to set the tone of Monet's interests and must have opened his eyes to contemporary painting. Boudin's contacts with fellow artists were quite strong; he was one of a group of artists that met at the Saint-Siméon farm, a country inn to which he had brought Courbet and which was also a favorite spot of Diaz, Troyon, Cals, Daubigny, and Corot.

Beginning in 1861 he spent the winters in Paris, but worked directly from his subjects during most of the rest of the year. He traveled extensively and worked in Brittany, the south of France, Bordeaux, Belgium, Holland, and Venice.

He participated in only one Impressionist exhibition, the first in 1874. In subsequent years he preferred to show at the Salon (in 1874 he violated the Impressionist group's rules by including work in both the Salon and the Impressionist exhibition). Although he abandoned the group's exhibitions, he shared in common with most Impressionists the same dealer, Durand-Ruel, who put on important exhibitions of Boudin's work in 1883, 1889, 1890, and 1891.

Gustave Caillebotte

(1848-1894)

Caillebotte came from a wealthy bourgeois Parisian family. He studied in Bonnat's studio and was admitted to the Ecole des Beaux-Arts in 1873. At approximately the same time he made his first contacts with the Impressionists. In 1876 he was included in the second Impressionist exhibition and subsequently became a principal force in the movement as well as a staunch supporter and patron of his friends.

His earliest works were realist-oriented scenes of contemporary life and views of Paris. About 1882, under Monet's influence, he began to concentrate on landscape and painted a number of views of the Seine at Argenteuil.

He bequeathed to the French Government his large collection, composed entirely of Impressionist works, and thereby introduced Impressionism into the collections of the French National Museums.

Works by Caillebotte were included in the Impressionist Exhibitions of 1876, 1877, 1879, 1880, 1881, and 1882.

Mary Cassatt

(1844-1926)

Mary Cassatt was the daughter of a wealthy Pittsburgh banker. She arrived in France in 1868, studied with Chaplin, and traveled to Italy, Spain, and Belgium. Degas befriended her and acted as her adviser and unofficial tutor. He invited her to exhibit with the Impressionists, and her work was included in the Impressionist exhibitions of 1879, 1880, 1881, 1882, and 1886. Her palette and interest in light allied her naturally with the Impressionists; her subject matter, emphasis on "line" and "drawing", and her debt to the compositional techniques of the Japanese print indicate the strong influence of Degas.

She persuaded Louisine Havemeyer to take an interest in the work of the Impressionists and therefore had an indirect role in forming the core of the Impressionist collection of the Metropolitan Museum.

She died, nearly blind, at the Château of Beaufresne, Mesnil-Théribus (Oise).

Paul Cézanne

(1839-1906)

In 1862 Cézanne enrolled in the Académie Suisse in Paris, where he met Pissarro and Guillaumin. He often took part in the Manet-dominated discussions at the Café Guerbois; there he also encountered an old childhood friend, Emile Zola. From 1863 to 1870 he divided his time between Aix and Paris; this first period, described as "romantic" or "baroque," reflects a strong interest in Delacroix and Venetian Mannerism. He lived at Auvers-sur-Oise from 1872 to 1874 and often painted with Pissarro, under whose tutelage he began to use light tones, although he never adopted a thoroughly Impressionist palette.

In 1874 and 1877 he was included in the Impressionist exhibitions.

After 1882 he lived alone at Aix-en-Provence, until joined by his wife and son in 1891. By the mid-eighties he had moved beyond Impressionism and focused on the underlying structure and aesthetic order of painting. He used color sparingly and reduced his palette to a range of blues, browns, pinks, and greens that only minimally modeled form and grew increasingly lyrical toward the end of his life.

In 1895 the dealer Ambroise Vollard gave Cézanne a large exhibition in Paris. The public was unenthusiastic, but the show was a revelation for the younger artists, who hailed Cézanne as the master for the new avant-garde. In 1904 Cézanne exhibited at the Salon d'Automne where in 1907 he was given a retrospective exhibition spanning his career.

Hilaire Germain Edgar Degas

(1834-1917)

Degas came from a family of bankers who had lived in Naples since 1789. In 1854 he studied under Lamothe, a pupil of Ingres and Flandrin, for entrance into the Ecole des Beaux-Arts. The following year he entered the school but stayed only briefly.

He spent 1856 and 1857 in Rome and Naples studying the Italian Primitives. As a history and portrait painter in the tradition of Ingres, Degas exhibited regularly at the Salon until 1870. But a specific feeling for modern life and subjects, a taste for original composition, experiments with the instantaneous recording of movement, and, by the mid-seventies, his discovery of pastel and new media techniques led him toward the Café Guerbois group of painters and writers.

Degas traveled extensively in Europe (Italy, England, Belgium, Holland, Spain) and visited America in 1872-1873, staying for several months with relatives who had settled in New Orleans.

Around 1890 Degas's already ailing eyes began to fail him; he worked in brighter and brighter colors, favoring pastel, and emphasized monotypes and sculpture in order to compensate for his steadily deteriorating eyesight.

He exhibited in all but one (1882) of the Impressionist exhibitions.

Armand Guillaumin

(1841-1927)

Guillaumin was born in Paris in 1841; his family had originally come from Moulins. In 1864 he worked at the Académie Suisse, where he knew Cézanne and Pissarro. After taking a job with the Government Bridges and Highways Department in 1868, he became a Sunday painter and produced mainly views of Paris and the suburbs.

From 1870 on he was a frequent visitor to Dr. Gachet in Auvers-sur-Oise; Gachet long remained a faithful friend and collector of his work, although he is best remembered today as the doctor who treated van Gogh during the final stage of his illness. Guillaumin continued to paint in the Paris area (Damiette, Epinay-sur-Oise) and later, from 1891, in the Creuse region (Crozant) and in the south of France (Agay). In 1904 he traveled briefly to Holland.

He exhibited for the last time at the Salon des Refusés in 1923. He died six months after Monet at the age of 87.

Edouard Manet

(1832-1883)

Manet, whose father was a lawyer, came from an upper middle-class family. He entered Couture's studio in 1849 but was at odds with conventional academic schooling and preferred to train himself by copying in museums in France and abroad. In 1853 he was in Italy; in 1856 he visited Germany and Holland. His admiration for 17th-century Spanish art (Velasquez, Zurbaran, Murillo) led him to Spain in 1865; he would also have had the opportunity to study Goya.

By 1861 he had had a work accepted for the Salon (*The Spanish Singer,* The Metropolitan Museum of Art). In 1863, however, the Salon jury refused his *Déjeuner sur l'herbe* (Musée dù Louvre, Galerie du Jeu de Paume) along with two other pictures; it was shown, nevertheless, at the Salon des Refusés, where it caused a scandal.

Several private shows of Manet's work were held at the Galerie Martinet (1861, 1863, 1865), and in 1867, not having been invited to participate in the show for the Exposition Universelle, he erected a temporary building on the nearby Place de l'Alma where he exhibited fifty of his own works. About the same time he had begun to attend gatherings at the Café Guerbois, where he met the Naturalist painters and writers. He made a strong impression on the young painters, and the group that would later found the Impressionist movement gravitated to him.

Manet became a staff officer in the National Guard when the Franco-Prussian war broke out in 1870. After the war he rejoined his family at Oloron; later, in Arcachon and Bordeaux, he painted landscapes. This marked the first time that Manet had painted in the open air, a habit that he practiced extensively during the next few years under the influence of Monet, whom he had met again at Argenteuil.

By 1880 Manet had begun to suffer from ataxia, but, nevertheless, while living in Bellevue (1880), Versailles (1881), and Rueil (1882), he continued to paint. The pictures of gardens he did in Rueil are among his best work.

Manet never exhibited with the Impressionists; he submitted instead to the Salons, perhaps preferring the official prestige that had eluded him early in his career. *Boating* (no. 22), for example, was exhibited in the Salon of 1878. Since 1863 he had submitted regularly to the salons and was occasionally refused (1866, 1867, 1876); in the eyes of the public, however, he never overcame the scandals caused by his *Déjeuner sur l'herbe* (Salon of 1863) and *Olympia* (Salon of 1865; Musée du Louvre, Galerie du Jeu de Paume).

Claude Monet

(1840-1926)

Monet was born in Paris but lived until he was twenty in Le Havre, where Boudin introduced him to plein-air painting. In 1859 he went to Paris for a brief visit, but, encouraged by Troyon, he decided to stay there against his family's wishes. He studied with the academic painter Charles Jacque and at the Académie Suisse, where he met Pissarro.

After his military service, he returned to Le Havre in 1862 where he again painted with Boudin and then with the Dutch landscape painter Jongkind. Later the same year he returned to Paris and enrolled in the classes at Gleyre's studio. There he met Renoir, Sisley, and Bazille; the four often traveled to the Fontainebleau Forest to practice plein-air painting in the region near Barbizon.

Monet exhibited for the first time at the 1865 Salon; he had neither financial nor critical success in the early years and decided in 1869 not to submit to Salon again. His work of this period shows the influence of Courbet and Manet; but by 1866-1867 his *Terrace at Sainte-Adresse* (no. 26) and *Women in the Garden* (no. 25) showed signs of new experimentation and a move toward plein-air painting in light tones. Throughout the sixties and seventies Monet had little money and was often unable to purchase paint and canvas.

During the Franco-Prussian War he went to England with Pissarro; while there he admired the work of Turner. After a brief stay in Holland he returned to France and lived at Argenteuil from 1872 to 1878. He exhibited in five of the eight Impressionist exhibitions and was given a one-man show at La Vie Moderne in 1880.

During his stay at Vétheuil (1878-1883) he devoted more and more of his attention to studies of light and atmospheric effects; subject matter as such became subordinate to effects of color and light. The work that began with his arrival in Giverny (1883) leads inevitably to the "series" paintings, pure studies of light and atmosphere as manifested by a specific environment at a specific time of day (*The Haystacks,* 1891; *The Poplars,* 1890-1891; *The Rouen Cathedral Façades,* 1892-1894; *The Water Lilies,* 1899 and thereafter).

During the eighties and nineties Monet traveled widely, searching for subjects that would provide the sort of compositional format that would encourage, or permit, pursuit of his interest in color, light, and atmosphere. The places he visited include Pourville, Etretat, the Côte d'Azur, Belle-Ile, London, Venice, and Antibes.

During the First World War Monet made a number of large studies of *Water Lilies* at Giverny; they were intended for a decorative cycle that he offered to the French Government in 1922, but he continued to work on them until his death. The cycle has been placed, in accordance with his wish, in two rooms of the Orangerie des Tuileries.

Suffering from cataracts, Monet was, like Degas, nearly blind when he died at the age of 87.

Berthe Morisot

(1841-1895)

Berthe Morisot showed an early talent for painting; she worked first with Chocarne and then with the Lyonnais painter Guichard, a pupil of Ingres and Delacroix. By 1860 she was painting in the open air with Corot. In 1868 she met Manet in the Louvre, where she was copying Rubens; this chance meeting was to have a strong influence on Morisot's art and life. The Manet and Morisot families spent a vacation together at Fécamp, and afterward, in December of 1874, Berthe was engaged to Eugène Manet, Edouard's brother. During the engagement Edouard Manet made several portraits of his future sister-in-law, one of which, *Berthe Morisot with a Fan,* came to the Louvre with the Moreau-Nélaton Collection. A few years later Manet used Berthe as a model for *The Balcony* (Musée du Louvre, Galerie du Jeu de Paume).

In 1874 she took part in the first Impressionist exhibition and afterward exhibited regularly with the group. After 1880 she came under Renoir's influence, especially noticeable in the greater richness of her palette. Previous to the Impressionist exhibitions she had shown in the Salons, where she made her début in 1864.

Throughout her life she was in contact with artists, musicians, and writers, including Daubigny, Daumier, Zola, Baudelaire, Chabrier, Rossini, Renoir, Degas, Monet, and, of course, Manet; Mallarmé became one of her closest friends and admirers.

Camille Pissarro

(1830-1903)

After studying in Paris (1842-1847), Pissarro returned to his home in the West Indies. Together with Fritz Melbye, a Danish painter, he worked briefly in Venezuela. By 1855 he was back in Paris where he spent short periods in various studios but worked most regularly at the Académie Suisse, where he met Claude Monet. Early in the sixties he began to paint in the open air and was strongly influenced by Corot as well as Courbet and Delacroix.

He exhibited in the Salon des Refusés of 1863, and in the official Salons of 1864, 1865, and 1866. Before the Franco-Prussian War he lived in Pontoise and Louveciennes, popular sites among the Impressionists. In 1870 he and Monet went to England for the duration of the war. After his return he became a key member of the Impressionist circle and showed in all of the Impressionist exhibitions.

In Pontoise, where he lived after the war, he persuaded Cézanne to join him and introduced him to plein-air painting and the use of a light palette. It was not long, however, before the influence of Cézanne reverberated in Pissarro's work.

In the mid-eighties Pissarro became interested in Seurat and the Neo-Impressionists' style and ideas, but by 1890 he had already begun to return to a more orthodox Impressionist manner. Durand-Ruel gave him a retrospective exhibition in 1892; this resulted in financial and critical success for the first time after thirty years of poverty and struggle.

Pissarro settled in Eragny in 1884 but traveled widely in search of new subject matter : Moret, Le Havre, Dieppe, London, Rouen, and, of course, Paris, where he painted the boulevards, the square of the Comédie Française, the Garden of the Tuileries, the Place du Carrousel, the Pont Neuf, and the Quai Malaquais. He not only returned to his Impressionist style of the seventies but to many of the subjects as well.

Pierre Auguste Renoir

(1841-1919)

In his youth Renoir, who showed talent as a draughtsman, was apprenticed to a porcelain manufacturer for whom he decorated ceramics in an eighteenth-century style. He was accepted at the Ecole des Beaux-Arts in 1862; he entered the Gleyre studio, where he met Sisley, Bazille, and Monet. They often traveled to the Fontainebleau Forest where they practiced plein-air painting and acquainted themselves with the members of the Barbizon school.

Renoir's early work shows the influence of Diaz, Courbet, and Delacroix. By the late sixties he and Monet, sometimes painting side by side, emerged as the leading painters of the group that would become the Impressionist circle. He took part in the first Impressionist exhibition in 1874, but on several occasions he forsook the group's shows for the official Salon.

He made two journeys to Algeria, in 1881 and 1882, and returned with canvases in brilliant color. Following a study of Ingres and a journey to Italy, where he discovered the work of Raphael and the Italian primitives, Renoir began to abandon Impressionism in 1883, although the seeds of the crisis can be traced to his work of the late seventies. This, his "Ingres period," is characterized by precise drawing, a rather dry style, and harsh colors. In the eighties he began to travel a great deal, probably as a result of the critical and financial success following the Salon of 1879 in which he exhibited *Madame Charpentier and Her Family* (no. 38). He spent time on the Normandy coast, on the Côte d'Azur, at Guernsey, and at La Rochelle. After 1885 he divided his time between Paris and Essoyes, the village where his wife was born.

About 1890 Renoir adopted a more painterly style emphasizing fullness of form. He abandoned typically Impressionist subjects in favor of portraits and nudes; the latter grew increasingly important in his work.

About 1892 he traveled in France and abroad (England and the Netherlands). In 1903 he moved to Cagnes, where he remained for the rest of his life. Despite painful arthritis he continued to paint, producing works typified by a dominant red or pink tonality and the full development of the lyricism characteristic of his best work.

Alfred Sisley

(1839-1899)

Although born in Paris, Sisley was the son of well-to-do English parents. He spent only the years 1858-1862 in England when he was in London to train for a career in business. With his father's consent he returned to Paris in 1862 and entered the studio of Gleyre where he met Monet, Renoir, and Bazille. His earliest Salon entries in the mid-sixties reflect the influence of Corot, Courbet, and Daubigny, whose styles he began to consciously imitate in 1864, the year that Gleyre closed his studio, freeing Sisley and his three precocious friends to pursue their own ends.

He worked in Marlotte in 1866, stayed in Honfleur in 1867, and later lived in Bougival and Louveciennes. About 1870 he came under the influence of Monet and painted landscapes of the Ile-de-France (Voisins, Marly). After a brief visit to England, he lived at Sèvres from 1875 to 1879 and made a permanent home at Moret in 1882.

Sisley's work was included in the Impressionist exhibitions of 1874, 1876, 1877, and 1882. In 1879 he submitted to the Salon but was refused. Durand-Ruel gave him a one-man show in 1883 in Paris and another in 1889 in his recently opened New York gallery.

Sisley never knew the critical or financial success that came to most of the other Impressionists. In 1886 poverty forced him to consider making fans as a source of income. Only a few weeks after his death his achievement showed signs of gaining proper but belated recognition in a series of articles written by Gustave Geffroy.